THE BUSH GARDEN

Also by Northrop Frye

Fearful Symmetry: A Study of William Blake

Anatomy of Criticism: Four Essays

The Well-Tempered Critic

The Educated Imagination

T. S. Eliot

Fables of Identity

A Natural Perspective: Essays on the Development of Shakespearean Comedy and Romance

The Return of Eden: Five Essays on Milton's Epics

Fools of Time: Studies in Shakespearean Tragedy

The Modern Century

A Study of English Romanticism

The Stubborn Structure

The Critical Path

The Secular Scripture

Spiritus Mundi

Northrop Frye on Culture and Literature

Creation and Recreation

The Great Code

Divisions on a Ground

The Myth of Deliverance: Reflections on Shakespeare's Problem Comedies

THE BUSH GARDEN

ESSAYS ON THE CANADIAN IMAGINATION

NORTHROP FRYE

INTRODUCTION BY LINDA HUTCHEON

This edition published in 1995 by
House of Anansi Press Limited
1800 Steeles Avenue West
Concord, Ontario
L4K 2P3
Tel.(416) 445-3333
Fax (416) 445-5967

First published in 1971 by House of Anansi Press Limited

Canadian Cataloguing in Publication Data

Frye, Northrop, 1912–1991
The bush garden : essays on the Canadian imagination

2nd ed.
ISBN 0-88784-572-X

1. Canadian literature — 20th century — History and
criticism. 2. Painting, Canadian. I. Title.

PS8077.F78 1995 C810.9'005 C95-931803-8
PR9184.6.F78 1995

Cover Design: the boy 100 &
Tannice Goddard, S.O. Networking
Computer Graphics: Tannice Goddard & Mary Bowness
Printed and bound in Canada

*House of Anansi Press gratefully acknowledges the support
of the Canada Council, the Ontario Ministry of Citizenship, Culture,
and Recreation, Ontario Arts Council, and Ontario Publishing Centre
in the development of writing and publishing in Canada.*

Contents

The Field Notes
of a Public Critic

"N is for Northrop, egghead supreme,
Essays explaining what everything means."
Canlit Confidential, #14 of 26

CANADIAN POET AND CRITIC Eli Mandel once claimed that the
Canadian criticism of Northrop Frye — that world-renowned
and most formidable theorist of literature — was cogent and
powerful but also widely misunderstood. In fact, Mandel
thought that misreadings of it would one day form their own
fascinating chapter in the literary history of Canada, and no
doubt my own prefatory remarks will contribute to that
chapter. Nevertheless, twenty-five years have passed since the
original publication of *The Bush Garden,* and it seems an
appropriate time to think again about the contribution of the
man who was said to have defined the Canadian imagination
for this century. The subtitle of this book is indeed *Essays on
the Canadian Imagination,* and though the writings published
here are all occasional pieces, some now almost fifty years old,
all of them speak to Frye's conception of what has made the
Canadian imagination distinctive.

Predictably (this *is* Canada), Frye's particular conception
came under fire — from the very start. Over time, some com-
mentators have come to feel that its influence on Canadian

literature and criticism has been pervasive but destructive; others have felt it to be minor and overestimated. But when *The Bush Garden* appeared in 1971, the reviews were pretty well unanimous in hailing it as a landmark text. This is not to say that there were not the usual accusations that Frye had fathered a brood of myth-obsessed poets, whose erudite and academic work he paternally protected in his reviews. But Frye's resistance to such parental roles is well documented: "It is no part of the reviewer's task to tell the poet how to write or how he should have written." Yet, in one reviewer's terms, the "witty malice" of Frye's detractors had to contend with the "noisy reverence" of his fans.* And in Canada that sort of thing doesn't happen unless a book has somehow hit the mark.

Reading *The Bush Garden* and the first reviews of it from the vantage point of a quarter century is an intriguing experience. The book was very warmly received: it was complimented for its readability, its insights, its scholarship, its wit. Despite the fact that it is actually a collection of odd bits and pieces — reviews from the *University of Toronto Quarterly* in the 1950s, lectures, introductions and conclusions to other books — early readers were quick to note a continuity of vision or, more accurately, a developing vision of what makes Canadian poetry and visual art particularly "Canadian." Far from being predictable, dogmatic, or prescriptive, the volume often went against the grain of contemporary thinking, offering what one critic called "a stimulating archive of literary heresies, controversies, and contradictions."** What is fascinating for me is that it *still* reads this way today. The writer of these pieces still comes across, in another reviewer's words, as "one of the gentlest of creatures, whose quiet wit and serene prose belie the controversial nature of his theories" (Wahl 5). The specific reasons for controversy are inevitably going to be different today, but Frye's provocative vision of the Canadian imagination — mentally garrisoned against a terrifying nature,

*C. Wahl, review in *Canadian Reader* 12.3 (22 March 1971): 5.
**Louis Dudek, "The Misuses of Imagination: A Rib-Roasting of Some Recent Canadian Critics," *Tamarack Review* 60 (October 1973): 52.

frostbitten by a colonial history — is a vision that still has the power to provoke, just as the judgements he made about individual writers and artists in his reviews still have the power to irritate and delight.

Frye, as literary theorist, was notorious for claiming to refuse to play the rating game. He did not feel that it was the job of the scholar to make value judgements or to make them either the goal or the starting point of criticism. But he also argued that value judgements presented specific problems for the Canadian critic, in particular. As he wrote so memorably in 1965 in the conclusion to the first edition of the *Literary History of Canada* (reprinted here): "If evaluation is one's guiding principle, criticism of Canadian literature would become only a debunking project, leaving it a poor naked *alouette* plucked of every feather of decency and dignity." Yet, as the first half of *The Bush Garden* illustrates so well, Frye — as reviewer — did not hesitate to evaluate, and, however severe his criticisms, every *alouette* was left feathered, with decency and dignity intact. These "Letters in Canada" surveys of Canadian poetry from the *University of Toronto Quarterly* all date from the 1950s, but their value today is not simply historical (that is, as documents of Frye's developing views or as judgements on particular poets and their works). They read today as models of tact, even when they are at their most devastating; they set newly appropriate standards of civility and respect in critical writing. I know such qualities are not necessarily appreciated today in the cut and thrust of reputation-making and -destroying in the Vanity Fair of media attention. But there may be many things to learn today from these reviews, with their hard-nosed evaluations — based on openly admitted criteria — combined with a generosity and a respect for the act of creation. Think about how rare it would be today to find a remark — offered without irony — like Frye's respectful comment that, in one poet's book, "one finds, if not always genuine poetry, at least a genuine effort to write it." Frye tends toward the descriptive in such reviews, as if he wants to let a book be evaluated in terms of what the poet wanted to do with it rather than what the critic thought he or she should have done.

Yet, at times, these reviews also read today like a diary —
not an intimate diary, to be sure, but a record nonetheless of
Frye's developing responses to Canadian poetry. Though the
conventions of critical writing at that time place the imper-
sonal "one" in the writer's chair, the "one" responding is
always recognizably Frye, whether "one regrets a rather self-
deprecatory melancholy" in a poem or "one experiences the
thrill of response to authentic craftsmanship" in the rhythm
of a line. There is more of the personal and the tentative in
the early reviews, I think, but what never disappears is that
sense of both excitement and frustration that comes from his
intense engagement with the work of different generations of
writers over an entire decade. He is always delighted by
technical ability, but it has to be craftsmanship used to some
end: he is as willing to call ideas immature as he is to call
verse pedestrian or "muscle-bound and squirming." But his
standards are not secret ones: in the reviews themselves (as in
his scholarly work published in the same years) Frye outlines
openly how he thinks poetry works. And he does it clearly,
eloquently, and often wittily:

> The difference between the simple and the insipid, in
> poetry, is that while simplicity uses much the same
> words, it puts them together in a way that keeps them
> echoing and reverberating with infinite associations,
> rippling away into the furthest reaches of imaginative
> thought. It is difficult for a critic to demonstrate the
> contrast be between the simplicity that keeps him
> awake at night and the mediocrity that puts him to
> sleep in the day.

In reviewing *The Bush Garden* on its first appearance, Louis
Dudek claimed that no critic in Canada had "delivered more
devastating and ponderous evaluations, fatal verdicts as well as
eulogies, than Northrop Frye" (Dudek 53). Frye himself may
have claimed in 1955 that he didn't know — or much care —
how posterity would sort out and rank the poets of his day, but
part of the pleasure of reading his reviews of them *today* lies

precisely in the possibility of comparing Frye's judgements with those of posterity. However, the fact that the subsequent careers of Earle Birney, P.K. Page, A.J.M. Smith, Miriam Waddington, Phyllis Webb, and others have vindicated Frye's evaluations of their work cannot be separated entirely from the power of his particular view of them and thus of his role in forming the canon of Canadian poetry in the 1950s. Frye's sympathies — both aesthetic and personal — are clear in his obvious delight in the work of James Reaney, Jay Macpherson, and especially E.J. Pratt. But he is also surprisingly open, even generous, as a reviewer. Always even-handed, he will note "lapses" in one poet's work only because, as he puts it, "the general level of writing is good enough to make them show up." Always honest, he isn't afraid to change his mind. Irving Layton provides a case in point. In the 1950s Layton published one, sometimes two, books of poetry a year, and Frye dutifully reviewed them all. One of the pleasures of reading these "Letters in Canada" surveys is watching Frye go from a suspicion in 1951 that there might be a "real poet buried" in what he saw as a "noisy hot-gospeller who has no real respect for poetry" to his evaluation only five years later that Layton was the most considerable Canadian poet of his generation — though that self-advertising, posing poetic persona in some of the poems obviously continued to irritate him. (Even at the end of the decade, Frye still felt the need to separate the "genuine poetry" from Layton's "stage personality.")

There is often a quiet humour in, for instance, judgements that a poet may be "much more at ease with the vegetable than with the human world" or in remarks about the fast careers of American poets who can progress "from gargle to Guggenheim in six easy volumes." But there is also formidable learning along with that verbal wit. Frye's remarkable memory is legendary, but it operates in these reviews in unobtrusive but enlightening ways: relevant echoes of Donne or Hopkins are noted; the revealing influence of Shelley and Keats is pointed out. In his "David Milne: An Appreciation," it is the history of western painting, from the medieval to Masaccio, from Cézanne and Chagall to the Group of Seven,

that Frye brings to bear on Milne's work. In all his critical writing, Frye had the gift of wearing his vast learning with a kind of grace and elegance that matches the wit and lucidity of its expression.

He also had a fine sense of his audiences — both the one he knew and the one he wanted to create, in Canada, for poetry. We tend to forget today what the Canadian cultural scene was like before things like the Canada Council and other government initiatives helped to create an audience for Canadian writing, before the days when the teaching of Canadian literature was a "given" in Canadian schools. Frye wrote his reviews for a specifically Canadian audience, not for "invisible posterity." As he wrote in his final contribution to "Letters in Canada":

> The reviewer's audience is the community of actual and potential readers of poetry. His task is to show what is available in poetic experience, to suggest that reading current poetry is an essential cultural activity, at least as important as keeping up with current plays or concerts or fiction. He has the special problem, too, of bridging the gap between poetry and its public. . . . I have spent a great deal of my space in trying to explain as clearly as I can what the poet is saying, and what is characteristic about his handwriting, so to speak, in imagery and rhythm. I have felt that it is well worth insulting the intelligence of some readers if one can do anything to breach the barriers of panic and prejudice in others.

In the years since 1959, when those words were written, and the present, much has changed in Canada. The "indifferent public" and "conscientiously contemptuous critics" of Canadian writing are much less in evidence today.

These brief prefatory remarks are not the appropriate occasion to trace the shift in public knowledge and appreciation of Canadian culture, but it may be worth noting not only the major difference between Frye's reviews in the 1950s and, say, Margaret Atwood's self-consciously (if self-deprecatingly)

nationalistic *Survival* (published in 1972, the year after *The Bush Garden,* and by the same press, House of Anansi), but the even greater difference between Atwood's book and something like Frank Davey's recent *Post-National Arguments.* In other words, one of the most noticeable changes for today's reader of Frye's collected pieces — written from 1950 to 1970 — is that very real difference in the quantity and quality of both Canadian literature and Canadian criticism. There is also a significant difference in the quantity and quality of knowledge *about* that literature and criticism, and as reviewer and critic, but also as teacher and editor, Frye was instrumental in helping to make that difference. In 1965, in the conclusion to the first edition of the *Literary History of Canada,* Frye wrote: "while much Canadian verse could be honestly described, by the highest standards of the best twentieth-century poets, as metrical doodling, it could also be described, just as honestly and perhaps more usefully, as the poetic conversation of cultivated people." Yet, little more than a decade later, in his companion conclusion to the next edition of that work, he could happily celebrate "a bulk of good writing" with an "extraordinary vitality and morale behind it." "Canadian literature is here," he proclaimed in 1976, though he also added that it was "perhaps still a minor but certainly no longer a gleam in a paternal critic's eye." In 1991, just before his death, Frye could look back and see the history of that change in both quality and recognition: "English Canada, the land nobody wanted, the land that seemed unable to communicate except by railways and bridges, began, from about 1960 on, to produce a literature of a scope and integrity admired the world over."

What may not seem to have changed very much, however, what may well seem all too familiar to today's readers of *The Bush Garden* is the seemingly perennial problem of Canadians' need to define their identity. In the days of free trade, many of Frye's early remarks on this topic still seem all too relevant. Witness the different context but the equally potent ironies of reading in the 1990s his 1971 quip: "But it is with human beings as with birds: the creative instinct has a great deal to do

with the assertion of territorial rights." In his preface to the original edition of this volume — a preface Robert Weaver once rightly said was, in itself, worth the "price of admission"* — Frye makes a distinction between identity and unity in Canada, and it is a distinction that has meaning (perhaps even more, though in a different way) today than it did twenty-five years ago:

> Identity is local and regional, rooted in the imagination and in works of culture; unity is national in reference, international in perspective, and rooted in a political feeling. . . . Assimilating identity to unity produces the empty gestures of cultural nationalism; assimilating unity to identity produces the kind of provincial isolation which is now called separatism.

Today we may read those words and think of the former U.S.S.R. or Yugoslavia as well as Canada, but Frye is writing, we should recall, just after the War Measures Act has been declared, and is reacting viscerally to what he calls the "squalid neo-fascism of the FLQ terrorists." Within the distance of only five years, in 1976, he could more positively point to the impact of Quebec and its new sense of identity as the "decisive cultural event in English Canada" in those years. But the separatism that goes with regionalism in *every* part of Canada, from Newfoundland to British Columbia, was something of which he remained suspicious, preferring instead a liberal sense of "real unity" that "tolerates dissent and rejoices in variety of outlook and tradition, recognizes that it is man's destiny to unite and not divide."

Readers of *The Bush Garden* today may or may not agree with the political position Frye chose to take in 1971; times have changed. While, as he put it, "[c]ulture, like wine, seems to need a specific locality," Frye also felt that "forms of literature are autonomous: they exist within literature itself, and cannot be derived from any experience outside literature."

*Robert Weaver, "Canadian Intellectuals? Well, Besides McLuhan There's Northrop Frye," *Macleans* 84 (April 1971): 86.

What many have seen as a major contradiction in Frye's work — between theories of general mythic patterns in literature and assertions of a specifically Canadian culture — is indeed a real tension in his writing about Canada. In the preface to this volume, he admits that his academic work had been mainly oriented toward world literature and had addressed an international reading public. Yet he insists that it had also "always been rooted in Canada" and had "drawn its essential characteristics from there." While he was busy writing those reviews of Canadian poetry in the *University of Toronto Quarterly*, he was also developing his major theoretical statement, his *Anatomy of Criticism*. As I mentioned earlier, he never hid the criteria for his evaluations; similarly, he never hid the reasons for his preferences. His theories may have determined his likes and dislikes, but at least the theories were out there in the public domain to be judged themselves. (And judged they were.) Frye published a theoretical study, *The Stubborn Structure*, the year before *The Bush Garden* and, inevitably, the two were often reviewed together. One book presents Frye as the "academic critic"; the other gives us a view of the "field worker" or, in George Woodcock's term, the "astute and rather genial public critic."* For Frye, the public critic is the one who "represents the reading public at its most expert and judicious." This is also the person who should show the larger public how literature is to be "absorbed into society." But it is worth noting that the subtitle of the academic critic's book, *The Stubborn Structure*, is *Essays on Criticism and Society*.

In other words, the theorist of aesthetic form was always also the theorist of what he called the "imaginative social vision." That was what teaching was all about for Frye; that's probably why he sat on the Canadian Radio and Television Commission. The liberating role of the imagination was a social role — whether it be in poetry or painting. It is, for instance, Lawren Harris's social concern that Frye sees as

*George Woodcock, "Criticism and Other Arts," editorial, *Canadian Literature* 49 (Summer 1971): 5.

building the crucial bridge between his art and his society. Today the outward terms of this particular debate may have changed: we are more likely to talk of the "political" (in its broadest sense) than the "social," and the word "imagination" may sound a bit too romantic for some contemporary ears. But the intense public attention given in recent years to issues of "political correctness" would suggest that issues of language and literature are indeed social issues, today as well. No matter what personal opinion or position may be held by individuals, no one can deny that feminist challenges, for example, have permanently changed the way modern Canadian society thinks and the very words it uses to articulate those thoughts. A simple and obvious example: in English, "he" is no longer considered the gender-neutral, universally applicable pronoun that it was twenty-five (or even five) years ago.

The overtly political dimensions of the "social imagination" were by no means foreign to Frye's thinking, however. Seeing Canada as a small nation between huge empires, in the 1971 preface to *The Bush Garden* Frye called it "practically the only country left in the world which is pure colony, colonial in psychology as well as in mercantile economics." He made fun of our national anthem, transposing its "true north strong and free" into "a sham south weak and occupied." He would later write that, lacking the American revolutionary tradition, Canada had gone from "a pre-national to a post-national phase without ever having become a nation." It was his strong historical sense that made him describe Canadian culture in this way: initially less a society than "a place to look for things" (furs, minerals, pulpwood), Canada could be forgiven, perhaps, for its early imitative and colonial imagination. In the same years that the United States was being defined as a nation (in the eighteenth century), Canada was being defined as a colony. Frye felt that poetry, especially, flourishes in national-sized units: other sizes, such as empire (too big) and province (too small), made for anti-poetic environments. English Canada's imperialist heritage and Quebec's regional self-definition were therefore both suspect and both equally part of the "colonial tendency" he saw as that "frostbite at the

roots of the Canadian imagination." Between 1867 and the First World War, he would later argue, Britain's cultural impact had been enormous in English Canada because the community offered by Empire (and then Commonwealth) was appealing: British institutions acted as a protective wall for the "garrison" of colonial culture. But not even that was able to protect Canada from the immense cultural and economic power of the United States.

Frye later compared a protest by the Cree and Inuit peoples of the North — against the destruction of their cultures by southern Canadian mass-media intrusion — to English Canada's similar protest against American cultural imperialism. That comparison deliberately puts nonaboriginal Canadians into the position of colonialist power vis-à-vis the First Peoples of the land. I have no doubt that Frye, were he writing today, would not write as unselfconsciously as he does in some of these early pieces in *The Bush Garden* of Indian primitivism, brutality, or ferocity. In fact, over the next two decades, he loudly protested the stereotyping of Native peoples, and repeatedly called to public attention Canada's history of destroying, not preserving, indigenous cultures. But even in 1959, in a review of *Anerca*, a collection of Inuit (then called Eskimo) poems, he noted: "Nature cannot exterminate such a people: only civilization, with its high-powered death-wish, can do that." And, for Frye, the colonial mentality that had exploited the Native peoples of Canada was also responsible for exploiting the land upon which they had first lived.

Writing in *The Bush Garden* about Pratt's poem *Brébeuf and His Brethren*, Frye notes how Pratt makes the Native antagonists in the poem into representatives of humanity "in the state of nature," "agents of its unconscious barbarity." That terror of the hostility of nature was what Frye came to see as the single most important defining force on the Canadian imagination. Many others would follow him in this view over the years to come, but Frye articulated most powerfully, perhaps, the impact on the Canadian national consciousness of the historical and physical reality of a "vast country sparsely inhabited." Faced with "the unknown, the unrealized, the

humanly undigested," Canadians built their psychological garrisons while they materially laid down railway tracks and street grids. They also created what he called a poetry of "incubus and *cauchemar*" — the same language he chose to describe "the twisted stumps and sprawling rocks, the strident colouring, the scarecrow evergreens" in the paintings of Tom Thomson. But Frye still wanted to separate the creative imagination from what was — and is — (as he memorably put it) "the conquest of nature by an intelligence that does not love it." What, in 1956, Frye had identified as an American trait — the spirit of entrepreneurial capitalism that had won the American Revolution but resulted in "an enthusiastic plundering of the natural resources of a continent" — he would later see as a Canadian failing as well. He would call for a "détente with an outraged nature" in order to solve what he felt were rapidly becoming the major social problems of Canada: "ecology, the extinction of animal species, the plundering of forests and mines, the pollution of water." He argued that the feelings of Canadians toward nature had changed over time from terror to guilt, as they "polluted and imprisoned and violated" but never really lived with nature.

The paradoxical "bush garden" of Frye's title is a good image for this ecological confrontation of the natural and the human. Frye simply notes without further comment that he has "pilfered" the image from Margaret Atwood's *The Journals of Susanna Moodie*. But in that context, the paradox becomes poignant. In a dream vision, Atwood's pioneer stands in her Canadian garden — now "sold, deserted and / gone to seed." But, since this is a dream, she can see down into the earth where the potatoes, radishes, and beets she once planted still live their lively vegetable lives, without her human cultivation. When she bends to pick strawberries that are "surging, huge / and shining," her hands come away "red and wet." The poem ends:

> In the dream I said
> I should have known
> anything planted here
> would come up blood.

Those who know Atwood's book may recall that, a few pages earlier, this woman had "planted" the body of her young son, dead by drowning, in this same earth. It is not that the terror of "the indifference of nature to human values" may not be a just-ified terror, Frye seems to imply, but that in turn can never justify the wholesale violation that is part of the past (and present) relationship between the human and the natural in Canada: rail lines (and the settlement that followed) dis-placed people and changed the ecological balance as much as oil fields or nuclear power facilities might today.

It is therefore likely not with unreserved praise and not without some irony that Frye would note, as he does in the con-clusion to the *Literary History of Canada*, that it is "in the inarticulate part of communication, railways and bridges and canals and highways, that Canada, one of whose symbols is the taciturn beaver, has shown its real strength." On the next page, Frye mentions, in passing, Marshall McLuhan as a disci-ple of Canada's foremost theorist of communication, Harold Innis. McLuhan's interest in technology and in questions of media power and control was very different from Frye's focus on the transforming and liberating power of the poetic imag-ination, but they have long been linked together not only as colleagues in the Department of English at the University of Toronto but as "our first genuine critics," as Dudek put it in the early 1970s. However temperamentally diverse, these two thinkers were both concerned with the social role of both art and the criticism of art. Society has changed in the last twenty-five years and so too has the particular social role we may wish to give to the creative and the critical "imagination." But the need to define some such role continues to be felt in the writ-ings of Canadians as diverse as Marlene Nourbese Philip and Neil Bissoondath, or, for that matter, Mordecai Richler and Daphne Marlatt.

As Canadians are fond of reminding the rest of the world, Northrop Frye was born and, despite many attractive offers, worked his entire professional life in Canada. Many people outside the country as well as inside know him as the founder of "archetypal criticism." In the early writings of *The Bush*

Garden: Essays on the Canadian Imagination, we also come to know him as that timely and influential commentator on the fledgling, self-consciously independent culture of Canada before 1970. Yes, many things have changed since then, but so many of the arguments and judgements of the occasional pieces collected in this volume are still relevant. One reviewer's words of praise — words that had sounded like overstatement to me years ago — have, with time, come to sound more like understatement: Frye, he wrote, had "the courage to confront the present without distaste, the past without nostalgia, and the future without fear."* And so it would seem from the essays of *The Bush Garden.*

LINDA HUTCHEON
UNIVERSITY OF TORONTO

*Jon Slan, "Writing in Canada: Innis, McLuhan and Frye: Frontiers of Canadian Criticism," *Canadian Dimension* 8 (August 1972): 46.

Author's Preface

WHAT FOLLOWS IS A RETROSPECTIVE collection of some of my writings on Canadian culture, mainly literature, extending over a period of nearly thirty years. It will perhaps be easiest to introduce them personally, as episodes in a writing career which has been mainly concerned with world literature and has addressed an international reading public, and yet has always been rooted in Canada and has drawn its essential characteristics from there.

The famous Canadian problem of identity may seem a rationalized, self-pitying or made-up problem to those who have never had to meet it, or have never understood that it was there to be met. But it is with human beings as with birds: the creative instinct has a great deal to do with the assertion of territorial rights. The question of identity is primarily a cultural and imaginative question, and there is always something vegetable about the imagination, something sharply limited in range. American writers are, as writers, not American: they are New Englanders, Mississippians, Middle Westerners, expatriates, and the like. Even in the much smaller British Isles we find few writers who are simply British: Hardy belongs to "Wessex," Dylan Thomas to South Wales, Beckett to the Dublin-Paris axis, and so on. Painters and composers deal with arts capable of a higher degree of abstraction, but even they are likely to have their roots in some very restricted coterie in Paris or New York.

Similarly, the question of Canadian identity, so far as it affects the creative imagination, is not a "Canadian" question at all, but a regional question. An environment turned outward to the sea, like so much of Newfoundland, and one turned towards inland seas, like so much of the Maritimes, are an imaginative contrast: anyone who has been conditioned by one in his earliest years can hardly become conditioned by the other in the same way. Anyone brought up on the urban plain of southern Ontario or the gentle *pays* farmland along the south shore of the St. Lawrence may become fascinated by the great sprawling wilderness of Northern Ontario or Ungava, may move there and live with its people and become accepted as one of them, but if he paints or writes about it he will paint or write as an imaginative foreigner. And what can there be in common between an imagination nurtured on the prairies, where it is a centre of consciousness diffusing itself over a vast flat expanse stretching to the remote horizon, and one nurtured in British Columbia, where it is in the midst of gigantic trees and mountains leapinginto the sky all around it, and obliterating the horizon everywhere?

Thus when the CBC is instructed by Parliament to do what it can to promote Canadian unity and identity, it is not always realized that unity and identity are quite different things to be promoting, and that in Canada they are perhaps more different than they are anywhere else. Identity is local and regional, rooted in the imagination and in works of culture; unity is national in reference, international in perspective, and rooted in a political feeling. There are, of course, containing imaginative forms which are common to the whole country, even if not peculiar to Canada. I remember seeing an exhibition of undergraduate painting, mostly of landscapes, at a Maritime university. The students had come from all over Canada, and one was from Ghana. The Ghana student had imaginative qualities that the Canadians did not have, but they had something that he did not have, and it puzzled me to place it. I finally realized what it was: he had lived, in his impressionable years, in a world where colour was a constant datum: he had never seen colour as a cycle that got born in spring, matured in a burst of autumn flame, and then died out

into a largely abstract, black and white world. But that is a factor of latitude rather than region, and most of the imaginative factors common to the country as a whole are negative influences.

Negative, because in our world the sense of a specific environment as something that provides a circumference for an imagination has to contend with a global civilization of jet planes, international hotels, and disappearing landmarks — that is, an obliterated environment. The obliterated environment produces an imaginative dystrophy that one sees all over the world, most dramatically perhaps in architecture and town planning (as it is ironically called), but in the other arts as well. Canada, with its empty spaces, its largely unknown lakes and rivers and islands, its division of language, its dependence on immense railways to hold it physically together, has had this peculiar problem of an obliterated environment throughout most of its history. The effects of this are clear in the curiously abortive cultural developments of Canada, as is said later in this book. They are shown even more clearly in its present lack of will to resist its own disintegration, in the fact that it is practically the only country left in the world which is a pure colony, colonial in psychology as well as in mercantile economics.

The essential element in the national sense of unity is the east-west feeling, developed historically along the St. Lawrence–Great Lakes axis, and expressed in the national motto, *a mari usque ad mare*. The tension between this political sense of unity and the imaginative sense of locality is the essence of whatever the word "Canadian" means. Once the tension is given up, and the two elements of unity and identity are confused or assimilated to each other, we get the two endemic diseases of Canadian life. Assimilating identity to unity produces the empty gestures of cultural nationalism; assimilating unity to identity produces the kind of provincial isolation which is now called separatism.

The imaginative Canadian stance, so to speak, facing east and west, has on one side one of the most powerful nations in the world; on the other there is the vast hinterland of the north, with its sense of mystery and fear of the unknown, and the curious guilt feelings that its uninhabited loneliness seems to inspire in this exploiting age. If the Canadian faces south,

he becomes either hypnotized or repelled by the United States: either he tries to think up unconvincing reasons for being different and somehow superior to Americans, or he accepts being "swallowed up by" the United States as inevitable. What is resented in Canada about annexation to the United States is not annexation itself, but the feeling that Canada would disappear into a larger entity without having anything of any real distinctiveness to contribute to that entity: that, in short, if the United States did annex Canada it would notice nothing except an increase in natural resources. If we face north, much the same result evidently occurs: this happened to the Diefenbaker campaign of 1956, which has been chronicled in books with such words as "lament" and "renegade" in their titles.

Whenever the east-west context of the Canadian outlook begins to weaken, separatism, which is always there, emerges as a political force. Every part of Canada has strong separatist feelings: there is a separatism of the Pacific Coast, of the Prairies, of the Maritimes, of Newfoundland, as well as of Quebec. Ontario, of course, began with a separatist movement from the American Revolution. But since the rise of the great ideological revolutionary movements of our time, whether communist, fascist, imperialist, Islamic or what not, separatism has been an almost wholly destructive force. The successful separations, like that of Norway and Sweden in 1905, took place before the rise of these movements. In India and Pakistan, in the Arab-Jewish world, and in many other centres divided by language, colour or religion, separatism has seldom if ever stabilized the prejudices which gave rise to it, but has steadily increased them. Even where there is no political affiliation, the separation of Cuba from the American sphere of influence, or of Yugoslavia from the Russian one, cannot be a politically neutral act. Quebec in particular has gone through an exhilarating and, for the most part, emancipating social revolution. Separatism is the reactionary side of this revolution: what it really aims at is a return to the introverted malaise in which it began, when Quebec's motto was *je me souviens* and its symbols were those of the habitant rooted

to his land with his mother church over his head, and all the rest of the blood-and-soil bit. One cannot go back to the past historically, but the squalid neo-fascism of the FLQ terrorists indicates that one can always do so psychologically.

What has just been said may seem inconsistent with some of what is said later on in this book; but the essays cover a period of thirty years, and naturally conditions in Canada itself have changed a good deal in that time. At the same time the changes have occurred within an intelligible pattern of repetition. The most striking changes are in French Canada, but some of those changes recapitulate earlier developments in English Canada. Thus the admiration for France, which on one occasion took the form of picketing a Cabinet Minister for saying that a French-made aeroplane was not as good as an English-made one, indicates a phase of colonialism now obsolete in the other culture. Similarly, separatism in the Atlantic or Prairie provinces is often based on a feeling that Ontario regards itself as an Israel or Promised Land with the outlying provinces in the role of desert wanderers: this is much the same as the attitude that Quebec separatism explicitly adopts toward the Francophone Canadians in New Brunswick or Manitoba. There may be a clue here to the immediate future prospects of the country worth investigating, and the following essays, with all their repetitions and dated allusions, may provide some useful historical perspective.

I grew up in two towns, Sherbrooke and Moncton, where the population was half English and half French, divided by language, education and religion, and living in a state of more or less amiable Apartheid. In the Eastern Townships the English-speaking group formed a northern spur of New England, and had at a much earlier time almost annexed themselves to New England, feeling much more akin to it than to Quebec. The English-speaking Maritimers, also, had most of their cultural and economic ties with New England, but their political connexion was with New France, so that culturally, from their point of view, Canada stopped at Fredericton and started again at Westmount. There were also a good many Maritime French families whose native language was English,

and so had the same cultural dislocation in reverse.

As a student going to the University of Toronto, I would take the train to Montreal, sitting up overnight in the coach, and looking forward to the moment in the early morning when the train came into Levis, on the south side of the St. Lawrence, and the great fortress of Quebec loomed out of the bleak dawn mists. I knew that much of the panorama was created by a modern railway hotel, but distance and fog lent enchantment even to that. Here was one of the imaginative and emotional centres of my own country and my own people, yet a people with whom I found it difficult to identify, what was different being not so much language as cultural memory. But the effort of making the identification was crucial: it helped me to see that a sense of unity is the opposite of a sense of uniformity. Uniformity, where everyone "belongs," uses the same clichés, thinks alike and behaves alike, produces a society which seems comfortable at first but is totally lacking in human dignity. Real unity tolerates dissent and rejoices in variety of outlook and tradition, recognizes that it is man's destiny to unite and not divide, and understands that creating proletariats and scapegoats and second-class citizens is a mean and contemptible activity. Unity, so understood, is the extra dimension that raises the sense of belonging into genuine human life. Nobody of any intelligence has any business being loyal to an ideal of uniformity: what one owes one's loyalty to is an ideal of unity, and a distrust of such a loyalty is rooted in a distrust of life itself.

In the last essay in this book I speak of the alternating rhythm in Canadian life between opposed tendencies, one romantic, exploratory and idealistic, the other reflective, observant and pastoral. These are aspects of the tension of unity and identity already mentioned. The former is emotionally linked to Confederation and Canadianism; the latter is more regional and more inclined to think of the country as a series of longitudinal sections. They are the attitudes that Pratt symbolizes in *Towards the Last Spike* by MacDonald and Blake, and in fact they did at one time have analogues in our political philosophies. I first became aware of this polarization

of mood through Canadian painting, which is why I include three short pieces on painting here. The romantic and exploratory tendency was represented for me by Thomson, the Group of Seven (especially Harris, Jackson and Lismer), and Emily Carr; the pastoral tendency by most of the better painters before Thomson and by David Milne later. "Canadian and Colonial Painting" was contributed to *The Canadian Forum*, whose good-natured hospitality has helped so many Canadians to learn to write. The piece is polemical and immature, but I think it got hold of a genuine theme. The tribute to Milne appeared in the second issue of *Here and Now*, accompanied by illustrations which the imaginative reader should have little difficulty in reconstructing. The Lawren Harris essay was the preface to the book of his writings and paintings edited by my classmate R. G. Colgrove and published in 1969: it is therefore recent, but its attitude is very close to another article on Harris written many years earlier.

I joined the Department of English at Victoria College, and there became exposed to the three personal influences described in "Silence in the Sea." This lecture inaugurated a series established in honour of Pratt by Memorial University in 1968. When I was still a junior instructor, the first edition of A. J. M. Smith's *Book of Canadian Poetry* appeared (1943), and my review of it in *The Canadian Forum* was perhaps my first critical article of any lasting importance. It is hard to overstate my debt to Mr. Smith's book, which brought my interest in Canadian poetry into focus and gave it direction. What it did for me it did for a great many others: the Canadian conception of Canadian poetry has been largely formed by Mr. Smith, and in fact it is hardly too much to say that he brought that conception into being. The article on the narrative tradition resulted from a lead given me by the same book: this article was translated by Guy Sylvestre and appeared in an issue of his magazine *Gants du ciel* which was devoted to English Canadian poetry. The "Preface to an Uncollected Anthology," a paper read to the Royal Society in Montreal in 1956, follows the same general line — in the original there was some deliberate overlapping with the narrative tradition

article, as the latter was available only in French and in a periodical that had ceased publication. Towards the end it touches on the question of popular culture, which is also glanced at in the review of Edith Fowke's collection of folk songs, also from *The Canadian Forum.*

At the time that I reviewed Mr. Smith's anthology, I was struggling with my own book on the symbolism of William Blake (*Fearful Symmetry,* 1947). In the last chapter of that book the conception emerges of three great mythopoeic periods of English literature: one around 1600, the age of Spenser, Shakespeare and the early Milton; one around 1800, the age of Blake and the great Romantics; and one around the period 1920–1950. I thought at first of writing my second book on Spenser, but the pull of contemporary literature was too strong and the theory of literature too chaotic, and I was drawn to a more general and theoretical approach which ultimately became the *Anatomy of Criticism* (1957). When I had got started on this, in 1950, during a year I had off on a Guggenheim Fellowship, I was asked by my colleague J. R. MacGillivray, then editor of the *University of Toronto Quarterly,* to take over the annual survey of Canadian poetry in its "Letters in Canada" issue which had been made by the late E. K. Brown from the beginning of the survey nearly up to the time of his death. Reviews from the ten essays I wrote through the decade of the 1950s form the bulk of the present book.

These reviews are too far in the past to do the poets they deal with any good or any harm, not that they did much of either even at the time. In any case the estimates of value implied in them are expendable, as estimates of value always are. They may be read as a record of poetic production in English Canada during one of its crucial periods, or as an example of the way poetry educates a consistent reader of it, or as many other things, some of them no doubt most unflattering to the writer. For me, they were an essential piece of "field work" to be carried on while I was working out a comprehensive critical theory. I was fascinated to see how the echoes and ripples of the great mythopoeic age kept moving through Canada, and taking a form there that they could not

have taken elsewhere. The better the poet, the more clearly and precisely he showed this, but the same tendencies could be seen even as far down as some of the doggerel, or what I called the naive verse.

By myth I meant, not an accidental characteristic of poetry which can be acquired as an ornament or through an allusion or by writing in a certain way, but the structural principle of the poem itself. Myth in this sense is the key to a poem's real meaning, not the explicit meaning that a prose paraphrase would give, but the integral meaning presented by its metaphors, images and symbols. Naturally before this view had established itself it was widely misunderstood, and I became for a time, in Mr. Dudek's phrase, the great white whale of Canadian criticism. That is, I was thought — still am in some quarters, evidently — to be advocating or encouraging a specific "mythological school" of academic, erudite, repressed and Puritanical poetry, in contrast to another kind whose characteristics were undefined but which was assumed to be much more warm-hearted, spontaneous and soul brother to the sexual instinct. Such notions came mainly not from other critics but from poets making critical *obiter dicta*. It does no great harm, however, for poets to be confused about the principles of criticism as long as some of the critics are not.

I was still engaged in this survey when I was approached by my friend Carl Klinck of Western Ontario, with his project for a history of English Canadian literature, and I joined his committee. The conclusion which I wrote for this history repeats a good many conceptions worked out earlier during the poetry reviews, but it is closely related to the rest of the book in which it first appeared, and is heavily dependent on the other contributors for data, conceptions and often phrasing. I emphasize this because I have edited the text, to save the reader the distraction of being continually referred to another book, and the editing has concealed my debts.

For a long time it has been conventional for Canadian criticism to end on a bright major chord of optimism about the immediate future. This tone is in a curious contrast to the pervading tone of Canadian economists, historians, political

theorists and social scientists. Some observers of the Canadian scene, including Professors Donald Creighton and George Grant, feel that there has been too long and too unchecked a domination of the longitudinal mentality in Canada, and that the tension between region and nation has finally snapped. Certainly a century after the American Civil War, the true north strong and free often looks more like a sham south weak and occupied — sham because there has been no war with this confederacy and no deliberate occupation. The national emphasis is a conservative one, in the lower-case sense of preserving the continuity of political existence, and it is typical of the confusions of identity in Canada that the one genuinely conservative Canadian party of the twentieth century, the CCF, expired without recognizing itself to be that. However, what seems to reason and experience to be perpetually coming apart at the seams may seem to the imagination something on the point of being put together again, as the imagination is occupationally disposed to synthesis. Perhaps that is part of the real function of the imagination in every community, and of the poets who articulate that imagination. In any case, there are many titles from many of the best known Canadian poets, "Resurgam," "Words for a Resurrection," "News from the Phoenix," "The Depression Ends," "Poem for the Next Century," "O Earth Return," "Home Free," "Apocalyptics," for the Canadian critic to murmur in his troubled sleep.

The title of the book has been pilfered from Margaret Atwood's *Journals of Susanna Moodie*, a book unusually rich in suggestive phrases defining a Canadian sensibility.

NORTHROP FRYE

From "Letters in Canada"
University of Toronto Quarterly

1950

READERS OF CANADIAN POETRY will often have seen the name of Mr. James Wreford, both in literary periodicals and in the fine little anthology of a few years back, *Unit of Five*. A collection of his verse, *Of Time and the Lover*, makes the fourth volume in McClelland and Stewart's "Indian File" series. Mr. Wreford lives in Ottawa, and has several qualities in common with his predecessor Lampman, notably a tendency to be much more at ease with the vegetable than with the human world. He has, however, worked harder to reconcile his love of nature and his vision of the city of the end of things. His imagery turns on the antithesis of winter and spring: he associates winter with the contemporary world and spring with the promise, not only of better times, but of deliverance from the winter world through the infinity of the moment of love and faith in the Resurrection. The central theme that love's not time's fool thus applies to patriotic and religious as well as sexual love. A conventional frame of ideas, certainly, but a solid one to build on.

Mr. Wreford is a pensive and elegiac poet: his best phrases are usually embedded in long ruminating poems, and seem to need that kind of context. Sometimes, too, a sudden poignancy breaks out, as it were unawares, from a more commonplace setting:

The little children of her hands
run with the horses on the sands
cry and are fastened into bands.

Metaphysical poetry is not a good influence on him: the echoes of Donne and Hopkins in his religious poetry merely add discord: some of his puns are striking ("To part, it is to die in part"), but verbal conceits and satiric rhymes are often laboured. He is not a poet who can absorb either the prose statement or the prosaic world; his social comment is generally querulous and preoccupied, and he is ill at ease with commercial clichés and technological images. He is best in straight couplet and quatrain and in a Housman-like baldness of statement:

no strong men and no heroes,
no brave, eternal youths,
but only fiddling Neroes
and purple, proud untruths.

This is from the title-poem at the end, which is by far his finest work, and which shows many skilful variations in its octosyllabic metre:

found pure when the snow is shadowed with
the whiteness of a cloud of snow,
how can you now destroy
the host of your essential joy?

There are lapses of inspiration and of taste in Mr. Wreford's book, but there is also a dignified simplicity and a sincere eloquence.

Norman Levine's *The Tight-Rope Walker* shows a high level of competence in what is so far a rather restricted range. Mr. Levine is an expatriate, or regards himself as one: he has left what he calls the land of "parchment summers and merchant eyes" for England, and many of his poems have a Cornish setting. His poems are also elegiac, even to the point of using a

lamenting refrain, but he has more affinity with paradox and complex statement. "Cathedral by Sea" works out a fine contrast between the physical energy of the sea and the spiritual energy and physical stillness of the building. The title-poem makes an oddly touching symbol out of its central theme:

> He was not lost. Only a little lonely
> He walked as a graveyard while around him
> Cities were no more than small lights
> Severed at the head by fog.

"Airman and Seagull Killed by Water" manages to reach an admirable final line, "What floats is dead," through some vigorous but tangled imagery. . . .

This is clearly not a banner year for Canadian poetry: the above practically exhausts the more sophisticated part of the output. In Canada, however, as elsewhere, there appears every year a fair quantity of naive or primitive verse, to use terms more familiar in the criticism of painting. There is no reason why all of this should be out of the range of critical interest: a good deal of Burns, of Wordsworth, of Kipling, even of Emily Dickinson, is naive poetry, and what Mr. Goodridge MacDonald calls "the truisms of popular song" are always well worth stating. One looks hopefully and constantly, in reading through this material, for some signs of an ability to express the simple rather than the commonplace emotion, to use traditional metres without unenterprising monotony, to make the art of writing a poem a fresh experience instead of a conditioned reflex of nostalgia. Occasionally one is rewarded, but self-consciousness and schoolmarmism hang cloudily in the poetic atmosphere. Some achieve a certain uniform competence, but otherwise there is nothing for a reviewer to say except to hope that they will find their audience. The same may be said of the Poetry Books of Alberta and Saskatchewan. The latter has a picture of a wildcat on its cover, but the poetry is unvaryingly gentle. . . .

1951

The title poem of Philip Child's *The Victorian House and Other Poems* is a flashback narrative. The narrator has to sell his family home, and in throwing it open to a purchaser memories come back to him and build up a picture of his early life. As he muses, the contrast widens between the realized knowledge of love he has gained from his home and the externalized knowledge of hatred he has gained from watching the passage of wars and dictatorships. Gradually the impression of the reality of the former and the illusoriness of the latter increases until he gains a fleeting sense of an eternal home life in a single body of love. At that point the sharpest of all his memories, a friend dying in the confidence of resurrection, is illuminated for him. The theme of a death which no longer matters is summed up by the purchaser, who decides to tear the house down and use its bricks to build a new one.

In the narrative itself one regrets a rather self-deprecatory melancholy, a gentleness that often seems merely tentative, and, more technically, a mannerism of quoting too many tags from Shakespeare. It is in the interspersed lyrics where one best realizes how well practised a writer Mr. Child is. There his self-consciousness relaxes, and the poet in him speaks directly. In the first stanza of "Prometheus brings a pretty culture" and the sharp simplicity of "How still they lie, the dead" the narrative comes into a clear imaginative focus, and we do not feel, as we too often do in the body of a poem, that words are being used partly as a barrier between the poet and his reader. The lyrics which follow the title poem give, I think, a better impression of Mr. Child's variety and range as a poet than it does. Of these, there is the very impressive "Macrocosm," with its precise but not over-neat conclusion:

> Beyond my sight the cloudless sky
> Is troubled with artillery.

and "Descent for the Lost," a poem on Judas Iscariot which returns to a theme that haunts the title poem also, that the

redemptive power of Christ cannot rest until it has sought the lowest depth of human isolation.

Two first collections of poets already fairly well known to readers of Canadian poetry are issued by the First Statement Press of Montreal. Number eight in the New Writers series is Anne Wilkinson's *Counterpoint to Sleep.* The title does not mean that the poems are a cure for insomnia: it means that Miss Wilkinson is essentially a dream-poet. At her best she has the significant vividness of the remembered dream, or nightmare; at her worst the confusions and obliquities of the forgotten one. Miss Wilkinson is clever: too clever for her own good, sometimes, when a self-conscious avoidance of the obvious leads to a rather wearying verbal dissection of her themes. There is some unsuccessful fantasy, and even the wit of "Winter Sketch" does not conceal the fact that it is bad metaphysical poetry to speak of a snowfall as

> Immaculate conception in a cloud
> Made big by polar ghost.

But when the desire to say something breaks through the preoccupations of saying it a real poetic ability emerges. On this level we find the grisly variant of "Lord Randall" which so raised my hair when I first read it in *Contemporary Verse,* the teetering spiralling rhythm of "Tower Lullaby," and the unsteady but genuine eloquence of "The Great Winds."

Number seven is Kay Smith's *Footnote to the Lord's Prayer and Other Poems.* The note on the back of the cover speaks of "her serious limitations, her crudities of music and structure," which is something new in publishers' blurbs. The revival of the medieval habit of paraphrasing the liturgy has its dangers, notably the danger of having the quotations provide all the impressiveness of the poem. This, I hasten to say, is not what has happened here: in fact I wish Miss Smith had refrained from quoting the clauses, as the poem would be less tied down without them, and its theme is clear enough. In her peroration, no doubt, one feels chiefly that Eliot does this kind of thing much better, but as a whole the poem is a distinctive

meditation, with only one or two lapses into religiosity. I like
the way she occasionally breaks from syntax to suggest a simi-
lar process in prayer, and the varieties of metrical organization
show a better sense of structure than her publishers give her
credit for. Of the other poems, "Conversations with a Mirror"
seems to me an excellent design from a stock pattern; here
again the subtitles, "The Girl Speaks" and the rest, are unnec-
essary, and make the poem look more naive than it is. On the
whole, Miss Smith's high intelligence seems almost a disad-
vantage: such poems as "The Clown" and "When a Girl Looks
Down," which seem to be moving toward a poignant concrete-
ness, dissolve at the end into a generalized and contemplative
vision.

Of the more conservative offerings, I find Charles Bruce's
The Mulgrave Road most consistently successful. His material is
almost insistently unpretentious, confined to the simplest
landscapes of farms and fishing villages in Guysborough
County, Nova Scotia. One begins, probably, by feeling that
nobody can make new poetry out of such material, then one
reads:

> Slowly the days grow colder, the long nights fall;
> Plows turn the stubble, fires are tended, and apples
> Mellow in cellars; and under the roots of maples
> Mice are burrowing. And the high geese call.

We are forced to recognize the measured authority of these
elegiac cadences. We may say grumpily that anyway this *kind*
of thing has often been done before. But repeating ready-
made formulas is one thing; working within a convention is
quite another. Mr. Bruce is quoted on the dust cover as saying
that nostalgia is the silliest word in the language, and the
remark is probably the key to his success. His themes have not
really been exhausted by poetry; they have merely been
exploited by nostalgia. The false notes induced by the latter,
such as the "Wondering how they know" which puts a senti-
mental blur on the end of the otherwise flawless "Country
Sunday," are very rare, and hence noticeable. He turns his

back on all the compulsions that so often go with the poetic impulse: he knows, he says, that

> gulls on waves of surging air
> Will never get me anywhere —

which well evokes the immovable repose that one often senses in a Maritimer's mind.

Thomas Saunders is another regional poet, and his *Horizontal World* is Saskatchewan. Mr. Saunders may best be described, perhaps, as a metrical conversationalist: that is, he works in the idiom represented by Robert Frost, and is best when he is discursive, commenting on the life of the prairie and understating its harsh and obvious ironies. Too often, however, he fails to resist the temptation to underline his points and oversimplify his situations. I wish "Armand" had not gone on into a murder, not because such things never happen but because they are literary clichés when they do. Yet there is much that is readable in his book, and it is no small feat to put colloquial speech as authentic as this into blank verse:

> But now quick-growing wheats are ripe
> And harvested before July is out,
> Some places, or by middle-August at
> The most — with no big threshing-gangs, like in
> The steamer days, touring the country like
> A circus until after snow.

The poetry of social protest, during the thirties, was attached to a number of powerful supports: it had a philosophy in Marxism, a programme of action in the proletarian revolution, and a reading public among bourgeois intellectuals. It never achieved a really distinguished expression, but it spoke for a large and influential pressure group. *Nous avons changé tout cela;* the poet's heart is no longer so far on the left side, and the poetry of social protest has retreated into a disembodied anarchism, in some respects a reversion to the

old artist-versus-society theme of earlier decades. One of the leaders in this anarchistic development is evidently Kenneth Patchen, whose merits are not yet entirely clear to me, though his mind certainly has some of the imaginative qualities of a great poet. The movement has a Canadian representative this year in Irving Layton's *The Black Huntsman*.

The idea in Mr. Layton's poetry is to use an intensely personal imagination as an edged tool against a world cemented by smugness, hacking and chopping with a sharp image here, an acid comment there, trying to find holes and weak spots where the free mind can enroot and sprout. It is the misfortune of this technique that the successes are quiet and the faults raucous. There is a real poet buried in Mr. Layton, a gentle, wistful, lonely, and rather frightened poet who tells us how his childhood love for Tennyson grew into a defiant fear of a hostile and pursuing world:

> Now I look out for the evil retinue
> Making their sortie out of a forest of gold.

But where the imagination is conceived as militant, there is apt to develop a split between what the poet can write and what he thinks he ought to write for his cause. Most of Mr. Layton's book is the work, not of the poet in him, but of a noisy hot-gospeller who has no real respect for poetry. The latter speaks in a violent rhetoric which is deliberately summoned up, an incantation that tries to make devils reveal themselves but succeeds only in nagging the air. The same lack of spontaneity in the imagery is betrayed by repetition. One can get as tired of buttocks in Mr. Layton as of buttercups in the *Canadian Poetry Magazine*; and a poet whose imagination is still fettered by a moral conscience, even an anti-conventional one, gives the impression of being in the same state of bondage as the society he attacks.

Michael Hornyansky's *The Queen of Sheba* won the Newdigate Prize for Poetry at Oxford, which is, if I remember correctly, awarded for the best poem on a set theme. Those

who assigned the Queen of Sheba must have expected a good deal of paraphrase of the Song of Songs and a whole cargo of cassia, spikenard, aloes, frankincense, and other ingredients of the popular *orientale.* There is a certain amount of this in Mr. Hornyansky, but on the whole it is well subordinated to the main theme, the development in Solomon's mind from weariness through love to the resigned detachment expressed in Ecclesiastes. The poem is written in a sonorous five-line stanza rhyming *abcba, cdedc,* etc. In the third and last part the somewhat too carefully modulated utterance begins to take on more warmth and life. It is an admirable practice piece, and it probably won by several lengths. . . .

A selection of the poems of Duncan Campbell Scott, with an introductory memoir, appeared last year as one of the posthumous works of Professor E. K. Brown, my predecessor in this survey, whose tact, skill, erudition, and comprehensiveness in making it I had long admired, and am now fully in a position to appreciate, if somewhat wryly. The memoir is supplementary to the essay on Scott in the same author's *On Canadian Poetry.* Whatever one thinks of the total merit of Scott's very uneven output, he achieved the type of imaginative balance that is characteristic of so much of the best in Canadian culture down to the present generation, when altered social conditions are beginning to upset it. On one side he had the world of urbane and civilized values; on the other, the Quebec forest with its Indians and lonely trappers. He could write a poem on Debussy and a poem on a squaw feeding her child with her own flesh; he was at once primitive and Pre-Raphaelite, a recluse of the study and a recluse of the forest. Not since Anglo-Saxon times, it seems to me, has there been the same uneasy conflict between elemental bleakness and the hectic flush of a late and weary civilization that there has been in Canadian poetry and painting of the period from Confederation to the depression. It had to go as the country became more urbanized, and we may regret its passing only if nothing new comes to replace it. . . .

1952

This year both of Canada's two leading poets have a new book to be discussed, and as one of them comes from Newfoundland and the other from British Columbia, there was never a neater opportunity of demonstrating the theory of cultural containment. I am inclined in any case to assert the existence of a Canadianism in Canadian poetry. Poets do not live on Mount Parnassus, but in their own environments, and Canada has made itself an environmental reality.

The United States is a symmetrical country: it presents a straight Atlantic coastline, and its culture was, up to about 1900, a culture of the Atlantic seaboard, with a north-south frontier that moved westward until it reached the Pacific. Canada has almost no Atlantic seaboard, and a ship coming here from Europe moves, like a tiny Jonah entering an enormous whale, into the Gulf of St. Lawrence, where it is surrounded by five Canadian provinces, all out of sight, and then drifts up a vast waterway that reaches back past Edmonton. There would be nothing distinctive in Canadian culture at all if there were not some feeling for the immense searching distance, with the lines of communication extended to the absolute limit, which is a primary geographical fact about Canada and has no real counterpart elsewhere. The best paintings of Thomson and the Group of Seven have a horizon-focussed perspective, with a line of water or a break through the hills curving into the remotest background. In Emily Carr, too, the real focus of vision seems to be in the depth of the forest, *behind* the picture as it were. The same feeling for strained distance is in many Canadian poets and novelists — certainly in Grove — and it can hardly be an accident that the two most important Canadian thinkers to date, Edward Sapir and Harold Innis, have both been largely concerned with problems of communication.

Most of the poetry of E. J. Pratt, including *Brébeuf,* has been a kind of summing up of the first phase of Canadian poetic imagination. In that phase Canada appeared in a flat Mercator projection with a nightmarish Greenland, as a country of isolation and terror, and of the overwhelming of human

values by an indifferent and wasteful nature. It was a part of the development of poetic Darwinism from Tennyson and Melville (whom a Canadian critic was the first to appreciate, and who has many links with Pratt) to Hardy and Conrad. Since *Brébeuf,* Pratt has shown an increasing interest in techniques of communication, an interest which may well go back to his early days as a student of psychology. In his fine poem "The Truant," the David of human intelligibility confronts the stupid Goliath of nature, and in *Behind the Log* a network of wireless telegraphy, radar, and asdic contains the whole action of the poem. The theme of the epic act of communication in Canadian history, the linking of east and west by a great railway, was thus a logical one for Pratt to choose for his latest poem, *Towards the Last Spike* (Macmillan, viii, 53 pp., $2).

But while the choice of theme may have been easy, the theme itself is fantastically difficult. The poem is in the epic tradition, without any of the advantages of epic to sustain it. No narrative suspense is possible where the ground has all been surveyed; no heroic action can be isolated in so concentrated an act of social will:

> As individuals
> The men lost their identity; as groups,
> As gangs, they massed, divided, subdivided,
> Like numerals only.

The foresight and courage of Macdonald and Van Horne almost disappear in an intricate pattern of railway building, parliamentary strategy, industrial development, political unification, financing, and foreign and colonial policy. The real hero of the poem is a society's will to take intelligible form; the real quest is for physical and spiritual communication within that society. I have a notion that the technical problems involved in *Towards the Last Spike* are going to be central problems in the poetry of the future. And I think that the ingenuity with which these problems have been met would make the poem a historical landmark even for readers who disliked it as a poem.

In the first place, Pratt has here, as in *Behind the Log,* to give

the sense of the energy of work as diffused through the whole action of the poem, with no real climax at the end. (Some younger writers who are interested in the theory of "composition by field" may see an important aspect of it in this poem.) The driving of the last spike is technically a climax; imaginatively, it is an anti-climax. Strathcona has only one spike to drive in after the thousands that have preceded it, yet he fumbles it, and Van Horne has nothing to do but clear his throat and say "well done." The feeling of letdown after prodigious strain is part of the realization that men's work, like women's, is never done, and that the moment any act of social heroism is completed, it is absorbed into society and becomes part of new work.

In the second place, a poem of heroic action reminds us of the quest-poem, where a hero goes out to kill a dragon. But here the real dragon to be killed is dead already: the obstacle is the torpor and inertia of unconscious nature, not an active or malignant enemy. Pratt's dragon

> A hybrid that the myths might have conceived,
> But not delivered,

is a somnolent dragon, "asleep or dead," "too old for death, too old for life," who can resist only passively. The device of turning the azoic into the monstrous is, like all poetic devices that are any good, very old, and can be traced back at least to the *Odyssey*; but Pratt's carefully muted, unfaked description is profoundly contemporary, and has all the typically Canadian respect for geology in it. Like other dragons, this one guards a treasure hoard: there is again irony in the contrast between Macdonald's frantic efforts to get money out of the clutching fists of bankers and the riches revealed by every dynamite blast on the line — "nickel, copper, silver and fool's gold" — and not only fool's gold either.

There would be much more to say about the poem if I had the space. There is the contrast between the desperate, quixotic, east-west reach from sea to sea which is the vision of Macdonald (Van Horne too, it is said, "loved to work on shadows"), and the

practical, short-sighted vision of Blake, which sees the country realistically, as a divided series of northern extensions of the United States. (I don't know how true this is historically, but there is far too much accurate Canadian history now, and far too little accurate Canadian vision.) There is the portrait of Strathcona as a Canadian culture-hero, a combination of Paul Bunyan and Sam Slick,

> ripping the stalactites
> From his red beard, thawing his feet, and wringing
> Salt water from his mitts; but most of all
> He learned the art of making change.

Above all, Pratt is a poet unusually aware of the traditional connection between poetry and oratory. The memory of 1940, when human freedom had practically nothing left to fight with except Churchill's prose style, is clearly fresh in his mind. A Communist magazine has criticized *Towards the Last Spike* for seeing the theme entirely in terms of the leadership of Van Horne and Macdonald, ignoring the workers. Pratt's point, however, is not that workers are the slaves of great leaders, but that leaders are the slaves of great words. Marlowe's Tamburlaine might have died unknown if he had not happened to hear the phrase "To ride in triumph through Persepolis." Similarly, it is only when Blake can think of a menacing phrase like "To build a road over that sea of mountains" that the fate of Canada is really in danger. Besides, all forms of communication are closely linked to poetry in imaginative appeal, and in this nomadic culture people who cannot write poetry are dependent on poets to express their inarticulate sense of the link. Pratt is one of the few poets I know who can understand such a feeling:

> Intercolonial, the Canadian Southern,
> Dominion-Atlantic, the Great Western — names
> That caught a continental note and tried
> To answer it.

Many readers of poetry today are brought up, whether they realize it or not, on Poe's dictum that a long poem is a contradiction in terms. For them, a Keats ode represents what poetry can do, and Shelley's *Revolt of Islam* what it cannot do. Hence they tend to examine poetry in terms of surface texture, and lose the faculty of appreciating the skill displayed in structure. Such an approach to *Towards the Last Spike*, where the surface is often as rough and forbidding as its theme, is much too myopic. An unfavourable judgment on such a line as "His personal pockets were not lined with pelf" should not set up an indicator of value in a poem which is so deliberately tough, gnarled, and cacophonous. With that warning, the reader may be safely left to discover for himself the unsuccessful images, the labouring of minor themes, the forced humour, and the dull stretches. The faults of the poem are obvious and commonplace; its virtues are subtle and remarkable.

What else is "distinctively Canadian"? Well, historically, a Canadian is an American who rejects the Revolution. Canada fought its civil war to establish its union first, and its wars of independence, which were fought against the United States and not Europe, came later. We should expect in Canada, therefore, a strong suspicion, not of the United States itself, but of the mercantilist Whiggery which won the Revolution and proceeded to squander the resources of a continent, being now engaged in squandering ours. There is in Canada, too, a traditional opposition to the two defects to which a revolutionary tradition is liable, a contempt for history and an impatience with law. The Canadian point of view is at once more conservative and more radical than Whiggery, closer both to aristocracy and to democracy than to oligarchy.

The title poem of Earle Birney's *Trial of a City and Other Verse* (Ryerson, 71 pp., $2.50) is described in its sub-title as "A Public Hearing into the Proposed Damnation of Vancouver." The time is the future, the setting the kind of pseudo-legal kangaroo court which is the main instrument of McCarthyism, as packed and framed as a shipment of pictures, where everything is conducted on the crazy Alice-in-

Wonderland principle of sentence first, verdict afterwards. The blowing up of Vancouver has already been decided upon by a mysterious "office of the future," represented by a lawyer named Gabriel Powers. As this name indicates, the setting has for its larger background the ancient theme of wrath and mercy, of man's perpetual failure to justify his existence in the sight of the gods by his merits, a failure now brought to a crisis by his new techniques of self-destruction. Powers, therefore, who seems to be a messenger of the gods, is actually a projection of man's own death-wish.

The only one to speak for the defence is a Mr. Legion, who represents the ordinary Vancouver citizen. He has, understandably, a strong prejudice against being annihilated, but it proves more difficult than he expected to refute the case of the prosecution. The city seems to Captain Vancouver only the pollution of the virginal nature he remembers. To an Indian chief, who speaks for what is essentially an aristocratic point of view, the white man's city is an obscene disease that has devoured his own people. To Gassy Jack, a sailor and saloon-keeper of the early days, it represents a perversion of life far more sinister than his own relatively healthy vulgarity and vice. Finally William Langland, author of *Piers Plowman,* appears: in all English culture no better spokesman could have been found for the conservative-radical opposition to oligarchy mentioned above. He finds in Vancouver more or less what he found in medieval London: a society based on profiteering, or what he personified as Lady Meed.

The trouble with Legion is that he does not speak for the real Vancouver, but for the mercantilist Whiggery that has taken it over. His values and standards are precisely what is being condemned. He is the present as the inevitable consequence of the past, hence a future of annihilation is the inevitable consequence of *him.* At the crisis of the argument, he is suddenly pushed out of the way by a housewife. She stands for the real life of really free people, where the present is, at every moment, a new creation of meaning, of wonder, and of love. In such a conception of the present there is no causality, no inevitable future, no dead reckonings, and as she speaks the

court begins to dissolve into unreality, even the imperious "Powers" being reduced to saying only "I'll have the skeleton."

I have emphasized the unity and seriousness of the theme because the brilliance of the writing may mislead one into regarding it only as a verbal stunt. It is true that for virtuosity of language there has never been anything like it in Canadian poetry. Gabriel Powers speaks in a *Finnegans Wake* doubletalk which, like *Finnegans Wake*, is both very funny and eerily haunting:

> From the ash of the fir springs the fire-weed;
> From the ask of his faring your fear.

A professor of geology speaks in the archaic rhythms of Anglo-Saxon, and Legion in what the Germans call *knittelvers*. Langland's speech is, of course, a reproduction of Langland: such phrases as "an ego to an auto" may be a trifle too sophisticated for him, but

> Yea, then I moved west to my hill's margin
> and saw a soft middleclass swaddled in trees,
> in unfrequented churches and fears not a few.

has exactly the right balance between parody and recreation. The play's wit puts it in the same league as E. E. Cummings and Auden; and as compared with Auden, it seems to me to have attained a crystalline transparency of thought. I imagine that the lines of the housewife:

> By all the past we know our freedom is renewable each
> moment

or

> How could I know, without the threat of death, I lived?

would in Auden be sagging with the weight of Heidegger's *Augenblick* and Kierkegaard's *Angst*. Birney's seriousness is

simple (to the verge, on the last page, of being sentimental); it is only his wit that is erudite.

Wit is also prominent in the other poems in the book: it is in a poem about Christmas which describes how a star appeared as a "*nova* in *Virgo*"; in satires on censorship, on signs reading "restricted," on an ill-fated Mr. Chubb of Minnesota, and in an account of a plane trip across Canada, where, in spite of some excellent passages, some of the boredom of the trip seems to have leaked into the poem. The other poems are largely concerned with the immense trees and sinister mountains of British Columbia landscape, whose moods the poet knows well how to convey. A few gingerbread conceits ("the pacifist firs," "revolver sun," "the pointless point of the peak") are unfunctional, but do not spoil them. There is also a cryptic but very attractive exercise in myth, "St. Valentine is Past."

It is good to see Mr. Alfred Bailey's poems collected in *Border River* (Indian File no. 5; McClelland & Stewart, 61 pp., $2.50), and its appearance puts him into the front rank of Canadian poets. He writes usually in long assertive sentences, very close to prose in rhythm, but with the metrical features of the rhythm carefully marked. One gets the impression of a muttered crepitation of sound, a reticence of voice and thought that makes the reader strain for attention, as though the poet had his back turned. Professor Ross's remarks on the blurb mention the influences of Eliot and Dylan Thomas, which are there, but Eliot and Thomas are highly sensuous poets. Compared to them, reading Mr. Bailey is at first like walking over cinders. Accents stick spikily through the metrical feet; jarring rhythms and assonances turn up in the most disconcerting spots, and in two poems he pulls the last syllable of the line off its stem, like a child picking flowers. The forbidding landscape is not relieved by his fondness for the imagery of dry bones and dead trees, nor by a dense tangled diction that all too often makes the reader stop and wonder what the hell he is talking about.

However, dry bones can harm no one, as Eliot would say, and the difficulties created by intelligence and honesty are

always worth attacking. We discover with Mr. Bailey what we discover with all good poets who look obscure at first but turn out to be rewarding. The difficulties are primarily his, and only incidentally ours. He speaks of the poet as pursuing his truth through the labyrinths of appearance and reality, and the river of his title poem grows into a symbol of poetic imagination. Its reefs and shoals are like the barriers that convention and dogma try to impose on the searching intelligence of the poet; it twists and zigzags and seems to lose its way in a wilderness, but always it is going toward an infinite sea. There are religious overtones, especially in the last of the three sections, but it is a religious feeling in which the central virtue is hope rather than faith:

> There will be no world there when we are there,
> and no one to know, even the lone hand
> at the wheel
> whose face is caught in a tanned and wrinkled dream.

and as we grow accustomed to the style, we become sensitive to the skill with which rhythm and speed alter to fit the curves of the thought:

> Tread silently lest someone wake
> to sense the peace that passeth here.
> Handle the creaking hinge with fear
> and into the yard tread softly
> over by the chicken coop
> dig us a hole, say five feet and a bit.

I get very tired of the critical cliché that everything in poetry should be hard, concrete, and precise. That dogma was lugged in to rationalize the techniques of imagism thirty years ago, and it is time to realize that it is only one more formula, like the unities, designed to save critics the trouble of making independent judgments on poetry. It is quite possible to construct just as good poetry out of diffused, muzzy, and generalized language. Byron's "She walks in beauty like the night" is a very lovely

poem, and it is a masterpiece of vagueness. Mr. Bailey's diction bristles with concreteness and precision, usually to its advantage, but I think he is equally good, and even more eloquent, when he relaxes into a more "romantic" rhetoric:

> there to grow strength of body, faith of mind,
> accustomed to the water's way
> and understanding of its kind
> there
> in the green sea day.

Of the shorter books, the best, I think, is Jay Macpherson's *Nineteen Poems* (Mallorca, Spain, Seizin Press, 9 pp.). Miss Macpherson is, at least outwardly, a traditionalist: she writes in tight resonant stanzas, usually quatrains, with an adroit use of classical mythology, and in a mood which is predominantly elegiac, though it can take in some fanciful humour too in the opening poem. It is a type of writing that has not been heard much in Canada since Louis MacKay forsook the chambers of the east. She seems to have the rhythmical structure of the whole poem clearly in her mind at the start, so that she can vary the length of the individual lines skilfully and subtly. In "The Comforted" two classical images, the thread of life spun by the Fates and the clue through the Cretan labyrinth, are identified; "The Oracular Head" mingles memories of Cassandra and Friar Bacon; and "The Ill Wind" is a kind of distilled ballad:

> To reply, in face of a bad season,
> Pestilential cold, malignity,
> To the ill wind weeping on my shoulder:
> "Child, what have I to do with thee?"
>
> Is to deny the infant head
> And the voice complaining tirelessly:
> "Is there room for one only under your cloak,
> Mother, may I creep inside and see?
> Did you not know my wicked will
> When you summoned me?" . . .

Louis Dudek's contributions this year are spread over three volumes, each showing a perceptibly different aspect of his style. *Twenty-four Poems* (Toronto, Contact Press, iv, 24 pp., $1) evidently is a sequence of impressions, one for each hour of the day: at any rate the first poem is called "Dawn" and the twelfth "Noon." They are strongly pictorial in mood, full of colour, and at times are merely decorative pattern. One continually thinks of paintings: so, rather unfortunately, does Mr. Dudek himself, as it seems to me that an over-explicit reference to Klee injures an otherwise fine sonnet. There is nothing startlingly good in the sequence, yet one is always just on the point of calling him facile and being brought up short by something like:

> Breath blown into a telephone:
> What ghosts are we
> to tell each other how alone
> lovers can be?

The Searching Image (Ryerson, 12 pp., $1), on the whole, contains more serious poetry, some of it, though disappointingly little, on a level with the best of his earlier work in *Unit of Five* and *East of the City*. "Theme with Variations" is a series of vivid sketches of sunrise in a city, in a long swinging oracular rhythm, and there is a delicately elaborated conceit in the opening poem, "The Bee of Words." His favourite theme is the affinity between the creative powers of the mind and the vital energy that produces beautiful things in nature, particularly flowers:

> Yet love may tell one who grows a plant
> How a miraculous ignorance surrounds
> Each living thing. . . .

He has more room to operate in *Cerberus* (Contact Press, 98 pp., $1), a collection of the work of three poets, Dudek, Irving Layton, and Raymond Souster, each of whom prefaces his poems with a manifesto. In deference to his colleagues, Mr.

Dudek endeavours to recapture some of his earlier feeling for social problems, but it is clear from his manifesto that he is no longer in danger of confusing poetry with popular rhetoric. He realizes that the enemy of poetry is not social evil but slipshod language, the weasel words that betray the free mind: he realizes that to create requires an objective serenity beyond all intruding moral worries about atomic bombs and race prejudice. One sentence is particularly striking: "Actuality itself is a metaphor made of iron, the diseased poem which man has erected out of mass frustration, out of centuries of evil." Of the poet he says:

> You will not learn from him of your danger,
> You must fear a more mean and mechanical murder.

As long as he preserves this austere detachment, he writes at his best, but his hold on it is uncertain: "A Drunk on the Sidewalk," for instance, is a fine poem except for two silly lines at the end; "Suburban Prospect," on the other hand, keeps a dry irony all through.

Mr. Dudek's ideas are more advanced than those of his two collaborators, and so it is not surprising that he writes with more authority than they do. Mr. Layton's work includes a number of epigrammatic squibs on other writers, the best of them, I blushingly report, being aimed at me. He speaks of "the holy trinity Of sex revolution and poetry," and each of these is conceived as an explosion of creative energy against the inhibitions of prudery, exploitation, and philistinism respectively; a trinity more or less incarnate in Freud, Marx, and Whitman. The associating of the creative and the procreative functions, the tendency to talk about writing poetry instead of presenting it, and the conception of effective language as deriving from vocabulary rather than rhythm, are fallacies that get in the way of his militant writing. No other poem of his has anything like the quality of "To a Very Old Woman," where he forgets his self-consciousness and his mission and simply studies his poetic subject:

> . . . your face is a halo of praise
> That excludes nothing, not even Death.

Mr. Souster's vignettes of modern social life are done with much sincerity, and it would be a very hard-boiled critic who could read any poem of his without sympathy for what has been attempted. But in great poetry there is no difference between form and content, whereas one feels in Mr. Souster that though the content is interesting and valuable, it could have been expressed just as well in many different ways. His poems consequently sound moralizing and prosaic, attempting to express their subject by the energy of direct statement alone. When he writes "To an Antisemite" and says:

> All the filth of you and your kind, dark rats
> Of The Big Terrible City, sick, tormented, afraid,

one feels that anti-Semitism, approached in that way, is beyond the reach of poetic utterance, just as hell is beyond the reach of charity. Mr. Souster seems to me an introspective poet, better at entering his own or others' minds than at describing or commenting on the social scene.

Another poet with some Canadian connections who appears again this year is Robert W. Service, now nearly eighty, who has been living in Europe. *Rhymes of a Rebel* (New York, Dodd Mead [McClelland & Stewart], x, 213 pp., $3) interests me chiefly because, since I began to make this survey, I have read so much verse in exactly the same idiom, and I wonder how far Mr. Service's earlier books may have influenced it. There was a time, fifty years ago, when Robert W. Service represented, with some accuracy, the general level of poetic experience in Canada, as far as the popular reader was concerned. The amount of good serious poetry produced in this country last year is evidence enough that, whatever querulous complaints may still be made about Canadian philistinism, there has been a prodigious, and, I should think, a permanent, change in public taste. . . .

1953

The technical development of a modern lyrical poet is normally from obscurity to simplicity. As long as he is writing primarily for himself, his thought will be rooted in private associations, images which are linked to ideas through his own hidden and unique memory. This is not his fault: he can write only what takes shape in his mind. It is his job to keep on writing and not get stuck at that point, above all not to rationalize any failure to advance by asserting that one must write this way in an unpoetic age. It is the critic's job to tell him and the public that whatever his stuff means, it sounds genuine enough. Then he is likely to pass through a social, allegorical, or metaphysical phase, an awkward and painful phase for all concerned. Finally, a mysterious but unmistakable ring of authority begins to come into his writing, and simultaneously the texture simplifies, meaning and imagery become transparent, and the poetry becomes a pleasure instead of a duty to read. It takes a heroic supply of talent, practice, patience, and courage to get to that point. The process cannot of course be hurried by an act of will, but it can be affected by the environment. It was much easier to mature in England thirty years ago than to mature in America now, for example, no doubt because of all the adolescent fixations in American life. A glance at any American anthology reveals a series of poets who have progressed from gargle to Guggenheim in six easy volumes, and have still not seriously exploited their own resources. The number of such underdeveloped lyrical poets has created the illusion that the various stages of development are actually outposts. Every once in a while, however, we run across a poet who reminds us that when the lyrical impulse reaches maturity of expression, it is likely to be, as most lyrical poetry has always been, lilting in rhythm, pastoral in imagery, and uncomplicated in thought.

Patrick Anderson's *The Colour as Naked* (McClelland & Stewart, 93 pp., $2.75) is the work of a poet who is approaching maturity of expression, and who has shown himself to be, I think, essentially a poet in the pastoral tradition, the

tradition of Wordsworth and of so many unpretentious but highly durable English poets of the previous generation. The influence of Auden has helped to give lightness and drive to his rhythm; the influence of Dylan Thomas ("my generation's genius," Mr. Anderson calls him, and certainly the greatest contemporary pastoral poet) has helped to give power and richness of feeling to his imagery. Bits of the cocoon of his apprenticeship cling to him here and there: he writes with conviction when he is the only person in his world, but the impact of "social significance" is usually disastrous. "The Lecturer as Prufrock" unites two of the most unnecessary ideas in literature, a parody of Eliot and a satire on the intellectual; "The Junior Class" is creaky and wooden; "Dialectics" belongs to that dreary metaphysical interregnum from which poetry now seems to be slowly recovering, and the closing "Ballad of a Young Man" is a fine and eloquent poem which deflates into bathos as soon as society appears over the horizon. Again, there is a telltale formula of "the adjective noun of noun" type, where the first noun is usually concrete and the second abstract, which most poets are unconscious of using (though many bad poets use practically nothing else), but which is very frequently the sign of undigested allegory, a perfunctory hitching of image to idea that marks incomplete craftsmanship. I find "their seas of risk," "the white horse of her bed," "the pretty architecture of our pleasure," "the columns of a cold and violent newspaper sky," "the firm and muscular body of faith," and (to make an end) "that island littoral of your eyes' bird brightened canopies," most in the less successful poems. But there is remarkably little fogged-up writing: even the words which seem to have a private significance for the poet, such as "long" and "green," obscure nothing in the meaning.

All of which prepares one to say that *The Colour as Naked* is delightful to read and is recommended without reservation. Over and over again, in the "Song of Intense Cold," in "The Ball," reminiscent of Rilke in both theme and rhythm, in "A Monkey in Malaya," with its octosyllabic couplet that picks up the appropriate echoes of Vaughan and Marvell and with its

Rousseau-like tropical stylization, in "The Strange Bird," in the dazzling verbal patterns of the sestina and the six songs, and perhaps too in the lively narrative of the "Ode to Haydon" — in these and many other places we feel that the poet "brings it off." That is, the imagination has tamed fancy: conceits which would be only highbrow wisecracks in inferior writing have fused into a form that can only be called inevitable, the way it should be. The "Song of Intense Cold" begins:

> One night when the stars are exploding like nails
> comes Zero himself with his needle,
> an icicle full of the cold cocaine
> but as tall as the glittering steeple
> that pins us down in the town.

We recognize at once that if the phrase "exploding like nails" says nothing to common sense it says exactly the right thing to the poetic sense. Similarly with the drowsy blurring of images in "An Apple before Bedtime":

> eating a last slow apple: Keep still, keep still,
> rose coal not fall from fire nor murmur
> dogs on their paws of dream nor ever
> lamp flare. . . .

Many of the most effective poems are based on a quiet conversational tone — again I should call it a pastoral idiom — with a beautifully controlled melody that does not try too hard for ingenuity either in sound or in meaning. Sometimes, as in "A Seaside Fragment," one feels that there are too many lines, certainly too many run-on lines, before we finally come to what we are waiting for:

> But suddenly there swells
> the sea's big muscle, suddenly the air
> darkens and it is later and strangely cold.

Elsewhere we are conscious only of the kind of weight that good writing can achieve when the discipline of a great tradition gets behind it:

> The bitter rain is in the wind
> and something older than the rain, or cloud
> frayed from the night-packed West and closing down
> on the vast continent of fields, the wires
> of many fences and their moaning shreds
> and many eave-ends and their waving cries
> (low crying in the child's ear as his hair
> clips to his head — and then the flowers pour
> away from him, and the melancholy sheep
> stand in the wind with thistles in their curls
> and the water is affrighted). Then the tree
> comes in upon one, blows.

Not all the book is on that level, but the point is that it *is* a level, a quality of writing and not a self-conscious rhetorical stunt. It compels us to admire, not Mr. Anderson's dexterity or skill or other such precarious qualities, but simply his actual achievement.

The poems in Douglas LePan's *The Net and the Sword* (Clarke Irwin, 56 pp., $2) are based on his experiences with the Canadian Army in Italy, and are, as one would expect, elegiac in tone. The title poem indicates a complex pattern of imagery — I should call it symbolism if that were not so restrictive a word — which runs through the whole book and ramifies and modulates into every poem. A fight between two gladiators, one armed with a sword and shield and the other with a net and trident, was a common feature in the Roman arena. Generally the net man won. In Mr. LePan's book the sword is the symbol of the young Canadian invader, with his smooth rifle-barrels and straight back, the "bronze rigidity" of his discipline showing a will not so much to conquer as to clean up the mess. He seeks the sun and the clear light, gorges on persimmons and the wine of the country, and preserves a vague hope that he is somehow part of a crusade. Against him

is the net: first of all the net the technique of modern war forces on him, of "telephone wires, tank-traps, minefields," of camouflage and "the vehicles that sulked under leafy nettings," then the sinister entanglement of ruin and misery that war leaves behind it, and finally the sense of Italy itself as a huge stomach digesting, like a jungle, the havoc wrought by every invader whether he be "Visigoth or Canadian." What the sword is trying to cut through to is some vision of Paradisal peace and contentment which one gets fleeting glimpses of in Italy even in war, a vision identical with "Skating at Scarborough, summers at the Island," the corresponding vision of peace brought by the soldier with him from home:

> From untarnished lakes and rivers,
> Lakes of sweet water, skies of unsullied godhead.

Meanwhile the contrast between the soft Italian night and its "peacock train of stars" and the deadly illumination of shell-bursts is all that is so far apparent of the "fruition born of elected action." The failure to achieve anything more than a dumb misery brings the poet back to the central image of his previous volume, the wounded body imprisoned in its own net, the labyrinth of nerves and bowels from which only a futile and wistful tenderness can emerge:

> Corrupted
> Our lungs breathe out a new heaven of pity and concern.

The larger implications of this imagery are suggested only by a small but remarkable tucked-in poem called "Idyll": the main poems, "Tuscan Villa," "Meditation after an Engagement," "Field of Battle," and "Elegy in the Romagna" deal with the foreground battle-symbols.

One obvious comment, that the horror of battle is somewhat strangled in fine writing, needs to be qualified by the fact that the muffling of shock and the numbing of pain in the midst of intense beauty form one of the poet's themes, and a part of his "net" imagery. In "An Incident," for example, the

dissolving of a shot soldier's body into a decorative landscape
is precisely the irony the poet intends. Besides, the poems are
not battlepieces but elegies, meditations on war recollected in
tranquility. Nevertheless one is at times baffled by the compli-
cations of the style: in "Meditation after an Engagement," for
instance, which ought to be, and to some extent is, emotion-
ally a key poem, one becomes irritably aware of a barbed-wire
entanglement of rhyme — more exactly, an eight-line stanza
rhyming *abbcaddc*. (The next poem, "The Lost Crusader," is in
an elaborate canzone stanza rhyming, so help me, *abcadcdbc*.)
However, the rhymes here are not disturbing in themselves, as
they tend to be at the end of "One of the Regiment," for
instance, where "trumpet-tell" and "style" are two weak ones.
One objects rather to a certain self-consciousness in the
writing, marked by such phrases as "the white caesura that
stripped down longings" or "eyelids that fleur-de-lis the dark,"
to forced inversions of the "castles builds" type, and to some
difficulties with digesting the explicit statement, as at the end
of "Reconnaissance in Early Light," though the existence of
such difficulties is a good sign, as it indicates that the poet has
a genuine lyrical sense.

These lapses are noted only because the general level of
the writing is good enough to make them show up. No poem
in the book is bad, or even unsuccessful. The style as a whole
is sonorous and eloquent; long lines vary easily with short
ones; passages of pentameters are skilfully broken by short-
line lyrics, and the variation of vowel-sounds and consonants
is delicate and at times deeply moving. One experiences the
thrill of response to authentic craftsmanship in the rhythm of:

> Delicately dawn will come with a garland of headlines —
> But not to sensitive retinas damaged;

or of:

> Cruel snows can hardly bear such lightness,
> Deftness;

or the dreamy melting of sounds and shapes in:

> For seas are skies and skies are seas, where float
> Cool swansdown clouds that sundown has subdued.
> Shadowed the snow about a swan's white throat;
> The daylight melts; slowly they drift and brood;

or the subtlety of:

> Till I wonder if it is they that please me, or the thought
> Of myself years on, remembering the light through the fig-tree,

where the strange working of the will to survive in the middle of the most lethal dangers is very accurately caught. The book is full of such pleasant surprises, but, as with Mr. Anderson, its more solid virtues are the important ones. The main impression one derives from it is produced by the poetry itself, not by the felicities it picks up in passing. One remembers its essence, the poetic assimilation of intense experience by a thoughtful and sensitive mind. The imaginative sword has cut its way through all the nets of verbal cleverness, heavy moralizing and ready-made melodrama that beset the poet struggling with so oppressive a subject.

Ronald Hambleton's *Object and Event* (Ryerson, 38 pp., $2.50) begins with a series of vignettes of Canadian life, more particularly urban life. They are Audenesque in tone and technique, with light-verse stanzaic patterns and lively crackling rhymes. There is erudition as well as observation — the first poem is in the convention of disillusioned "answer" to Marlowe's "Come Live with Me" — and the author is equally good both at assonance and at the rhyme of monosyllable against suffix which has the effect of a disappointment-rhyme:

> This man knows history,
> And facts don't lie;
> He steps on graves now
> None too gently.

The main theme is the contrast between the world of civilized "objects," geometrical, ugly, inhuman, and sterile, and the world of human "events," that pass away as soon as they come with all the pathos of time. The feeling expressed by the phrase "radar of indifference," the sense of the city as full of eyes that stare but never see, is perhaps the most vividly conveyed mood. The style is epigrammatic, and in epigram the poet throws harpoons while the reader amiably pretends to be a pachyderm and tests them for sharpness. If they are not sharp, however, they fall with a dull thud, and are felt to be pointless because they should have a point. "The Criminal" and "At the Asylum" are pointless in this sense: we get a reporter's commonplaces instead of the distinctive poignancy that we look for in poetry. This is true even of the more elaborate "The Little Theatre," as it takes more than puns to produce wit:

> We of the Land of the Third-Big-Week
>> Never know how to act;
> We welcome the fiction within our clique
>> But never the ugly fact.

The second part of the book has less of the clarity of the first: nearly every poem has a fine phrase or image buried in mixed metaphors and didacticisms, as though the whole poem were only a pretext to communicate some crucial part. One approaches each poem like a berry-picker, extracting a bit of colour, beauty, and form from a thorny tangle of words. In "Ancient Priest," for instance, we find:

> knowing as a hound that hobbles
> Droopingly doorward when an outward step fills
> His serviced ears . . .

which is very lovely, though I get only a vague and diffused impression of the ancient priest himself. In the following stanza from "In Bed,"

As if our duality
 Had eclipsed my self,
And by some agility
Kept acres pressed
For our interest
 Into the sweet gulf
Of your lips and breast.

the accuracy of the first two lines makes one try to believe, unsuccessfully, that the rest of the stanza is not the arid gibberish it seems to be. "Sockeye Salmon" has a theme as potentially moving as that of, say, Baudelaire's albatross, but it talks itself away into fuzziness. However, we judge a poet by his best things, and in the last two poems in the book, "After-Dinner Sleep" and "Nocturnal," there is a consistent attempt to fill the whole poem with clarity and sincere feeling. One is based on Eliot's "Gerontion" and the other a poem of Donne's but both are, probably for that very reason, thoroughly original. It is well worth struggling through pages of fugitive glimmers to get to something as articulate as the image of the gulls in the former poem, or, in the other, of:

The nightingale, the breath of spring,
The footsteps that in winter ring,
Are bells that cry as sinners sing. . . .
In ether rolls the idle ball,
Its firmness we doubt not at all,
But if it fell, how far a fall!

There are not many other serious books of verse this year. *Love the Conqueror Worm*, by Irving Layton (Contact Press, 49 pp., $1.50), consists very largely of what one has come to recognize as Laytonese — forced language and flaccid rhythm — but at the beginning of the book there are a few poems with some freshness and originality. The reader is not only encouraged, but looks forward to seeing an even better book next year. "The Perverse Gulls" has wit rather than mere

facetiousness; "Cemetery in August" and "A Vision" are gen-
uine epigrams, and "The Death of Moishe Lazarovitch" has a
poignancy that is sustained to its close:

> I do not know how they lifted him up
> Or held the vessel near their mourning silk,
> But their going was like a roar of flames
> And Matter sang in my ears like poured milk.

All My Brothers, by J. S. Wallace (New Frontiers, n.p.), illus-
trated with lino-cuts by Karl Rix, is verse in a familiar
Communist idiom, sometimes laboured, especially in the Yanks-
go-home passages, sometimes corny, especially in the conces-
sions to such non-political poetic themes as making love, but
sometimes also crisp and precise. It derives much of its
strength from the simple intensity of the Marxist view of the
capitalist world:

> Praise God from whom all blessings flow
> Provided it's the God we know
> Who sends us gushers fat with oil
> To keep our hands unspoilt by toil.

Such poetry acquired illegitimate virtues twenty years ago
from the masochism of bourgeois intellectuals; it acquires
illegitimate obloquy now that the masochism has turned in a
different direction. It is most important to keep the tone of
genuine anger and contempt at hypocrisy alive in our poetry,
no matter where it comes from or for what motives it is
uttered. . . .

Most of the more technically competent naive verse
produced every year is based on the theory that certain sub-
jects or themes are inherently poetical: that the poet who aims
at beauty should search in his memory for pleasurable expe-
riences, and then use words as a charm to recall them. As the
main function of the words is to stimulate the reader to
remember a parallel experience of his own, the actual quality

of the writing does not matter: it is enough for it to be cadenced in a familiar and unobtrusive way. This is the nostalgia theory of poetry, corresponding to the picturesque theory of painting. It is, of course, all wrong, but many people think it right, and this is a free country. It is often accompanied by a querulous sense of the disapproval of some reptilian intellectuals or moderns, who think beauty old-fashioned and want everything to be as bleak and obscure as possible. Often, too, its claims are endorsed by critics, including some who ought to know better, who classify it in a "conservative" or "romantic" school. It is, however, purely and simply the doggerel school, and one of its most skilful practitioners in Canada is Edna Jaques, whose *The Golden Road* (Thomas Allen, 86 pp., $1.25) appears in this year's production.

I call Miss Jaques skilful because there is no nonsense about her, no queasy aspirations for all this and poetry too. The opening lines of her book indicate her mastery of the central technical device of nostalgic verse, a list of reminders or stimuli, vigorously checked off one after the other:

> The strong clean smell of yellow soap,
> A farmer plowing with a team,
> The taste of huckleberry pie,
> A pan of milk with wrinkled cream.

Poem after poem exhibits a similar shopping-list sequence: "Mended Things," "Keepsakes," "Drug Store Smells," occasionally varied by a phrase that shows a sharp awareness of what she is doing:

> There is a sweet nostalgic charm,
> About an old Ontario farm,
> That pulls your heart strings all awry,
> A clean breath taking sweep of sky
> An old grey barn built on a knoll . . .

and so on through another inventory. The tone of her writing is equally central to her approach. The psychologists have

made us familiar with the disasters wrought by unpleasant and
repressed memories; they have naturally said much less about
the memories we select, the smoothly edited and censored
transcript of wholesome food, happy children, simple virtues,
and, of course, mother dear, which plays such a large part in
keeping us adjusted. Miss Jaques' rule is never to stop flatter-
ing the selective memory:

> Beneath the fire's lovely light,
> Faces take on a softer look,
> And little children from our street,
> Look like gay pictures in a book. . . .
>
> To lift the dull and commonplace
> Into a realm of love and grace.

No, if this kind of thing is worth writing, Miss Jaques is cer-
tainly a person who knows how to write it, and all our poets
who are ambitious of belonging to the "conservative" or
"romantic" school should learn about nostalgia from her. . . .

1954

The poetry of 1954 includes some reprinting of traditional
poets as well as new work, and it may be simplest to deal with
the serious verse in a roughly chronological order.

The impact of Lampman, Carman, Roberts, and D. C. Scott
on Canadian poetry was very like the impact of Thomson and
Group of Seven painting two decades later. Contemporary
readers felt that whatever entity the word *Canada* might rep-
resent, at least the environment it described was being looked
at directly. Like the later painters, these poets were lyrical in
tone and romantic in attitude; like the painters, they sought
for the most part uninhabited landscape. The lyrical response
to landscape is by itself, however, a kind of emotional photog-
raphy, and like other forms of photography is occasional and
epigrammatic. Its variety is provided essentially by its subject-
matter. Hence the lyric poet, after he has run his gamut of

impressions, must die young, develop a more intellectualized attitude, or start repeating himself. Carman's meeting of this challenge was only partly successful, and it has long been a commonplace that he badly needs a skilful and sympathetic selection. This is provided in *The Selected Poems of Bliss Carman*, edited by Lorne Pierce (McClelland & Stewart, 119 pp., $3.00).

Carman should, of course, have edited himself. I have heard the late Pelham Edgar turn a poem of Carman's into a thing of unalloyed delight by leaving out a couple of bad lines, but what a public reader can do an editor cannot do. What the selection brings out is that Carman's conscious mind and his poetic instinct were disastrously at odds. The first stage in the development of a romantic poet's mind is normally a sense of the unity of that mind throughout its variety of impressions: this in turn is likely to be projected as some form of pantheism, which has its advantages if properly developed, as Wordsworth shows, but the disadvantage of adding vagueness to monotony if it is not. Carman's conscious mind stuck at a broken-down and corny version of Emersonian over-soulfulness: his editor, with a touch of distaste, speaks of "his elaborate theory of Unitrinianism — spirit-leading; mental guidance, physical fulfilment — the full revelation of the doctrine of Personal Harmonizing." I don't know what all this means, but it sounds in more than one sense too awful for words, and I note that most of the poetic results are omitted from this selection. On the other hand, Carman's poetic sense told him, as it told Isabella Crawford before him and Pratt after him, that the most obvious development of a romantic landscape poet is towards the mythological, towards making his emotional impressions into a *dramatis personae* of forces at once human and natural. Carman's formative influences were late Victorian, and he follows Swinburne, Morris and Rossetti in enamelling nature with primary colours and peopling it with the pagan gods of the turning year, "Our Lady of the Rain," the dying gods Adonis and Attis, nymphs and fauns. And while his conscious mind called for songs of the open road and getting in tune with the infinite, his real poetic imagination became increasingly brooding, lonely and haunted:

The windows of my room
Are dark with bitter frost,
The stillness aches with doom
Of something loved and lost.

Outside, the great blue star
Burns in the ghostland pale,
Where giant Algebar
Holds on the endless trail.

This is the kind of thing we remember from Carman, and we are grateful to Dr. Pierce for confining himself to the memorable work, ignoring the pseudo-Carman, with his stentorian hymns to the Great Beyond like "Lord of my heart's elation," which are usually what get into anthologies.

A poet of the same generation as Carman is George Herbert Clarke, whose *Selected Poems* (Ryerson, xxvi, 54 pp., $3.00) have been edited by George Whalley. Clarke was a university professor, and his poetic qualities are the typically scholarly ones, notably a tendency to identify the poetic impulse with melancholy moods and sonorous diction. Like most such poets, he loves the sonnet and the commemorative ode. The poems are academic in every sense, springing from a world in which everything from ideas to flowers has been ordered and disciplined, a world which would be almost paradisal if it were not just close enough to the working world to recollect its disorder in a meditative tranquillity. Death is for such a poet best understood in the funeral of George V, where it has the maximum of dignity; poverty and pain are best understood as things that may distract one from true knowledge:

Perchance man may not climb
Higher than Pisgah on the mountain road
That twists and loops and narrows, for a load
Of fear cumbers his heart, and sweat and grime
Blind him. Benighted, he may mistake the trail. . . .

The limitations of such poetry are obvious enough, but it is still a valid form of poetic experience, and it is good sometimes to be reminded of more leisurely days when poets wrote odes on the hundredth anniversary of Queen's or McMaster and could feel convinced that

> Man was born
> To think eternal thoughts, yet to be torn
> Between the invisible world that looms sublime
> And this apparent, this ambiguous star.

The generation of poets growing up in the twenties encountered more urban and intellectual poetic influences, and found in T. S. Eliot especially a technique for adapting the old mythological themes to a human as well as a natural environment, and to ironic as well as to romantic uses. The mythological impetus itself simply reinforced the romantic heritage: Leo Kennedy's "Words for a Resurrection" is very close in theme to Carman's "Resurgam." This generation of poets is represented in the contributors to *New Provinces* (1936), two of whom, A. J. M. Smith and F. R. Scott, have issued new books of verse this year.

A. J. M. Smith has always been a careful and sparing writer, and *A Sort of Ecstasy* (Ryerson, viii, 55 pp., $3.50) contains several poems which appeared in 1943 in *News of the Phoenix,* and were not new then. Even the passage from Santayana which gives him his title appeared in the earlier book. Mr. Smith has the reputation of being a metaphysical poet in the tradition of Donne: Professor Collin's essay on him in *The White Savannahs* uses his own phrase, "difficult, lonely music," to describe the quality of his work. Certainly Mr. Smith is scholarly: we meet such phrases as "proud Romanticism" and "Apollonian energy," and part of the point about a poem on the H-bomb turns on the ironic application to it of a phrase from Shakespeare about mercy and from Hopkins about the Holy Spirit. Every poet demands his own kind of erudition; we need some knowledge of the *Odyssey* to understand "The Plot against Proteus," but we need much more classical

background than that to follow Carman's Sappho lyrics, and in both cases whatever obscurity there is is due to the reader's ignorance and not to the poet's wilfulness. Still, Mr. Smith's learning perhaps does interfere with his spontaneity. Too many of the poems seem to me to lack drive: the words do not develop rhythm but are fitted into a containing pattern. The poetry is intensely visual and conceptual; it slowly clarifies, but it does not dance. Sometimes, however, this slow clarification contains great emotional power, as in "The Bridegroom," in which the social and sexual anxieties of modern man come into a nightmarish focus:

> Where slaves or workmen strained to twist huge gears
> That moved vast vents or fed the flues,
> And fell some
> Into the fire, of sheer fatigue, and fried.

Looking at the new poems, one is surprised by the number of them that are romantic landscape poems in the Carman tradition: "To Hold in a Poem" is a summary of Canadian romantic themes. One wonders if the intellectualized irony of "Resurrection of Arp," even of the remarkable "Universe into Stone," is negative in direction, attacking the political and religious obstacles that prevent the poet from following a naturally romantic bent. That would account for a lack of exuberance in the difficult lonely music, if I am right in finding the lack there:

> I would put away intellect and lust,
> Be but a red gleam in a crystal dish,
> But kin of the trembling ocean, not of the dust.

Mr. Scott is a more fluent writer than Mr. Smith, and his *Events and Signals* (Ryerson, vi, 58 pp., $2.50) gives the impression of highly cultivated metrical conversation. This does not mean that it is shallow, but that its sincerity is controlled by urbanity. Its main theme is the inability of events in the modern world to produce signals that are profoundly communicative.

The poet stands in churches aware of, but untouched by, the symbols of communion; he reads newspapers which reveal a misery that he is powerless to affect; he goes through a day's duties realizing that

> Though all is available, nothing is taken
> that is not pre-selected, hence the unsubstantial
> is the practical, the theory all-important,
> and the routines, sub-conscious theories
> wall up the doorways slowly, one by one.

It is part of the paradox of such an attitude that Mr. Scott's verse is least convincing when it is most explicit, and at its best when sardonically observant. He is one of our best writers of epigram and light verse, and sometimes a serious epigram, such as "The Bird," hits a bull's-eye, but his fables are better without morals. In the first of the "Social Sonnets," for instance, the octave sets up a satiric situation with great economy and brilliance, but the sestet, by commenting on it, merely weakens the point already made.

Students are often urged to use short words of Anglo-Saxon origin when possible — the polite ones, that is — but there are so many abstract and technical words in the language that the basis of conversational rhythm in modern English is poly-syllabic, and a style founded on short Anglo-Saxon words can be the most artificial of all styles. Mr. Scott has grasped this fact about conversational rhythm, and he has brought to a high level of technical competence a kind of meditative, mus-ing poem through which the longer words of ordinary speech ripple with great colloquial freedom. "I am Employed," "My Amoeba is Unaware" and "Some Privy Counsel" are his best achievements in this vein. The same competence makes him extremely good at a kind of literary *collage*. "The Canadian Social Register" is based on an advertising prospectus, with all its fatuous phrases gripped in quotation marks like a pair of ice tongs. The very funny "Bonne Entente" I could quote, but I do not wish to save the reader the trouble of looking it up himself.

The next generation, growing up in a largely urbanized Canada, has two representatives this year. P. K. Page's *The Metal and the Flower* (Indian File Book, no. 7; McClelland & Stewart, 64 pp., $2.75) got the Governor-General's Medal, and deserved it, although my opinion of the practice of giving a medal to any poet over the age of ten is not high. But if there is such a thing as "pure poetry," this must be it: a lively mind seizing on almost any experience and turning it into witty verse. The taste is not faultless: sometimes a conceit is squeezed to a pulp, as in "Mystics Like Miners," "Christmas Eve — Market Square," and "Mineral," or dragged in by a too restless ingenuity, like the unpearled barbiturates in "Subjective Eye" or the hydrocephalic idiot in "Sleeper." The writing is less mannered than in *As Ten, as Twenty,* though she will still talk too much, in the sense that some of her points are made over-conceptually, in undigested prose. This is true of "The Permanent Tourists," for instance, where most of the impact is made by the first stanza. Although she is essentially an occasional poet, Miss Page has a symbolic language of her own that operates on three levels: a lower level of emotion and instinct, symbolized chiefly by the sea; an upper level of intelligence symbolized by angels and abstract patterns in white; and a middle level of metal and flower, rose garden and barbed wire, where there is passion but little communion:

> Black and white at midnight glows
> this garden of barbed wire and roses.
> Doused with darkness roses burn
> coolly as a rainy moon;
> beneath a rainy moon or none
> silver the sheath on barb and thorn.

This lovely stanza needs to be read in its context, for Miss Page is skilful at varying a stanzaic pattern throughout a poem — one of the most difficult techniques in modern lyric.

She seems interested in everything, from salt mines to ski tows, but resists the temptation to be merely decorative and looks for the human situations involved in what she sees. The

salt mine poem has a deceptively casual development in perspective from beauty to horror. Only a few subjects (such as "Freak") get outside her emotional range. Her studies of girls are perhaps the most obviously attractive of her poems: "Morning, Noon and Night," "Sisters," and "Probationer" are all highly successful, and the conclusion of "Young Girls," in her lower-level key, is a sensitive evocation of adolescent tremors:

> Too much weeping in them and unfamiliar blood
> has set them perilously afloat.
> Not divers these — but as if the water rose up in a flood
> making them partially amphibious
> and always drowning a little and hearing bells. . . .

She is also admirable in seeing a story within a scene, and "Man with One Small Hand," " Portrait of Marina" (a spinster bullied by a sailor-father and "antlered with migraines" in consequence), and "Paranoid" are excellent little novelettes. More elaborate are the longer fantasies, "Images of Angels" and "Arras," both very beautiful, the latter a somewhat elliptical treatment of the Alice-through-the-mirror theme. Miss Page's work has a competent elegance about it that makes even the undistinguished poems still satisfying to look at, and the book as a whole is as consistently successful in reaching its objectives as any book I have read since I began this survey.

Mr. Irving Layton, like Bliss Carman, is a poet whose conscious and creative minds are at odds, and the former has, up to now, effectively concealed the fact that he is not only a serious poet but an unusually gifted one. *The Long Pea-Shooter* (Laocoön Press, 68 pp., $2.00) is mainly satiric verse, the *double-entendre* in the title giving the general idea. The book takes what one might call, borrowing a term from architecture, a miserere view of humanity, but the ironic eye does not have free play; it is oppressed by a conscience-driven and resentful mind which sees modern society as a rock pile and the poet as under sentence of hard labour. When there is a core of detachment in satire, there may be a core of reality

in its caricature, but most of the world of *The Long Pea-Shooter*
is a depressingly unreal world. If the book stood alone, one
would be inclined to say that here is a remarkable mind that
has somehow missed its vocation. And yet, there is a personal
test which every critic applies to poetry, the test of involuntary
memorizing. If one remembers a poem, or part of a poem,
without making a conscious effort to do so, one is probably
dealing with a genuine poet. And the little pieces of phrase-
ology that keep sticking in one's mind are surprisingly
frequent:

> I saw a continent of railway tracks
> coiling about the sad Modigliani necks
> like disused tickertape, the streets
> exploding in the air
> with disaffected subway cars.

In any case, the question of whether Mr. Layton is a real
poet or not is settled by *In the Midst of My Fever* (Divers Press,
Majorca, 41 pp.). An imaginative revolution is proclaimed all
through this book: when he says that something "has taught
me severity, exactness of speech" or "has given me a turn for
sculptured stone," we see a new excitement and intensity in
the process of writing. At last it is possible to see what kind of
poet Mr. Layton is, and he proves to be not a satirist at all, but
an erudite elegiac poet, whose technique turns on an aligning
of the romantic and the ironic:

> Or hex me to see
> the great black-bearded Agamemnon
> slain by a danceband leader
> bonged on the head on the polished floor. . . .

The ridicule of the body, the sense that human genius grows
out of human corruption, has always been a central theme in
his work: here it becomes a co-ordinated vision of pity and
terror:

Life is horrifying, said Cézanne,
>but this is not
>what he meant who picked flowers blooming
>in the slaughterhouse; he meant the slit throats
The bear traps smeared with blood, the iron goads,
>the frightened servant-girl's Caesarian,
And this planet dancing about Apollo,
>the blood drying and shining in the sun. . . .

One finds something of value on nearly every page of this book: vivid imagery in "Metzinger: Girl with a Bird"; quiet eloquence in "Paraclete"; well-paced narrative in "The Longest Journey"; and, in "The Birth of Tragedy," this:

A quiet madman, never far from tears,
>I lie like a slain thing
>under the green air the trees
inhabit, or rest upon a chair
>towards which the inflammable air
tumbles on many robins' wing. . . .

Whatever lapses in expression one may find are of little importance when one is so constantly in touch with a poetic mind of genuine dignity and power. The real poet is now strong enough to dispense with the bristly palisade of self-conscious satire which has obviously been protecting him, not against the world, but against his own fear of sentimentality.

A still younger generation of poets born during the twenties of this century is represented in *Trio* (Contact Press, unpaged), a selection of verse by Gael Turnbull, Phyllis Webb, and E. W. Mandel. Here finally one meets the responses of people reared in a fully modernized Canada who find the forest as strange as Lampman found the city (see Mr. Turnbull's "Lumber Camp Railway"), and who accept politcal malaise and existential dread as the most elementary poetical assumptions (see Mr. Turnbull's "Twentieth Century," Miss Webb's "Earth Descending," and all of Mr. Mandel's

"Minotaur Poems"). In a way this acceptance has protected them, like an inoculation. Poets who reached maturity between 1930 and 1945 were affected by the world's hostility to creation: these poets take the hostility for granted, and have been driven back on poetry as the most solid basis for experience of anything they know.

None of them have as yet wholly distinguished the process of writing a poem from the process of finding a poetic subject and writing it up, and all of them are apt to take refuge in some kind of literary allusion when they approach the emotional crux of their poem. That there are influences and derivations, such as Marianne Moore in Miss Webb's "Standing," goes without saying: one should not look at those, but past them. Mr. Turnbull's "Post-Mortem" treats a difficult subject with great simplicity and directness, and "A Landscape and a Kind of Man" well evokes that curious nostalgia for mean streets that is a trade mark of contemporary sensibility:

> In some brick-infested town
> Where only the damp cobbles shine,
> And slate and soot and sameness blend,
> And smoke and cloud have no sure start or end,
> Crowded upon the margin of a garrulous sea. . . .

In Miss Webb another contemporary trade mark, the sense of apocalyptic parody, of the world soon coming to an end in after all a quite meaningless way, is what moves her to greatest eloquence:

> and, as a world tumbling shocks the theories of spheres,
> so this love is like falling glass shaking with stars
> the air which tomorrow, or even today, will be
> a slow, terrible movement of scars.

The variety of tone and technique in her work makes it interesting but somewhat uncertain in direction: "The Color of the Light" perhaps indicates most clearly both her latent powers and the core of a more individual style.

Mr. Mandel is less superficially attractive, with his strident rhythm full of strong beats and spondees, and is much more difficult to follow, with his superimposed mythopoeic imagery. But these are signs of staying power, and to my mind he is the one of the three most likely to develop not only in technical skill but in depth and range of vision. He is preoccupied by the perennial technical problem of transmuting the substance of myth into the form of immediate experience. And just as Carman turned to Sappho and the Adonis lament to express the plangent melancholy of a late pagan romanticism, so Mr. Mandel, born only a few years before Carman died, turns to the story of Theseus and the Minotaur to express our own sense of sinister initiation into some kind of fearful ordeal:

> It has been hours in these rooms,
> the opening to which, door or sash,
> I have lost. I have gone from room to room
> asking the janitors who were sweeping up
> the brains that lay on the floors,
> the bones shining in the wastebaskets,
> and once I asked a suit of clothes
> that collapsed at my breath and bundled
> and crawled on the floor like a coward.
> Finally, after several stories,
> in the staired and eyed hall,
> I came upon a man with the face of a bull. . . .

1955

Poetry, like painting, has two poles: the pole of content or subject-matter, the thing represented, and the pole of form, the conventional structure of the art. Painting may be very formal, as in geometrical ornament or abstraction, or it may be very representational, as in illusion-painting or *trompe l'oeil.* Poetry may be representational, as it is in reflective poetry where the poet describes a landscape, his emotions, his thoughts, or his society. When it is formal, the poet seeks metaphor, the language of pure identification that he shares

with the lunatic and the lover; he seeks myth, the stories of gods whose actions are not limited by reality, and hence form abstract literary patterns; he is erudite and allusive, for the forms of poetry are conventions and grow out of other poems; and he seeks apocalyptic imagery, the vision of a universe which is humanly as well as divinely intelligible. The representational tendency in poetry is sophisticated and civilized: the formal tendency is primitive, oracular, close to the riddle and the spell. In our day, however, the primitive tendency has been reached through a further refinement of sophistication: "modern" poets use myth, metaphor, and apocalyptic imagery just as "modern" painters use abstract or stylized patterns. In Canada, the Romantic nineteenth-century traditions are reflective and representational: "modern" poets have unconsciously bridged the cultural gap with the Indians, just as the painting of Emily Carr bridges the gap in British Columbia between a culture of totem poles and a culture of power plants.

Two volumes this year illustrate each of these tendencies in our tradition. *Sepass Poems* (mimeographed, 60 + 12 pp.) is a collection of Okanagan Indian mythical poems, recorded by a chief and translated by Mrs. Street. (They were apparently recorded in 1915 but not published because they conflicted with what scholars then thought they knew about the tribe's origin: an extraordinary reason, but that's what it says here.) They are myths of creation and flood, of the sun-god and his paradisal world, of the evil spirit, an Indian Ogopogo, at the bottom of a stormy lake; they are myths of metamorphosis, of how animals were shaped as they are; myths of Titans revolting against the sky-god and of a box of evils like Pandora's. In short, they are the same myths that we find in our European tradition. In spite of a slightly old-fashioned cast to the translation (the translator was born in 1857), the structural outlines and rhetorical devices of the original, notably repetition, obviously show through. They make fascinating and haunting reading.

The other tendency is illustrated in *The Selected Poems of Sir Charles G. D. Roberts* (Ryerson, xxvi, 100 pp., $3.50), edited

with a concise introduction by Desmond Pacey. This book is a companion volume to the selection of Carman by Lorne Pierce, reviewed here last year. Roberts is a subjective and descriptive poet, not a mythical one, and the organizing formal principles which give both intellectual and emotional unity to his work come out of his personal life. The formal basis of his poetry is chiefly in the recollections and associations of his Maritime childhood. Being a late Romantic, this means that his central emotional quality is nostalgia. From there he expands to descriptive landscape poetry, still usually with a nostalgic emotional core, and from there the next logical step would be to intellectualized poetry. Roberts tried hard to attain to this third stage, but had nothing intellectual in his mind, and Mr. Pacey has quite properly omitted the poetic results — still, the pattern of a representational poet is complete in him.

In 1955 there were four volumes of poetry of particular importance. Two, Wilfred Watson's *Friday's Child* and Anne Wilkinson's *The Hangman Ties the Holly*, are highly formalized poetry, making considerable use of relatively primitive forms, such as ballads and nursery rhymes. Miriam Waddington's *The Second Silence* and Irving Layton's *The Cold Green Element* are at once more subjective and more objective than the other two. They have very little in common with Roberts and his Romantic nostalgia, but their organizing associative patterns begin in personal experience, which in its turn shapes and colours a direct reaction to the world around them.

Wilfred Watson's *Friday's Child* (Faber and Faber [British Book Service], 56 pp., $2.00) is typically formal poetry, mythical, metaphorical and apocalyptic, using religious language because it is impossible to avoid religious language in poetry of this kind. The expected influences are present: Hopkins (notably in "I Praise God's Mankind"), Eliot, the later Yeats, and more particularly Dylan Thomas, the most exuberantly apocalyptic poet of our time. (There are two poems on Thomas, an "Admiration" and a "Contempt": the latter seems to deny the apocalyptic element in him, which I find incomprehensible, in spite of the great eloquence of the poem itself.)

Such themes and influences are by now familiar, and the familiarity is a challenge to the poet to "make it new," in Pound's phrase. It is an impressive tribute to Mr. Watson's integrity as a poet that he meets this challenge by being simple rather than clever, and a tribute to his ability that he succeeds.

The framework of his ideas and imagery is conventional enough. There is a world that is "real," and another world that is intelligible. The real world is the world of nature, where life and death, love and lust, chase each other around in a closed circle. Its presiding genius is an "old woman crossing and breeding all creatures," the central figure of the haunting "Ballad of Mother and Son." It is true that "the dead wave is pierced by the living reed," a phrase with overtones of Pascal indicating that life is as powerful and as primeval as death. Yet one discovers

> That love in its simple essence
> Is death mourned to magnificence,

and that the energy of passion is driven by the death-impulse: Tarquin the ravisher is "lit at death's white taper." In "In the Cemetery of the Sun" there is a wonderful evocation of the sense of life and death as simultaneously present: the city of Calgary is "a hill of tombstones" and the flapping clothes on Monday morning suggest the ghosts of the Crucifixion and Ezekiel's valley of dry bones.

The other, the intelligible world, is the world of divine presence revealed by Christ, and its first impact on the world of nature is one of total opposition, the light striking into the uncomprehending darkness, into a world protected from Paradise by "the hard mercy of the flaming sword." The terror inspired by the "windy bishop" — presumably the Holy Spirit — "who'd preach our dust home," is the terror of being confronted with something that threatens not death but annihilation — the same terror that made Eliot's Gerontion speak of "Christ the tiger." Yet there is a stage beyond this at which the world of light becomes simply the world of darkness illuminated, a new earth in a new heaven:

> . . . the exigent
> Last moment, when the creature at last comes home
> To reason, order, proportion, doom.

The reconciliation of the two worlds and the awakening of life-in-death to life is the theme of the powerful "Canticle of Darkness," typologically the key poem in the book, where we move from creation through the death and resurrection of Christ into a new creation.

Friday's Child is brought out by a well-known British publisher, and the blurb expresses a genuine admiration for the book, along with the faintest trace of polite surprise that lyrical tones more highly organized than a buffalo's mating call should come from the windy plains of Alberta. The present reviewer does not share the surprise, if it is there, but he fully concurs in the admiration. One gets very tired of poets who indicate an impressive subject and then walk quickly away from it, but Mr. Watson never starts anything he can't finish, even an apocalypse. He can describe Emily Carr in a way that reveals not what she painted but what she tried to paint, the vision she staked her life on. We feel that even a line as breath-taking as "When in her side my eyes were but blind seeds," or a phrase like "the tomb egg broken," is merely what fits the poem at that point: brilliant as the imagery is, there is no costume jewellery. A refrain, such as "Stand gentle in my words" in the "Canticle of Darkness," steadily tightens the tension and concentrates the reader's awareness, where a merely facile refrain would put him to sleep. "Friday's child is loving and giving," and the book shows the upsurge of creative energy that obeys the command of the thunder in *The Waste Land* to give, sympathize, and control. How posterity will sort out and rank the poets of today I do not know, nor much care; but in such poems as "In the Cemetery of the Sun," the "Canticle of Darkness" and perhaps the title poem, one may catch a glimpse of the reasons why, in the course of time, what the poet has to say about his culture becomes so important and what everyone else has to say becomes so much less so.

Anne Wilkinson's *The Hangman Ties the Holly* (Macmillan,

vi, 57 pp., $2.50) is another book of mythical and metaphorical poetry which has many resemblances to *Friday's Child*. The resemblances would be startling to anyone unaware of the highly stylized nature of such poetry. A poem of Mr. Watson's puns on "gone" and Maud Gonne; a poem of Mrs. Wilkinson's, "Swimming Lesson," a rather painful poem in spite of its crisp organization of narrative and description, speaks of "A good Seamaritan," "the warm gulf seam of love," and a girl who "did not holy believe." The subject of Mr. Watson's "O my Poor Darling" and of Mrs. Wilkinson's "The Pressure of Night" — very different and very remarkable poems — is the subject of beauty and the beast. Mr. Watson's "The White Bird" and Mrs. Wilkinson's "Dirge" are both based on the Cock Robin nursery rhyme, though Mr. Watson's bird connects with the Ancient Mariner's albatross and Mrs. Wilkinson's with the turtle-dove of marriage. The other nursery rhyme which gives Mr. Watson his title is quoted in Mrs. Wilkinson's "Once upon a Great Holiday." Mr. Watson's "And Should She Ask" and Mrs. Wilkinson's "I was Born a Boy" are both riddle-poems based on a conceit of reincarnation, like some of the early Welsh poems. Mrs. Wilkinson holds her own very well against this formidable competition — so well in fact that we must desert the comparative at once for the positive.

Mrs. Wilkinson's most obviously striking quality is a gift for sardonic parody. In brief we have the device of altering a stock phrase, a device that may again owe something to Dylan Thomas. Thus we have "new laid lovers," "a game they know by head," "one of those fly-by-days," and the like. In large we have the parody-poem, in most cases, including the title poem, "Dirge," and parts of "Christmas Eve," a folk song or nursery rhyme gone ingeniously sour. Virginia Woolf is described in the imagery of Ariel's sea song:

> From ivory pelvis spring
> Her strange sea changeling children;
> In sockets deep with six lost layers of sight
> The sea fans open.

Not since Leo Kennedy has a Canadian poet done much with the macabre as a theme, but Mrs. Wilkinson is much possessed by death. It would be difficult to put the grotesque futility of our burial customs into fewer syllables than this:

> A miser's grace
> To fill with lead
> The breathing earth
> That gave us bread,

or to make a more chillingly logical conclusion to the poet's conversation with two young lovers in a park:

> I moved
> To go but death sat down.
> His cunning hand
> Explored my skeleton.

Mrs. Wilkinson sees nature in sharp outlines — it is significant that one of her favourite words is "lens" — and she has a liking for clear colours and conventionalizing forms ("Italian Primitive"). There is also a deeper prophetic sympathy with nature, of the kind that organizes the fine little poem "Tigers Know from Birth," and flashes out a phrase like

> I put on my body and go forth
> To seek my blood.

What she emphatically is not is apocalyptic: the death that recurs so often is the guarantee of man's identity with nature: human nature is her metaphor, and she has no use for the religious language that assumes the uniqueness of humanity. Hence what we have is a kind of parody-apocalypse, a union of life and death in nature, and the last image in the book is one of a falling man.

We turn now to the two less formal and more representational poets. In Miriam Waddington's *The Second Silence* (Ryerson, vi, 57 pp., $2.50), there are no apocalypses or

erudite parodies: just as her metaphors are rooted in her own life, so are her myths in the society around her:

> The wine we drink is bitter
> Compounded of the blood
> Of not one Christ but many
> Who gained no holihood.

The central images of everyone's life are formed in childhood: the child's dream world is the world of the "second silence" in which creation begins. Mrs. Waddington's "Poems of Children" (the poems are arranged according to theme) move in the associative exuberance of the world of childhood, the world where everything is mysteriously linked with everything else. In sharp contrast to the brilliant clear outlines of the two previous poets, Mrs. Waddington's images break up into a kaleidoscopic impressionism:

> . . . Lullabies from an old book
> Of apples and nutmegs and peacocks that flew
> Ceaselessly circling a golden sea.
> (It was dream, it was dream,
> Light echoed and keys were lost in the sea.)

In adult life this associative world is driven underground into the subconscious, where the imagery of adult dreams, with all its guilt-ridden hauntings, collides or coincides with the outer world. This is the subject of the strikingly original "Morning until Night":

> . . . two black dogs dart out
> Swift as foxes to confound my eyes,
> And all the sudden wolves that had my dreams
> Revolving on fear startle me with their smiles . . .

Mrs. Waddington records both aspects of this conflict equally well. In "Poems of Love," especially "Thou Didst Say Me," the constant turning of the lover's individuality on its

axis, so to speak, is expressed by an intense murmuring of repeated sound, and in "Poems of Work" the squalor that a social worker sees in a modern city is recorded with the kind of sympathy that comes from being emotionally involved in everybody else's fate. In the last section, "Poems of Living," something of her earlier "Green World" imagery begins to creep back, like blades of grass rooting in pavement, particularly in the final poem, "Inward Look the Trees," which brings the book to an impressive close. Where she is least successful, the failure is due to intellectual excess, not deficiency, as in the poems to a teacher and a pupil, where there is too much unorganized metrical talk. But she has her own distinctive quality: a gentle intimacy and an unmediated, though by no means naive, contact between herself and her world.

Irving Layton's *The Cold Green Element* (Contact Press, unnumbered, $1.50) is also polarized between personal association and a direct reaction to experience, though in a more explosive way than Mrs. Waddington's book. In such poems as "winter fantasy" (his titles are in lower case) and "me, the p.m., and the stars," there is a subjective rearranging of images, of a kind that was called "surrealism" in the fashionable slang of twenty years back, dream poems a little like Chagall paintings. What many surrealists did not surrealize was that such techniques are of little point without their objective counterpart, the vision of a world which acts in as sex-goaded, as guilt-ridden, as arbitrarily foolish a way as the dream. Mr. Layton's fantasy is not irresponsible or a mere playing with verbal patterns, because the distortions of the poetic imagination are geared to the distortions of society. For this kind of writing a poet needs humour and technical competence, and Mr. Layton appears to have plenty of both. Sometimes the humour becomes sinister and Kafkaesque, as in "the executioner," and sometimes self-mocking, as in the end of "the poet entertains several ladies." In "me, the p.m., and the stars," when the poet is rebuked by the Prime Minister for throwing a snowball through somebody's window, the poet explains that he has met a "sage" — presumably Zarathustra — who has given him a motive for doing so:

~~He also said pity was loss, of power.~~
 Someone had to tell the people
 what was happening; it's indecent to let
 the death of the last god go by unnoticed.

The objective pole takes the form of social caricature — not satire or invective, for which Mr. Layton has no gift, but the mock-heroic, or, as in the lively "birds at daybreak," the mock-mythical. In "Golfers" he says:

 And you see at a glance
 among sportsmen they are the metaphysicians,
 intent, untalkative, pursuing Unity . . .

 And that no theory of pessimism is complete
 which altogether ignores them. . . .

Exactly in the middle between the fantasy poems and the social poems comes the remarkable title poem, an ironic personal myth of the poet as a hanged god or nature spirit torn apart and distributed through the landscape. No quotation can do justice to the intricate unity of the poem, but we can see as soon as we read it that it presents the organizing image of the book. Again we note an odd coincidence: it is the same image as that of the central poem of Mrs. Wilkinson's book, "Carol."

Of the poems mentioned, "Golfers" belongs to a second volume, *The Blue Propeller* (Contact Press, $1.00), where there are two or three other poems, including "Portrait" and "Mute in the Wind," that are witty and sharply pointed. Otherwise much of the book is an obstacle race for the sympathetic reader, a dark tunnel of noisy dullness. *The Cold Green Element* is infinitely better on all counts, and in it there are at least a half-dozen poems (including, besides those mentioned, the lilting "for Naomi" at the beginning) which have a rhythmical swing, an urbane humour and a technical finish guaranteed to make the reader's toes curl up in solid contentment.

II

Louis Dudek's *Europe* (Laocoön [Contact] Press, iv, 139 pp., $2.00) is diary poetry: a sequence of ninety-nine short pieces recounting impressions of a trip to Europe, from England through France, Spain, Italy, and Greece, and ending with the discovery that what Europe, a shattered and demoralized civilization, really reveals to the North American is the virtues of his own culture. The century of meditation is a fatal idea for a facile poet, and although at his best Mr. Dudek escapes being merely facile, I find large stretches of the book un-rewarding. In the first place, the influence of Pound is oppressive. Pound is everywhere: the rub-a-dub three- and four-accent line, the trick of snapped-up quotations and allusions, the harangues against usura, the toboggan-slide theory of the decline of Europe after the Middle Ages, and so on. In the second place, the conversational style brings the ideas into sharp relief, and the ideas are commonplace, prejudice reinforced by superficial tourism. To be told in rather pedestrian verse that the English are constrained by standards of what is and is not done hardly adds to the variety of one's poetic experience. Things improve however towards the end, where the rhythm firms up and begins to swing and lilt a bit, and where first-hand observation replaces second-hand theorizing. The eighty-first piece, a concise and ironic sketch of a Greek village, is an admirable vignette; and the ninety-fifth, on the sea, achieves the difficult feat of talking beautifully about beauty:

> Beauty is ordered in nature
> > as the wind and sea
> shape each other for pleasure; as the just
> know, who learn of happiness
> > from the report of their own actions.

Raymond Souster's *For What Time Slays* (mimeographed, 24 pp.) shows a more distinctive and unified style than any previous collection of his. There are still too many expendable

poems, based on a preoccupation with the process of writing, on a substituting of ready-made moralizing for observation and irony, and, most frequently, on an apparently unshakable conviction that the kind of sexual reverie indigenous to male boarding-houses is invariably poetic material. Such signs of immaturity are the result of too slavish an adherence to the conventions of his kind of poetry. In about every tenth poem he escapes these conventions and writes the kind of poem that only he can write. Usually it is an epigram based on observation unified by a single drop of emotional colouring: a type of epigram which for some reason has been more common in Chinese poetry than in our tradition:

I fear this skull-capped priest.

He tells his viewers
Someone must have Authority,

And clearly he is thinking of himself.

Two new series of collections of verse provide some very interesting work in small compass. Emblem Books are tiny little booklets put out by Jay Macpherson with covers by Laurence Hyde. There are three of them to date. Daryl Hine's *Five Poems* is a remarkable first volume, if one can call five poems a volume. Reading his long meditative lines is like watching heavy traffic at night: a brilliant series of phrases moves across a mysteriously dark background, the central driving force of the poem remaining elusive. It sounds condescending to speak of promise and a future, yet the sense of powerful gathering forces is stronger than any other reaction. The main line of development is probably indicated in such passages as this, from a dialogue of Theseus and the Minotaur (the Minotaur is speaking):

I am Charon, and I wait
 beside this lightless river for my gold;
my boat is paper; I am cold;
 the winds upon the water celebrate

> the soul's long shadow and the heart's
> red beacon; I perceive
> the wormy lover wearing on his sleeve
> funerals foreshadowed by his art. . . .

Jay Macpherson's *O Earth Return* is almost exactly the opposite in technique, using stanza forms, usually quatrains, with expertly varied timing, and with an interest in myth that classes her with the formal poets. The title indicates a Blakean influence, which is discernible, but the tradition is rather that of the Elizabethan lyric, where — as in Campion — the use of a mythical or conventional theme releases the emotion by detaching it from direct experience and containing it within the convention. Thus a poem that might seem at first glance to be only an allusive literary exercise becomes a kind of reservoir of feeling in which one's literary and personal associations mingle and are held in the kind of variable emotional contemplation that it is one of the primary functions of poetry to provide:

> Where is your god, Sibylla? where is he
> Who came in other days
> To lay his bright head on your knee
> And learn the secrets of Earth's ways?
>
> Silence: the bat-clogged cave
> Lacks breath to sigh.
> Sibylla, hung between earth and sky
> Sways with the wind in her pendant grave.

There are fewer surprises in the third Emblem Book, Dorothy Livesay's *New Poems,* where the main impression is of a disciplined and experienced handling of modern poetic idioms. A sense of a lonely pessimism, of the shutting off of communication, of the inevitable victories of winter and darkness, gives the poems a plaintively muted quality: they seem to struggle against a conviction that they cannot say much:

And deeper than flash
Of fin in well
Your thoughts dot, dash —
But never tell.

O when will you freeze
Glassy, clear
Frost-breathing image
On polished air? . . .

This survey was originally bibliographical as well as critical, and it may well be thought that a review which mentions twenty-three separate items can have only a bibliographical interest. There is perhaps some point in explaining the critical principle. The ideal reader often visualized by founders of little mags, who is eager to read contemporary poetry but has no ambition to write it, barely exists. Practically everybody who habitually reads poetry habitually writes it as well. That is as it should be: there are many things wrong with the position of the poet in modern society, but this is not one of the wrong things. The cultivated amateur is the backbone of all the arts, especially poetry, as the professional poet who lives by his verse is usually a writer of newspaper doggerel. Criticism concerned primarily with measuring the distance between amateur verse and great poetry is essential, but there will never be any lack of it. Meanwhile, what with an indifferent public, the conscientiously contemptuous critics, and perhaps his own frustrated ambitions, the amateur poet has a hard time of it. Yet in Canada, where there is no sharp line between the regular and the occasional poet, it seems more appropriate to look at a year's output inclusively, as a total power of articulation, shading from a luminous centre to a pleasantly blurred periphery.

In every year in Canada, including 1955, most of the published verse shows the features of occasional amateur writing. Lines will be pumped up with adjectives; rhymes in a sonnet will clang like a typewriter bell; stodgy rhythms will be harried into movement by starting every line with a heavy accent; a

sentence will begin in poetry and finish in vague prose; a failure in accurate expression will be concealed by an exclamation, and so on and so on. These faults also occur even in the best poetry, and many of the virtues of the best poetry reappear in the slighter books. Hence while much Canadian verse could be honestly described, by the highest standards of the best twentieth-century poets, as metrical doodling, it could also be described, just as honestly and perhaps more usefully, as the poetic conversation of cultivated people. After all, there are many who will read detective stories with pleasure even when they have the style of a riveting machine, the characterization of a tombstone, and the plot of a charade: perhaps poetry too might be approached with some tolerance for the convention as well as evaluation for the achievement. . . .

1956

Poetry cannot be written by an act of will, and society cannot produce poets by an act of will. There is a strong desire in Canada to have fine poetry written in the country, but the will of society, as expressed in education, can be directed only towards building up a cultivated public for poetry, a public which would be able to recognize fine poetry if it saw it. Otherwise generous words about welcoming new poets will be accompanied by complaints that all the poets who have appeared so far are too "modern," and do not sound like poetry as the reader remembers it to have been when he stopped listening to it in Grade Six. Young people should certainly be encouraged to write, for everyone can learn to write poetry up to a point — the point of discovering how difficult it is to write it unusually well. To get to that point is no mean achievement, as it is well past the substandard level of naive or doggerel verse which is the usual mode of amateur expression. But the main purpose of such encouragement is to breed a love of poetry, not to breed poets.

First Flowering (Kingswood House, xiv, 210 pp., $3.00),

edited by Anthony Frisch, is a collection of poetry and prose in both languages written by young people (twelve to nine-teen) in high schools all across Canada. Mr. Frisch has received warm praise, which he assuredly deserves, for the skill and energy with which he has carried out his task. The importance of what he has done is very considerable, though we should realize that the importance is educational and not literary in reference. The book is not an anthology of the Canadian writers of tomorrow: it is evidence of intelli-gence and cultivated taste among Canadian teen-agers. I imagine that a comparable cross-section of any other age level in Canada would produce much the same *literary* result, though of course with less freshness and charm. I understand that Mr. Frisch is now busy with a similar anthology taken from an older professional group, which will do much to confirm or refute me on this point. Of the poems in *First Flowering*, we rec-ognize all the familiar conventions of poetry on that level. There is the nostalgic poem, the realistic poem, the didactic poem, the parody or comic poem, the poem of observed or remembered beauty, and so on. Here and there something less predictable emerges, as in Charles R. Eisener's delightful "The Planets." But there is no reason to suppose that any of the contributors are about to start out on the lonely, uphill, flinty road of the professional poet. If there were any such, the book, for them, would be better entitled First Deflowering. . . .

Three Windows West, by Dick Diespecker (J. M. Dent & Sons, xvi, 160 pp., $3.50), is a strange mixture. Some of it is verse journalism of a type crisply described by W. H. Auden, in one of the better passages of "Under Which Lyre," as designed "For recitation by the yard In filibusters." A poem called "Prayer for Victory" was, the preface tells us, read to a million people in New York by Raymond Massey; it sold 35,000 copies on Canadian newsstands and 200,000 more copies were dis-tributed by a bank during a Victory Loan drive; it has reached an estimated total of over half a billion people:

Then, Dear God,
Make us worthy of Victory.
Give us the strength
To keep our pledges
To make a better world . . .
So that never again
Will there be a Hitler or a Mussolini,
A Himmler or a Goebbels;
Never again a blitzkrieg;
Never again the bitter treachery
Of Pearl Harbour. . . .

It is easier to turn on the mechanism of a conditioned reflex than to shut it off, and Mr. Diespecker has not escaped the fate of the sorcerer's apprentice. The sense of his formidable captive audience has given him a fatal fluency, which he employs in alternately addressing Dear God and summoning memories of the ol' swimmin' hole type:

Betcha Mom's in the kitchen right this minute
Making punkin pie.

If this were all his book contained, there would be no occasion for mentioning it in this survey. But here and there one finds, if not always genuine poetry, at least a genuine effort to write it, and a poem called "Return to Labour," which would be good anywhere, is, in this context, shockingly good. The opening poem, with a South African setting, is also, in spite of a persistent misspelling of "its" and a somewhat discouraging first line ("A bok-ma-kerri scolds the lagging stars"), both honest and attractive. It is a disturbing thought that the writing of such stuff as "Prayer for Victory" and its congeners may have required the self-destruction of an authentic poet.

The Poetry of E. J. Pratt, by John Sutherland (Ryerson, x, 109 pp., $3.75), is one of the few pieces of sustained Canadian criticism that I have read slowly, marking passages with a pencil. Pratt is a genuinely popular poet, and hence a difficult

subject for criticism: most of his readers read him for other values, and for many of the remainder, a poet with all those editions, honorary degrees, and medals (one could almost call him a gong-tormented poet) is too obfuscated by another kind of recognition. Mr. Sutherland's book is of importance, not only because it takes Pratt seriously, but because it takes poetry seriously, and accepts Pratt as a genuine and valid kind of poetic experience. It is important also as the only major work of a critic whose premature death has deprived the country of one of its most selfless and dedicated literary citizens.

Much of what he says about the relation of man to nature in Pratt, the ambivalence of Pratt's moral attitudes, and the point of identity between the slayer and the slain in his heroic narratives, is both new and sound. The symbolic expansion of Pratt's characters into Christian archetypes may not please every Pratt reader: granted the premises of this type of criticism, he does not falsify Pratt's meaning, but he does give the impression of straining his text. The reason for this may be that he seems to assume that Pratt is a poet who, through his background and also through some inner bent in poetry itself, absorbed a great deal of Christian symbolism more unconsciously than deliberately. I imagine that Christianity means something quite as positive to the poet as it does to his critic, and something rather more mature and complex. I feel that Mr. Sutherland misinterprets "The Truant," which is the central poem in the Pratt canon as far as belief is concerned: the "great Panjandrum" in that poem is not God, and the attitude of the man to him is not "secular," otherwise he could hardly swear allegiance to the "rood" in the last line. But with these minor reservations the book is a fine and eloquent study, as worthy of its author as it is of its subject.

III

The editor of *The Selected Poems*, by Raymond Souster (Contact Press, 135 pp., $2.00), is Louis Dudek, and he has done a good job, perhaps intended, as the rather odd title suggests, to be definitive. Mr. Souster is revealed as a most prolific poet:

ten collections of his work are in existence, of which I have
seen only six, and the selections from the four I have not seen
have given me a quite new idea of him. Mr. Souster is a genuine
poet whose qualities are subtlety and humour, but he often
spoils his subtlety with repetition and his humour with moral-
izing. Mr. Dudek's introduction approves of the moralist, but
his critical taste does not, and his selection disentangles Mr.
Souster's genuine poems from the straggly excelsior packed
around them in the original collections. Subtlety and humour
are also the qualities needed for epigram, and epigram is the
genre to which the poet has, wisely, devoted himself. The
effects of his epigrams are made chiefly by theme: verbal wit
and metrical dexterity, the normal characteristics of epigram,
are both rare. Occasionally there is a punch line, either
conventionally at the end ("The Bourgeois Child") or at the
beginning, as in the study of the "Drummer Man" which flows
easily out of its fine opening "Sooner or later he was bound to
put his sticks by." Mr. Dudek quotes Whitman on the "perfect
candour" to which the poet is entitled, but the essential, or
creative, candour in Mr. Souster is that of the candid camera.
For in the main his method is photographic, a sharply focussed
observation of life in the *fourmillante cité* and his moralizing is
akin to the photographer's sentimental caption.

There are still a few captions, but there is also a respectable
body of serious and subtle verse. I like very much the snapshot
of "Girls Playing Softball":

> But it doesn't quite come off.
> The voices are a little too high, the ball
> Never seems to behave properly, the bats
> Heavy and awkward.

There is a study of "Nice People," in which a poet

> Sits gravely in the back kitchen, arguing with the negro maid
> (Almost an intellectual herself) the pros and cons
> Of sterilizing the family cat now curled in the centre of the
> floor.

There are some sombre but admirable hospital scenes, and "Old Man Leaning on a Fence" and "Bridge over the Don" catch another big-city vignette: the gloomy stare into darkness which seems to mean only a vacant mind but actually means that the will to live is ebbing:

> Haven't you seen
> The river before, don't you know it runs, smells like a sewer?

And there are some poems that are just good fun, like "The Opener" and the poem which concludes the book, "Flight of the Roller Coaster."

In this kind of poetry all freshness and novelty come from the choice of subject: the whole creative energy is expended in looking for appropriate scenes and getting them into focus. Reflection and comment are left to habit, and habit produces only the commonplace: in Mr. Souster's poetry it produces mainly grousing. Mr. Dudek's poetry is a contrast in subject-matter, but the same general principle holds. Mr. Dudek is introverted and emotional: what takes fresh and novel shape in his poetry is a sensuous reaction. In *The Transparent Sea* (Contact Press, 117 pp., $2.00), a retrospective collection, the best pieces are songs conveying an immediate mood, such as the one beginning "A bird who sits over my door"; or studies in the movement and sound of words, like "Tree in a Snowstorm"; or ideas that suddenly twist round into paradoxes, like the admirable opening poem on the pineal gland, or his comparison of the universe to a watch which makes religion a search "for larger regions of clockwise justice"; or quick vivid sketches like "Late Winter" or "Lines for a Bamboo Stick," the latter with an Oriental reference; or a study of swift movement, like his picture of a little girl skipping called "The Child."

One of his favourite adjectives is "wet," and some of his best poems have the quality of the wet water-colour that is done quickly and makes its point all at once. Sometimes an image strikes him in a grotesque form, as in the astonishingly successful "Mouths"; sometimes as a muttering and brooding

anxiety, as in the near-prose fantasy "The Dead." One often feels that a poem is inconclusive, but then one often feels too that the inconclusiveness is part of the effect, as it is in a sketch. An example is one of the few photographic poems, "To an Unknown in a Restaurant." In such poetry the ideas or comments have to be equally unpremeditated. When they are, they break out with the oracular tone appropriate to ideas that are not hooked on to others:

> What we call nature is nothing else than
> the triumph of life other than our own —

In short, I feel that when the poet says

> The world I see (this poem)
> I make out of the fragments of my pain
> and out of the pleasures of my trembling senses

he is telling us the exact truth about his poetic process.

It follows that he is working against his best qualities when he writes in a sequence, whether of description or thought. Here he is dependent on habit, and produces the clichés of habit. In the "Provincetown" sequence there is the same kind of maunderlust that filled so much of *Europe*. Sexual imagery is also a trap for him, for sex is something he feels self-conscious and explanatory about. At other times he is not satisfied with inconclusiveness, and some of the poems sag into platitude in an effort to round off, as in "On Sudden Death" and elsewhere. Yet, as the examples above have made clear, there is much to be grateful for in Mr. Dudek's book, and a great variety of pleasant and melodious writing.

Phyllis Webb's *Even Your Right Eye* (McClelland & Stewart, 64 pp., $2.75) in the Indian File series, is contemporary in technique: one senses Marianne Moore and Wallace Stevens respectively in a pair of poems called "Poetry" and "In Situ," though of course this may be general idiom rather than actual derivation. But it is not the technique but the combination of decorative elegance in the diction and melancholy in

the mood that marks her affinities. Such poems as "Standing" and "Double Entendre" are almost a kind of verbal embroidery, making one wonder about the role of the typewriter carriage in the twentieth-century poetic process, or, as she says:

> shapes fall in a torrent of design
> and over the violent space
> assume a convention. . . .

The attitude which corresponds to such diction is one of amused detachment. She has a talent, not fully exploited, for sophisticated light verse, and the concluding "Earth Descending," which appeared in *Trio* two years ago and is like an adult version of the "Planets" poem in *First Flowering*, is still perhaps her best single poem. But the general principle holds that her most sharply realized writing comes in moods of doubt, loneliness, and unhappiness. When such writing occurs, the reader feels that he is no longer listening in on an educated monologue, but being directly spoken to:

> where does it dwell, that virtuous land
> where one can die without a second birth?

There are some uncertainties in the style. Strained is the syntax in "sensed is the green grape pulse" and "Sprouts the bitter grain," and the latter poem, for all its eloquence, has not quite sifted the allegorical ash from the metaphorical flame. On the other hand, "The Second Hand" seems to me successful all through, and "Sacrament of Spring," based on an April-is-the-cruellest-month theme, is something more than successful, with its haunting refrain and its line "The flower and the whip are wed." "Incidental," with its admirable final couplet, is brief enough to quote in full:

> In that indelible year
> when the soldiers came
> and the dogs and harpies visited churches
> the creatures of my infant dreams

rose up in agony and fear
and splayed the air with foetal screams
and left the year uncompromised.

The year then knew its form and fled
into the cities of the dead.

A Window on the North, by R. A. D. Ford (Ryerson, vi, 48 pp., $2.50) is the work of a poet who has been in the diplomatic service in Brazil and in Russia. The poems include two translated from Brazilian poets, one, "Confidences of an Itabirano," being a remarkable poem which makes one wish for more such translations. Six poems are translated or adapted from modern Russian poets. Four of them are from Sergei Yessenin, who, like Mayakovsky, committed suicide in the early years of the Communist régime. The implied contrast in imagery between the brilliant and turbulent south and the grey mechanized north enters the Canadian poems too, and is brought into focus in the long concluding poem, "Luis Medias Pontual in Red Square." This poem depicts the hollow ache in the soul of a disillusioned Spanish refugee in Moscow, who notes that Russia and Spain have both been touched by the Orient, and are alien to both East and West.

I have seldom read a book of poems so uniformly bleak and desolate in their imagery, yet bleakness, especially to a reader brought up in Canada, is a very appealing imaginative mood. Mr. Ford is in the tradition of Carman, Campbell, D. C. Scott and others who have communicated the sense of the lonely winter afternoons, the struggling sun, the lynx and wolf lurking in the black woods, the long white expanses of fields, and the resulting fear in the mind of the beholder who feels, so to speak, spiritually responsible for the landscape, stretching as it does "to the Arctic ends of the earth." It is essential that the mind should set itself against such a world, otherwise the world will move in and reduce the mind to its own level of merciless terror and death. This has already happened in a grim poem called "Roadside near Moscow," where the poet sees, but dares not look too closely at:

> the almost human-like
> Column of prisoners, waiting for the snow
> To fill in their tracks.

His favourite pattern is an extension of his south-and-north imagery, the contrast between the brilliant reds and yellows of autumn and the black and white winter. The symbol of the hunter, pursuing death in his red coat across the stubble fields, seems to reflect the world of the middle twentieth century, fading from its past heritage into its future dispossession. Sometimes a symbolism of fertile valley and bare hill is used instead, with the same meaning. In "A Delusion of Reference" the "delusion" is an instant of pattern or design, perceived a moment before "the universe Settles into its usual disarray." Mr. Ford's style is lucid and sober, qualities especially valuable in translators: it can be dull but is thoughtful and not sloppy, and his cosmopolitan influences and settings give his book unusual claims on our attention.

Leonard Cohen, *Let Us Compare Mythologies* (McGill Poetry Series, Contact Press, 79 pp., $2.00) is the first in a series of books featuring McGill poets, which we owe, as we owe so much, to the generous enthusiasm of Louis Dudek. The poems are of very unequal merit, but the book as a whole is a remarkable production. The erotic poems follow the usual convention of stacking up thighs like a Rockette chorus line, and for them Mr. Cohen's own phrase, "obligations, the formalities of passion," is comment enough. But it is an excess of energy rather than a deficiency of it that is his main technical obstacle. Sometimes moods and images get tangled up with each other and fail to come through to the reader, or allusions to books or paintings distract the attention and muffle the climax, as in "Jingle." In short, this book has the normal characteristics of a good first volume.

To come to his positive qualities, his chief interest, as indicated in his title, is mythopoeic. The mythologies are Jewish, Christian, and Hellenistic. The Christian myth is seen as an extension of the Jewish one, its central hanged god in the tradition of the martyred Jew ("Saviors"), and Hellenism is the

alien society which Christianity has come to terms with and Judaism has not. The mythical patterns of the Bible provide some of the paradigms of his imagery:

> The sun is tangled
> in black branches
> raving like Absalom
> between sky and water,
> struggling through the dark terebinth
> to commit its daily suicide.

Other mythical figures, such as the *femme fatale* at the centre of "Letter," "Story," and "Song of Patience," and the dying god of "Elegy," are of white-goddess and golden-bough provenance. Mr. Cohen's outstanding poetic quality, so far, is a gift for macabre ballad reminding one of Auden, but thoroughly original, in which the chronicles of tabloids are celebrated in the limpid rhythms of folksong. The grisly "Halloween Poem," with its muttering prose glosses, is perhaps the most striking of these, but there is also a fine mythopoeic "Ballad" beginning "My lady was found mutilated," which starts with a loose free verse idiom and at the end suddenly concentrates into quatrains. The song beginning "My lover Peterson" is simpler but equally effective, and so is another disturbing news item called "Warning." In "Lovers" he achieves the improbable feat of making a fine dry sardonic ballad out of the theme of a pogrom. No other Canadian poet known to me is doing anything like this, and I hope to see more of it — from Mr. Cohen, that is.

The year 1956 is certainly Irving Layton's year, as far as English Canadian poetry is concerned. Three collections of his work have appeared. *The Improved Binoculars* (Jonathan Williams, 106 pp.) is a selection of his poems, mainly from the collections of the last three years, with an introduction by William Carlos Williams. Dr. Williams writes with commendable enthusiasm, and I find only his epithet "backwoodsman" difficult — perhaps that is how Montreal looks from the perspective of Paterson, N.J. The collection is strongly

recommended to those who are becoming curious about this poet, and who have missed the individual volumes from which it has been made. This is also the third year that Mr. Layton has issued two books of verse, one containing most of his more serious poems, the other devoted chiefly to expressions of his poetic personality. The latter group comprises *The Long Pea-Shooter*, *The Blue Propeller*, and now *Music on a Kazoo* (Contact Press, 59 pp.). Mr. Layton's poetic personality is entertaining enough, but is altogether a more stereotyped and predictable character than the actual poet. *Music on a Kazoo* is chiefly remarkable for "The Dwarf," a Kafkaesque murder trial which brings out such evidence as this:

> The manufacturer excused
> himself, saying he had loved her, that he was
> not a sentimental philistine but a poet: he
> had provided the money.

There is perhaps nothing of major importance in *The Bull Calf and Other Poems* (Contact Press, 49 pp.), at least nothing with the excitement of the title poem of *The Cold Green Element* or the better poems in *In the Midst of My Fever*. But there are some excellent poems, which emphasize the growing serenity and precision in Mr. Layton's best work and his power of telling the whole disinterested imaginative truth about his subject, free of both querulousness and posing. These are qualities which the more self-advertising poems give little hint of. Mr. Layton has spoken of the influence of D. H. Lawrence, and there are certainly signs of that influence. There is the same sacramental conception of sex in "The Dark Nest," "Sacrament by the Water," and elsewhere, and the same ability to humanize the animal world in the title poem (about a newborn bull calf killed because he is unprofitable), and in a poem about a mosquito

> with a queer sort
> of dignity clinging to its inert legs.

There may be some Lawrence, too, in his sacrificial symbolism, which enters the bull calf poem and crops up elsewhere, as in a poem about chokecherries where the caterpillar-ridden leaves are a sacrifice for the cherries. But he has, for one thing, a sense of ethical reality that Lawrence lacked. He notes the "stale melodrama of guilt" in the brooding resentments of the inner mind; he notes the curious parody of self-sacrifice which will make a man deliberately undercut himself in order to maintain his good opinion of himself; he notes the alliance of morality and desire in sexual relations when he advises a seducer to make a wife feel that she is lying with her husband. This shrewd insight into the self-satisfactions of evil brings him closer to Kafka, even to Eliot, particularly in an extraordinary "hollow men" poem called "Letter from a Straw Man" and another called "Halos at Lac Marie Louise," where the skilful use of assonance-rhyme indicates an unobtrusive mastery of technique:

> It was a white skeleton
>> Of a tree ominously gnarled;
> And around the singular crow
> The stark crows whirled.

In short, Mr. Layton appears to be gathering together the powers and range of what is certainly the most considerable Canadian poet of his generation, and may soon become something more. . . .

1957

This is an unusually thin year: one good book, two promising ones, and a miscellaneous assortment of what the Elizabethans might politely have called a paradise of dainty devices, though it would be more accurate to speak of an amusement park of rhythmical gadgets. Some of these latter are pleasant and readable enough: with others, one is strongly tempted to take the plangent tone of a couplet which appears

on the opening page of one of the year's few published volumes:

> Last of the mighty oaks nurtured in freedom!
> Brambles and briars now supersede treedom.

However, here goes. The good book, of course, as the Governor General's committee has this time recognized, is Jay Macpherson's *The Boatman* (Oxford, x, 70 pp., $2.50). The book itself is one of the few physically attractive objects on my Canadian poetry shelves, and the fact is an appropriate tribute to its contents, for *The Boatman* is the most carefully planned and unified book of poems that has yet appeared in these surveys. It is divided into six parts. The first, "Poor Child," contains poems that appeared in a small pamphlet reviewed here some years ago: they form a series of tentative explorations of poetic experience, ranging in tone from the macabre "The Ill Wind" to the plaintive "The Third Eye." The next two sections are called "O Earth Return" and "The Plowman in Darkness." The titles come from two poems of Blake that deal with "Earth" as the whole of fallen nature in female form, and the subjects are chiefly the more common mythical figures connected with this "Earth," including Eve, Eurynome, the Cumaean Sibyl, Mary Magdalene, and the bride of the Song of Songs, identified with the Queen of Sheba. Hence the subtitle, "A Speculum for Fallen Women." The two parts are, like Blake's lyrics, matched by contrast against each other, the relation often being marked by identical titles. The contrast is not so much Blake's innocence and experience, though related to it, as a contrast between a theme idealized by a kind of aesthetic distance and the same theme made colloquial and familiar. "Sibylla," whose fate is described in the motto to Eliot's *The Waste Land*, appears in "O Earth Return" thus:

> Silence: the bat-clogged cave
> Lacks breath to sigh.
> Sibylla, hung between earth and sky,
> Sways with the wind in her pendant grave.

and in "The Plowman in Darkness" thus:

> I'm mercifully rid of youth,
> No callers plague me ever;
> I'm virtuous, I tell the truth —
> And you can see I'm clever!

In the last two sections the corresponding male figures appear. "The Sleepers," intensely pastoral in tone, is focussed on Endymion and his moon-loved daze, with overtones of Adonis and Adam. Then the figures of Noah and his ark emerge, expanding until they become identified with God and his creation respectively. The creation is inside its creator, and the ark similarly attempts to explain to Noah, in a series of epigrams in double quatrains, that it is really inside him, as Eve was once inside Adam:

> When the four quarters shall
> Turn in and make one whole,
> Then I who wall your body,
> Which is to me a soul,
> Shall swim circled by you
> And cradled on your tide,
> Who was not even, not ever,
> Taken from your side.

As the ark expands into the flooded world, the body of the Biblical leviathan, and the order of nature, the design of the whole book begins to take shape. *The Boatman* begins with a poem called "Ordinary People in the Last Days," a wistful poem about an apocalypse that happens to everyone except the poet, and ends with a vision of a "Fisherman" who, more enterprising than Eliot's gloomy and luckless shore-sitter, catches "myriad forms," eats them, drinks the lake they are in, and is caught in his turn by God.

Such myths as the flood and the apocalypse appear less for religious than for poetic reasons: the book moves from a "poor child" at the centre of a hostile and mysterious world to an

adult child who has regained the paradisal innocent vision and is at the circumference of a world of identical forms. In the title poem the reader is urged to follow this process as best he may:

> Then you take the tender creature
> — You remember, that's the reader —
> And you pull him through his navel inside out.

The wonderland of this Noah's ark inside Noah, where the phoenix and the abominable snowman have equal rights with books and eggs and the sun and moon, is explored in the final section: "The Fisherman: A Book of Riddles." The riddles are not difficult, the solutions being thoughtfully provided in the title, and, like so many of the Anglo-Saxon riddles, they are circumferential rather than simply elliptical descriptions, hence the riddle on "Egg" symbolizes the poet's relation to her reader as well:

> Reader, in your hand you hold
> A silver case, a box of gold.
> I have no door, however small,
> Unless you pierce my tender wall,
>
> And there's no skill in healing then
> Shall ever make me whole again.
> Show pity, Reader, for my plight:
> Let be, or else consume me quite.

Miss Macpherson chooses strict metres and small frames: she is, as the blurb says, melodious, but her melody is of that shaped and epigrammatic quality which in music is called tune. Within her self-imposed limits there is an extraordinary tonal variety, from the delicate *ritardando* of "The Caverned Woman" to the punning *knittelvers* of "The Boatman," and from the whispered *pianissimo* of "Aiaia" (the island of Circe) to the alliterative thundering of "Storm." She can — a noticeable feat in Canada — write a sexual poem without breaking

into adolescent pimples and cackles; she can deal with religious themes without making any reed-organ wheezes about the dilemma of modern man; she has a wit and an erudition that are free of wisecracks and pedantry; she can modulate in eight lines from "Philomel's unmeasured grief" to the human jay who

> Chatters, gabbles, all the day
> Raises both Cain and Babel.

The elegiac poems are the most resonant, and they make the strongest initial impression, though the lighter ones have equal staying power. There are few dying falls: usually a poem ends with a quiet authority that has a ring of finality about it, leaving the reader nothing to do but accept the poem — "Reader, take," as the riddle on "Book" says.

There is little use looking for bad lines or lapses in taste: *The Boatman* is completely successful within the conventions it adopts, and anyone dissatisfied with the book must quarrel with the conventions. Among these are the use of a great variety of echoes, some of them direct quotations from other poems, and an interest in myth, both Biblical and Classical, that may make some readers wonder uneasily if they should not be reading it with a mythological handbook.

One should notice in the first place that the echoes are almost invariably from the simplest and most popular types of poetry. They include Elizabethan lyrics ("While Philomel's unmeasured grief" sounds like the opening of a madrigal); the lyrics of Blake; hymns ("Take not that Spirit from me"); Anglo-Saxon riddles; Christmas carols ("The Natural Mother"); nursery rhymes ("Sheba"); ballads and newspaper verse ("Mary of Egypt" and the second "Sibylla"). The use made of these echoes is to create a kind of timeless style, in which everything from the tags of mediaeval ballad to modern slang can fit. One has a sense of rereading as well as reading, of meeting new poems with a recognition that is integrally and specifically linked with the rest of one's poetic experience. The echoes also enable the poet to achieve the

most transparent simplicity of diction. There is little of the "density" of more intellectualized poetry, and ambiguities and ironies are carried very lightly:

> In a far-off former time
> And a green and gentle clime,
> Mamma was a lively lass,
> Liked to watch the tall ships pass,
> Loved to hear the sailors sing
> Of sun and wind and voyaging,
> Felt a wild desire to be
> On the bleak and unplowed sea.

The flat conventional phrases here, including the Homeric tag in the last line, would seem commonplace or affected if their context had not been so skilfully worked out for them. It is true that for many readers there is nothing so baffling as simplicity, but Miss Macpherson's simplicity is uncompromising

As for mythology, that is one of poetry's indispensable languages: most of the major English poets, including the best poets of today, demand and expect a considerable knowledge of myth, and although Douglas LePan calls Canada a country without a mythology, the same thing is increasingly true even of Canadian poets. Miss Macpherson's myths, like her allusions, flow into the poems: the poems do not point to them. Knowing who Adam and Eve and Noah are will get one through most of the book, and although a glance at the opening page of Robert Graves's Penguin book on Greek myth might help with Eurynome, I find no poem that has the key to its meaning outside itself.

> Oh wake him not until he please,
> Lest he should rise to weep:
> For flocks and birds and streams and trees
> Are golden in his silver sleep.

For thousands of years poetry has been ringing the changes on a sleeper whom it is dangerous to waken, and the myths of

Endymion, of the bridegroom in the Song of Songs, of Adam, of Blake's Albion, of Joyce's Finnegan, are a few of the by-products. Such myths in the background enrich the suggestiveness of the above four lines, but the lines are not dependent on the echoes, either for their meaning or for their poetic value. Or again:

> The woman meanwhile sits apart and weaves
> Red rosy garlands to dress her joy and fear.
> But all to no purpose; for petals and leaves
> Fall everlastingly, and the small swords stand clear.

The reader who remembers his Milton, however vaguely, will see how the fall of sex from love to lust belongs in a complex which includes the first efforts at clothing, the appearance of thorns on the rose, the coming of winter after fall, the angelic swords over Paradise, and the aggressive use of sex which the phallic image of "small swords" suggests. But none of this would have any point if the quatrain itself did not carry its own meaning.

I have glanced at the critical issues raised by *The Boatman* because it seems to me a conspicuous example of a tendency that I have seen growing since I began this survey eight years ago. With the proviso that "professional" in this context has nothing to do with earning a living, the younger Canadian poets have become steadily more professional in the last few years, more concerned with poetry as a craft with its own traditions and discipline. The babble of unshaped free verse and the obscurities of private association are inseparable from amateurish poetry, but they are emphatically not "modern" qualities: serious modern poets in Canada struggle hard for clarity of expression and tightness of structure. The second volumes of Douglas LePan, P. K. Page, and James Reaney (of whom more next year) show this markedly, as do the first volumes of Wilfred Watson and Anne Wilkinson, and all the volumes of Irving Layton since *In the Midst of My Fever.* It is consistent with this that the more amateurish approach which tries to write up emotional experiences as they arise in life or

memory has given way to an emphasis on the formal elements of poetry, on myth, metaphor, symbol, image, even metrics. The development is precisely parallel to the development in Canadian painting from deliberately naive landscape to abstraction and concentration on pictorial form. As in 1890 with the Scott-Lampman-Roberts group, and again in the *New Provinces* generation, there seems to be once more in Canadian poetry, on a much bigger scale, a "school" in its proper sense of a number of poets united only by a common respect for poetry.

The title of Daryl Hine's *The Carnal and the Crane* (McGill Poetry Series, 52 pp., $1.50) comes from a ballad in which two birds (carnal in this context means *corneille*, crow) discuss the Incarnation. The *double entendre* in the word "carnal" suggests the theme of the dialogue of soul and body as well, and in connection with "crane" one very astute critic, Mr. Milton Wilson, has murmured the name of Hart Crane. Abandoning speculation, we find *The Carnal and the Crane* also a carefully planned book, leading up to and moving away from a central poem called "The Return from Unlikeness," a group of three dialogues on the Nativity. I take it that "unlikeness" is here used in its Augustinian sense of remoteness from God, by way of the conclusion of Auden's *For the Time Being*, so that a return from it, which the Incarnation makes possible, would be the achieving of a total identity, a universal homecoming in which everyone, including Judas Iscariot, goes to his own place.

We begin with the three kings, representing the three aspects of wisdom: wonder, trust in love, and distrust of unaided reason, confronting Herod. Herod agrees on the importance of finding

> . . . the silent centre of private wars
> of blind men who can't imagine all the stars.

But for himself he himself occupies that centre and cannot move out: in other words he is spiritual pride, the demonic centre in Everyman whose vision is despair. The second part deals with the shepherds, who by a most ingenious modula-

tion are identified with the Corydon and Alexis of Virgil's second eclogue. Virgil is traditionally a prophet of the Incarnation, but it is a very different eclogue that has made him so. Corydon and Alexis are also associated with Cain and Abel, destructive passion and its shepherd victim, and with the warning "armed head" of the witches' vision in *Macbeth*, which we remember was followed by a bloody child and a crowned one. The third dialogue deals with the Annunciation and the jealousy of Joseph. Against the invisible appearance of the Child is set the collapse of earthly power, symbolized by the recent assassination of Caesar, a theme developed later in a fine series of sonnets called "At Pompey's Statua."

The climax of the book is a series of three poems, of which the first two concern a "fat boy," a poet, seen first from the outside by his friends who bury him, and then from the inside as an unconscious denizen of Eden. The poet dies

> declaring that the universe was tandem,
> not single, quod erat demonstrandum.

Tandem means among other things fallen, and we hear a great deal about the "January apple," the twisting of love into lust, the fatality of the "father," and similar *topoi*. Mr. Hine's fallen world is an underworld of death and rebirth, many of its features derived from the sixth book of the *Aeneid*. It is associated with autumn and winter, the hunting season and "The air grown perilous with falconry," when Orion, the hunter and the winter constellation, lover of Aurora and type of cyclical rebirth opposed to the dialectic of resurrection, presides over both love and death. It is the world of "Avernus," where Aeneas, in one of the most eloquent poems in the book, wanders talking to the shadow of the silent Dido, and where sex is represented by the wound of Adonis. It is a world full of ferocious birds and beasts of prey, a "flood of animals" like those Dante fled from, including the wolf who "is time," and which in the aggregate are Cerberus, the watchdog of death, whom the friends of the fat boy assume to have swallowed him. We reach this world by being ferried over the Styx by Charon, who also haunted

Mr. Hine's earlier *Five Poems*. But a more concentrated look shows that Avernus is really a water-world *under* the Styx, the world that has never recovered from the deluge. In "The Boat" and "The Lake" (a frozen lake, modulating the water symbol to ice) this water-world expands into what Mr. D. G. Jones, of whom more in a moment, calls the more frequented and practical pool of Narcissus.

This world, then, *is* the pool of Narcissus: what goes on in it is the dreamy reflection of reality into which Adam fell, the hypnotized imitation of life by the ego. Marriage, for instance (see "Epithalamium," one of the most equivocal poems in that genre I have ever read), introduces lovers to an Elysium which is the reflection of Eden, but full of serpents and bitter fruits. What the flood did the fire shall overthrow, and the redemption of this world by Christ is usually symbolized by fire, the fiery furnace and the burning bush that burn without destroying, and in which reflections find their own true forms: "Lent's end in Easter, water's in ice that shone."

There are great inequalities in the success with which Mr. Hine expresses all this. "The Return from Unlikeness" seems to me a poetic exercise, not a realized poem, and I have no hesitation in calling "The Entombment" a positively bad poem, because no mediocre poet can be positively bad. I doubt if any Canadian poet has potentially greater talents than Mr. Hine, and few in recent years have struck out more vivid and haunting lines, lines that can become part of one's permanent reading. As we eavesdrop on the murmuring dialogues going on in the poet's mind, every so often a voice speaks, like Friar Bacon's head, with oracular simplicity and power. But these lines are often embedded, like Jack Horner's plums, in a context of rather soggy verbiage. Thus:

> . . . hero turns
> to Christmas Eve where Southwell's infant burns —
> heat as continence! fire as innocence!
> and the offended eye goes dark in marvels,
> while the heart asks of its thorns
> the sort of alchemy that transfigures peril.

The reference to Southwell's *Burning Babe* is creaky but passable; the next line is a fine comment on it; the third line is superb; the fourth and fifth are blither. One still, in speaking of *The Carnal and the Crane*, has to speak of expendable poems, of great advance, of promise and future achievement. These are not, to be sure, small things to speak of.

It is disturbing to find that, after the "fat boy" poems have reached some kind of synthesis, the final poem, "The Farewell," is still muscle-bound and squirming, and one feels the truth of the poet's remark:

> Only gargoyles leaning out of dogma,
> elements of doubt in faith's alloy,
> deny the gravitation of belief,
> defy the forts and pass the last frontiers.

But it is not the gravitation of belief that is the difficulty of using religion as metaphors for poetry: it is rather (apart, of course, from the superficial temptation to easy resonance) the rigidity of the construct from which the gargoyles lean. Christianity is held together by doctrine, compelling the poet to the struggle of digesting abstractions. One feels that the decentralized mythology in Miss Macpherson (to whom *The Carnal and the Crane* is dedicated) at any rate permits of a more relaxed and spontaneous poetic process. However, that is a technical obstacle only, and one that Mr. Hine is well equipped to surmount. More important, the modern religious poet is apt to confuse inspiration with a state of grace, and feel that it is safer to renounce the full authority of poetry and keep ironically swimming around with all us other poor fish. See Eliot and Auden, more or less *passim. Facilis descensus Averno,* and Mr. Hine clearly has no interest in being facile. He has a grotesque wit, of a kind that takes the stock example of vulgarity, the replica of the Venus of Milo with a clock in her stomach, and expands it into "Venus big with time," and we may look forward to a poetry of released powers and flying gargoyles.

D. G. Jones's *Frost on the Sun* (Contact Press, 46 pp., $1.50) shows a talent of considerable force emerging from some

undistinguished competence. There are a few rather laboured conceits, like "Public Figure," "Death of a Hornet," and "Clothesline"; the rare allusions to myth, in striking contrast to the two previous poets, are not made with much conviction, and an occasional flash of wit, like the description of a "Faculty Party" as "a matter of oral adventure" does not always prevent a poem from sagging into commonplace. These peripheral points noted, what remains is for the most part an intensely pictorial poetry, with reference to Marin, Klee, Hokusai, and the Chinese, the favourite subject being birds, which Canadian poetry seems to be strongly for this year. "Do poems too have backbones?" the poet asks in a poem called "John Marin," and he clearly knows the answer. In "A Problem of Space" he speaks of the power that a poem, like a picture, can gain by sketching in the essentials only, "Leaving all the rest to space." Poetry of course has the problem of rhythm in addition to that of pattern, and I think Mr. Jones succeeds most completely in his economical and disinterested ambitions when he is less preoccupied with visual design and lets his rhythm work itself out. In "Request" and "Soliloquy" a lilting variable rhythm sustains itself to the end — a notable achievement in free verse, which is so apt to cripple itself by cutting off its feet, like the dancer in Andersen's fairy tale. In "The Phoebe" the rhythm follows the fluttering movements of the bird, and in " The Time of the Fictitious 'I'" it follows the subject:

> Sometimes we are shattered. The
> > coherence gone, the planets of our brain
> > sail loosely in their microcosmic air.
> Sometimes we can
> > pick up nothing, start nothing;
> poise lost, stance lost,
> > neither in the wind nor out of it
> we must wait, on choppy seas,
> > till the wind turn,
> > till the moon come round,
> and wind and tide, again, draw on.

To write like this a poet has to be indifferent to his own cleverness, and achieve the kind of higher detachment in which genuine sympathy and insight become possible. There are deeper tones in the book, in "Desire is Not Lust," in "Strange Characters for Christmas," in "At Twilight in the Park," which make one hope that eventually such words as serenity and wisdom may be appropriate for this poet. "Strange Characters for Christmas" has a fine haunting phrase about "the silent bleeding of small human lives," and is written in quatrains in which the first and third lines rhyme and the second and fourth do not, giving the effect of a precise twist:

> And remember now the falling night
> And the years of the darkening Lord of Love
> And the illusive April of Platonic Light
> And the fiery winter of mechanic power.

"At Twilight in the Park" shows that it is possible to be delicate without being sentimental, and "November, Gananoque," despite a bad line or two, that it is possible to make something out of ugliness and boredom — no poet in this century can avoid that technical problem — without being cute.

Alfred W. Purdy's *Emu, Remember!* (Fredericton, Fiddlehead Poetry Books, 1956, 16 pp.) is conversational lyrical verse, less formally precise than his earlier work. It is quite skilful in the use of slant rhymes in "Poem" and "Elegy for a Grandfather," if more hampered by stock phrases of the "forest of always Sunday" type. The tone is strongly personal, as the poet tends to see nature as a wilderness of self-reflecting mirrors, whether it presents "halls of trembling glass" on shipboard or "vectors of light" at sunrise. In this situation one is in danger of going backward into the pure narcissism of nostalgia. The poet's distrust of this is marked in the phrase:

> . . . time is a wound
> Delivered when new things can't strike flame

and in the self-discoveries of "Cantos" and "Contraband." The

forward direction is the subject of two of the best poems, "Post Script" and "The Cave Painters." The cave painters, we are told:

> Having discovered an ache in the loins
> A clarity of colour, shores beyond their shores,
> Become inhabitants of loneliness and applicants
> To leave the mind-prison, be dissolved
> In the myth's creation and absorbed.

We may assume that this indicates the direction that Mr. Purdy's future writing will take, perhaps in fiction, as the biographical note suggests, where he will have a chance to recapture the more objective and dramatic qualities of his earlier work that are largely missing from this collection.

Three Dozen Poems, by R. G. Everson (Montreal, Cambridge Press, 51 pp., illus., $3.00), illustrated by Colin Haworth, with drawings "done with lamp black and a dry hog's hair brush," is amateur verse at its best — limited in its objectives, amused and amusing, unfailingly urbane, and with the primary aim of being pleasant to a reader. All the poems are brief epigrams in a cultivated speech in which life and literature meet on equal terms. Thus a vision of "Lovers under Parliament Hill," ending with the reflection that "lovers possess the world while overthrown," suggests Themistocles and Landor by contrast. Sometimes the wit increases to brilliance:

> In a dark house that they passed
> A telephone hunted with magical empty sounds,

the context of this being a crowd leaving a theatre after a performance of *The Tempest.* More deeply disturbing tones than this do occur, as in "Comical Sun," but they are rare. There is a conventional but nicely turned irony in "Coming Home in Winter" and "The Fishermen," and vigorously sketched imagery in "Late-August Breeze":

> A belly-low wolf breeze
> pursued a thistledown whose untied hair

and white face curved above the cattle-bellowing
lawn chairs. The leaves like fishes
turned death-white undersides. We later found
nothing was hurt except the feel of Summer. . . .

The other publications of the year are retrospective. *The Blasted Pine: An Anthology of Satire, Invective and Disrespectful Verse* (Macmillan, xx, 138 pp., $3.50) is edited by F. R. Scott and A. J. M. Smith. It is no surprise to readers of Canadian poetry that so unusually large a proportion of it should be satire and light verse. Canada's place on the revolutionary sidelines of the United States, and its status as a small nation between huge empires, determined that bent in our genius long ago. But still it took very expert scholarship and critical judgment to produce a book like this, which not only features such regular satirists as McLachlan, Glendinning, O'Grady, Leacock, and Hiebert, and such largely satiric poets of our day as Birney, Louis MacKay, Souster, Layton, Dudek, and Klein, but also isolates a most lively element from Pratt, Lampman, Wilson Macdonald, and many others, including of course the two editors. A few non-Canadian poems are included, notably Samuel Butler's "A Psalm of Montreal." Some questions suggest themselves. Are there no satiric folk songs? No poetic wits born of political controversy in the newspapers, especially in the previous century? Why is the religious satire exclusively Protestant: don't Canadian Catholics ever laugh at themselves? Is it editorial predilection or Canadian poetry that admits so little right-wing satire? Where is Pamela Vining Yule, that engaging discovery of the first edition of Mr. Smith's anthology? Meanwhile the book we have is delightful.

The Eye of the Needle (Contact Press, 71 pp., $2.50) is a collection of F. R. Scott's "satires, sorties and sundries," i.e., the light verse of one of our best light verse writers. There are a few new poems, but the majority are well known to readers of Canadian poetry. It is good to have them together. Many of them were inspired by the depression and allied events, and, appearing now in the full tide of the capitalist counter-reformation, with the political principles they support

obviously heading for the limbo that swallows all political prin-
ciple on this continent, they have an oddly desperate air. But
they are not, as the poet himself notes, out of date: rather they
remind us of all the things that we are zealously trying to for-
get: unemployment, exploitation, social and cultural snobbery,
the unscrupulousness of the press, the middle-class hypocrisy
that asserts that only striking workers are being selfish, the help-
lessness of the intellectual, and the fact that most of the
guardians of our destinies are exactly as stupid and
ill-informed as they appear to be.

Dorothy Livesay is a poet who has remained within a single
convention, though with modulations. *Selected Poems 1926–1956*
(Ryerson, xxii, 82 pp., $3.50) is a retrospective exhibition of
Miss Livesay's five volumes of verse, with an introduction by
Professor Pacey. The book is really her collected poems, with
some omissions: I do not know, for example, why the epilogue
to "The Outriders" is simply called "Epilogue." Miss Livesay is
an imagist who started off, in *Green Pitcher* (1929), in the Amy
Lowell idiom:

> I remember long veils of green rain
> Feathered like the shawl of my grandmother —
> Green from the half-green of the spring trees
> Waving in the valley.

The virtues of this idiom are not those of sharp observation
and precise rhythm that the imagists thought they were pro-
ducing: its virtues are those of gentle reverie and a relaxed cir-
cling movement. With *Day and Night* (1944) a social passion
begins to fuse the diction, tighten the rhythm, and concen-
trate the imagery:

> Day and night rising and falling
> Night and day shift gears and slip rattling
> Down the runway, shot into storerooms
> Where only eyes and a notebook remember
> The record of evil, the sum of commitments.

From "Prelude for Spring" on, the original imagist texture gradually returns, and is fully re-established by the end of the book:

I dream of California, never seen:
Gold globes of oranges, lantern lemons,
Grapefruit moving in slow moons,
Saucers of roundness
Catapulting colour.

Imagism tends to descriptive or landscape poetry, on which the moods of the poet are projected, either directly or by contrast. The basis of Miss Livesay's imagery is the association between winter and the human death-impulse and between spring and the human capacity for life. Cutting across this is the irony of the fact that spring tends to obliterate the memory of winter, whereas human beings enjoying love and peace retain an uneasy sense of the horrors of hatred and war. That man cannot and should not forget his dark past as easily as nature I take to be the theme of "London Revisited," and it is expressed more explicitly in "Of Mourners":

Not on the lovely body of the world
But on man's building heart, his shaping soul.
Mourn, with me, the intolerant, hater of sun:
Child's mind maimed before he learns to run.

The dangers of imagism are facility and slackness, and one reads through this book with mixed feelings. But it is one of the few rewards of writing poetry that the poet takes his ranking from his best work. Miss Livesay's most distinctive quality, I think, is her power of observing how other people observe, especially children. Too often her own observation goes out of focus, making the love poems elusive and the descriptive ones prolix, but in the gentle humour of "The Traveller," in "The Child Looks Out," in "On Seeing," in the nursery-rhyme rhythm of "Abracadabra," and in many other places, we can see what Professor Pacey means by "a voice we delight to hear."

The Selected Poems of Marjorie Pickthall (McClelland & Stewart, 104 pp., $3.00) has an introduction by Dr. Lorne Pierce. The introduction is written with much sympathy, but tends to confirm the usual view of this poet as a diaphanous late romantic whose tradition died with her. "With Marjorie Pickthall the old poetic tradition in Canada may be said to have come to its foreordained end. It came to its end at Victoria College. With a young student, E. J. Pratt, who borrowed books from the Library where Marjorie Pickthall was assistant, the new tradition began." Dr. Pierce knows far more about Marjorie Pickthall than I do, but still I have some reservations about this. She died at thirty-nine: if Yeats had died at the same age, in 1904, we should have had an overwhelming impression of the end of a road to Miltown that we now realize would have been pretty inadequate. Marjorie Pickthall was, of course, no Yeats, but her Biblical-Oriental pastiches were not so unlike the kind of thing that Ezra Pound was producing at about the same time, and there are many signs of undeveloped possibilities in this book. For some reason I had not read her little play, *The Wood Carver's Wife*, before, and I expected to find it Celtic twilight with a lot of early Yeats in it. It turned out to be a violent, almost brutal melodrama with a lot of Browning in it. Also, it is an example of a very common type of critical fallacy which ascribes to vagueness in her theoretical grasp of religion what is really, at worst, second-hand Swinburne, and, at best, the requirements of her genre. When she writes of Père Lalemant she is subtle and elusive, not because her religion was fuzzy, but because she was writing lyric; when Pratt writes of Brébeuf he is dry and hard, not because his religion is dogmatic, but because he is writing narrative. Anyway, I think she handed rather more over to Pratt, besides library books, than simply her own resignation. . . .

1958

James Reaney's *A Suit of Nettles* (Macmillan, pp. x, 54, $3.00) is a series of twelve pastoral eclogues, one for each month of the

year, modelled on Spenser's *Shepherd's Calendar.* The speakers are geese, and the tone is that of satire: there is a prelude addressed to the muse of satire. The themes are also reminiscent of Spenser: we have love songs (February), elegies (June and October), singing-matches (April and August), dialogues (January and July), fables (March), fabliaux (May), and a *danse macabre* (December). We begin in January with a Yeatsian dialogue between two geese, Mopsus and Branwell, in which the former, after making a fine caricature of the contrast between sacred and profane love, advocates forsaking both Elijah and Jezebel and adopting a calm rational view of the world, as white and sterile as the winter landscape. Branwell however protests that he wants "offspring summerson autumnman wintersage," and so the theme of fertility and sterility, the main theme of the poem, is announced. Sterility is symbolized in May by two lady experts in contraception who insist on tying up their husbands in "sheets of tight Glass, beaten gold, cork, rubber, netting, stoppers, sand," but who get pregnant in spite of it. In July it is represented by a progressive education maniac, with his hatred for mental order and for the learning habits that build it up. August introduces a third emasculate, a literary critic who has mastered the easy trick of giving the illusion of raising his standards by limiting his sympathies. The theme of fertility appears in the two spring songs of April, with a contrast of white-goddess and sleeping-beauty myths. The names of the singers, Raymond and Valancy, suggest an oblique commentary on the symbolism of two earlier Canadian poets, Knister and Isabella Crawford.

The first experience awaiting Branwell as he plunges into the cycle of the year is to be crossed in love, an experience that produces the melancholy songs of June and October, and is apparently the reason for his wearing a suit of nettles, which seems to represent life in the world of Eros or natural love, a mixture of stimulation and discomfort. At the end of the year is Christmas, to which the geese are ruthlessly sacrificed: this approaching débacle hangs over the whole book, and gives it a larger human dimension. One can hardly call this allegory, as no one expects such a poem to be an uncomplicated story

about geese. A religious theme is developed through the March fable, indicating that religion, like art and love, is a weapon of consciousness against death. This theme comes into focus in November, where, after three birds sing of the natural cycle from the perspective of winter, spring, and autumn respectively, Mopsus, the rationalist of January, introduces the symbolism of Christmas, which has to go here in view of the theme of the December eclogue:

> At the winter sunstill some say
> He dared be born; on darkest day
> A babe of seven hours
> He crushed the four proud and great directions
> Into the four corners of his small cradle.
> He made it what time of year he pleased, changed
> Snow into grass and gave to all such powers.

The climax of the book comes in the extraordinary firework show of September, a description of "Mome Fair." In Spenser mome means bumpkin and in Lewis Carroll it means away from home, but this is an ordinary small town fair in Ontario with its sideshows, ferris wheels, prize animals, freaks, and merry-go-rounds. The ferris wheel is here associated with a series of images from *The Golden Bough*, to which *A Suit of Nettles*, a story of a cycle of the year ending in a sacrifice, has obvious affinities. The merry-go-round illustrates the progress of human thought as it goes around its circle from Parmenides to Heidegger and so back again: this episode indicates a strong influence of the "vicous cicle" of *Finnegans Wake* on Mr. Reaney's book. The "funhouse" is "an attempt to compress Canadian history and geography into a single horrific scenic railway ride," as the author puts it, and is a series of emblematic riddles. Thus "an old Indian's skin is turned into horsewhips and shoelaces" refers to the death of Tecumseh, and "The train comes to grief in a drift of flour-dough" to the Titanic. At this point we become aware of the many links between the story of the geese and the story of Canada, the geese's Christmas being paralleled by the

appalling massacres of Canadians which result from the quarrels of Europeans. A drunken preacher sums it all up with a brief sermon on the two hanged victims, Jesus and Judas Iscariot.

Spenser intended his *Shepherd's Calendar* to be something of a stunt, a display of professional competence in a field which at that time was largely monopolized by easy-going amateurs. Similarly Mr. Reaney puts on an amazing technical show. The metres include a long ten-line stanza with four rhymes and an Alexandrine at the end in the first three months; a sestina in February, octosyllabic couplets in March, a variety of poul-terer's measure, with strong rhymes against weak ones, in May; dialogue prose in July; alliterative verse and catalogue prose (which is really a form of verse) in September, blank verse in December, and of course every variety of lyrical stanza, from the quatrains of May, June, and October to the complicated songs of April and August. Spenser got a friend to edit his book and provide an introduction and annotations: Mr. Reaney does his own editing, but invites commentary, not because he is pedantic or obscure, but because he has so much of the quality that is the opposite of pedantry, intellectual exuberance. Spenser's was a courageous effort, and met with a good deal of opposition from poets who complained that he "writ no language." Mr. Reaney's book will no doubt seem to many readers to have only too apt a title, to be bristly, forbid-ding, and irresponsibly inwrapped; or, in the words of his own goose-critic:

> No real emotion, no language of the people,
> Immoral in its basic avoidance of simplicity.

But at a time when most poets write, however unconsciously, with one eye on the anthologist, it takes a good deal of courage to work out a scheme like this — a Stratfordian courage, of the kind that took *Tamburlaine* to Broadway.

Courage, however, is often the only virtue of failure, and *A Suit of Nettles* is a remarkable success. Just how remarkable it is too early yet to say. Anyone familiar with the puckish

humour and twisted fantasy of Mr. Reaney's earlier volume *The Red Heart* might expect to find long passages in *A Suit of Nettles* where the poet is only playing around. The more one rereads the book the more one is convinced that there are no such passages. In February, for instance, we wonder why the tricks of inverted constructions and final spondees are used so persistently, until we see what fidelity they give to the fluttering movements of a bat:

> He hangs from beam in winter upside down
> But in the spring he right side up lets go
> And flutters here and there zigzagly flown
> Till up the chimney of the house quick-slow
> He pendulum-spirals out in light low
> Of sunset swinging out above the lawns. . . .

Similarly with the lovingly meticulous description of a cow in the alliterative verse of September. And while the line of narrative is easy enough to follow, a little study of the imagery will soon reveal a Joycean complexity of cross-reference and interlocking symbolism.

I have no space, with a dozen books still ahead of me, to dwell on the innumerable felicities of the writing. I will say only that I have never read a book of Canadian poetry with so little "dissociation of sensibility" in it, where there was less separating of emotion and intellect, of the directly visualized and the erudite. There are breath-taking flashes of wit, like the sexual image in January, "This stake and heart-of-vampire sexual eye of ooze"; there are moments of poignant beauty like the conclusion of June or the winter song in November; there are farce, fantasy, region, criticism, satire, all held together in a single controlling form. Mr. Reaney has not tried to grapple with contemporary life in the raw, but merely to perfect his poem. And — such is the perverse morality of art — he has succeeded, as I think no poet has so succeeded before, in bringing southern Ontario, surely one of the most inarticulate communities in human culture, into a brilliant imaginative focus.

The core of John Glassco's *The Deficit Made Flesh* (McClelland & Stewart, "Indian File Books," No. 9, pp. 64, $3.50) is a series of poems about rural life in that northern spur of New England known as the Eastern Townships. One might expect such a poet to sound like a Canadian Robert Frost, but Mr. Glassco doesn't, and I mention Frost only for contrast. Mr. Glassco's ground bass, so to speak, is the driving human energy that settles down to wrest a living from this harsh land, where

> while the eternal mountains stand,
> Immortal stones come up beneath the plough.

Under the grinding pressure of work in such a country the farmer is reduced to "rotten fenceposts and old mortgages," which is "No way of living, but a mode of life." Such a mode of life is based on necessity but behind the necessity is what the poet calls "The structural mania of the human heart," the lunatic compulsion to take thought for the morrow and keep rebuilding the Tower of Babel. There are several images of an exhausting uphill journey that gets one nowhere in particular and of dying coals blown into renewed heat by an alien power. We see how a feverish vision of a paradise of conquered nature forces generations to wear themselves out to construct and maintain a "Gentleman's Farm" or a "White Mansion." The latter, as the poet describes it, takes on something of the malignancy of a white goddess:

> Two hearts, two bodies clove, knew nothing more.
> Ere I was done I tore them asunder. Singly
> They fled my ruin and the ruin of love.
> I am she who is stronger than love.

Against this blinkered will to power are set those who have refused to be propelled by it. There is the "deficit made flesh" who gives the book its title, an old bum left on the hands of a town council meeting, whose helplessness inspires them with what the poet sardonically calls "The rainbow-vision of a lethal

chamber." In "Deserted Buildings," the poet meditates on the problem of the picturesque, the emotional response we give to ruined or deserted buildings like the "falling tower" of another poem which is the timing-tower of a race track. Perhaps our affection for such things has something to do with our sense of the latent irony in the illusions that drive a man to follow "his blind will to its end in nature." In "Stud Groom" the irony sharpens: the stud groom has renounced all ambition to live beyond the round of "another race, Another show," and as a consequence has given up everything that the world considers morally valuable for the sake of

> . . . an instant that lasts forever, and does no harm
> Except to the altar-fated passion it robs,
> The children it cheats of their uniforms and wars,
> And the fathomless future of the underdog
> It negates — shrugs off like the fate of a foundered mare.

Mr. Glassco is technically a very able poet, who can manage anything from villanelles to blank verse which, in "The White Mansion," he makes into stanzas by repeating the cadence of a line. The dactylic hexameter, for all its classical glory, seems in English to be good only for the most pastel kinds of romantic nostalgia, as in *Evangeline,* and it was an accurate sense of parody that chose it for "The Burden of Junk." The finest poem in the book, I think, is "Gentleman's Farm," where the alternating long and short lines of the stanza give a heavy thrust-and-relax rhythm, supported by the alternating of short words in description and longer ones in comment, and develop a most impressive cumulative power.

In some other poems of the book we move from the Eastern Townships into the mythical and religious archetypes that the poet has found embodied there. The white mansion thus expands into Penelope and her web in "The Web," and the structural mania of the human heart is illustrated in two sonnets called "Utrillo's World": I don't care for the second, but the first is a moving and eloquent poem. The driving force of life is connected with the Freudian imago or admiration

of the father, which is projected in religion as "Nobodaddy" (Mr. Glassco adopts Blake's term for the sulky bewhiskered sky-god of popular piety). This father-figure is explored psychologically in "The Whole Hog," and in "The Entailed Farm" the poet speaks of the adjustment of maturity reached by those

> Who composed our quarrel early and in good season
> Buried the hatchet in our father's brain.

In "Shake Dancer" we have a fine conceit in which the figure of the dancer is gradually transformed into the outline of her dance, the "man of air" that complements her erotic movements.

I do not find Mr. Glassco's book uniformly satisfying: the echoes of Donne in "A Devotion" bother me and I have so far missed the point of the ballad on the death of Thomas Pepys. But on the whole *The Deficit Made Flesh* exhibits a most unusual poetic intelligence and talent.

The title of Ronald Everson's *A Lattice for Momos* (Contact Press, pp. 58, $2.00) is a reference to the legend that Momos, unaware of the function of poetry, criticized the human body for its lack of a window that would reveal thoughts and emotions. This is Mr. Everson's second volume, and we learn that he has returned to writing poetry after an abstinence of a quarter-century. It is perhaps a consequence of this that his writing shows so much freshness, with a highly sophisticated naivete, as though such things as metaphor and metre were being discovered for the first time. In "L'Abbé Lemaitre's Universe" he spins a delicate web of seven quatrains around three rhymes; there are skilful slant rhymes in "One-Night Expensive Hotel" and initial rhymes in "Winter at Lac des Deux Montagnes"; "Fish in a Store-Window Tank" has the first quatrain and the sestet of a regular sonnet that isn't a regular sonnet, and he has a feeling the primitive mystery of the sound and sense of words that comes out in the very lovely "Christening" at the end of the book.

He is similarly able to exploit the fact that anything goes in

metaphor: in three poems he is dead and takes a corpse-eye view of life; in another he is the waves on a shore; in "June 21" he says:

> I laugh while huge reality
> a mindless lout, summersaults for my pleasure.

There is a reminiscence of Wallace Stevens in his bright intellectual precision, and, like Stevens, he has the knack of making the title of a poem a part of the poem itself, as in the fine quatrain which bears the title "To the Works Superintendent on his Retirement." Often an epithet or two will give an ordinary poetic conceit a new dimension of significance, like "Letter from Underground," which tells how young colts are shocked by an electric fence that "underprivileged beetles" crawl under undisturbed. Sometimes we get irony through the honesty of a simple description:

> A conformist
> in bluejeans-crewcut plays bold pioneer
> with a capgun.

His main theme is that of the innocent vision, the "original sin of childhood rapture," which in adult life operates as love. Love is an irrational emotion that makes more and more sense as the world that is supposed to be sensible is gradually distorted into the illusions of fear and the anxieties of a desperate ritual:

> A large wild animal
> prowls outside my office.
> I chant Audograph incantations
> and, bowing, drum the typewriter.

Similarly, the certainties of immediate experience and the "pleasure-principle," the feeling that one is the centre of the universe and the conductor of a universal orchestra (see "Corduroy Road through the Marsh") build up in proportion as

time and space dissolve into relativity. In "Fall of the City" the fall of Rome and of our own civilization are simultaneous; in "Fish in a Store-Window Tank" the poet is contemporary with his caveman ancestors; elsewhere we read of "darting slow-poke swallows" and of an aeroplane travelling "childhood-slow." Such themes are common enough among poets, but are not often handled with such unfailing good humour and intelligence. The book is also illustrated with drawings by Colin Haworth. The illustrations are said only to "match the moods" of the poems, but in most cases they do illustrate them, and very pleasantly.

Irving Layton's *A Laughter in the Mind*, published by Jonathan Williams, Highlands, North Carolina, in 1958, was reissued, with twenty additional poems, in February 1959, by the Editions d'Orphée of Montreal (pp. 100). This enlarged version is the one reviewed here. There is, as usual, an astonishing variety of themes and techniques, and it is difficult to make a generalization about the place of this book in the author's development. There is perhaps more consistent interest in strict metres — witness the blank verse of "Cain," the nine-syllable line of "Climbing," the irregular couplets of "A Roman Jew to Ovid" and "Laurentian Rhapsody," the lucidly simple stanzas of "Two Songs for Sweet Voices" and the curious Heine-like "Rain," and the easy lilt of "Dance, My Little One" and the third stanza of "Poem for the Year 2058":

> This is the house the jacks built
> Out of hemlock and gilt:
> The saints and lovers are dead
> And all is common as bread.
> Now none believe in greatness,
> The dwarfs possess the bridges.

The central themes of Mr. Layton's poetry are here too. Apart from the personal poems and satires, which are of more ephemeral interest, there is the sympathy with animals which makes their suffering, or even their physical expression, a mirror of human guilt, as in "Garter Snake," "Sheep," "Cat

Dying in Autumn," and "Cain" — this last on the shooting of a frog. There is a delicate vein of fantasy in two of the best poems in the book, "Venetian Blinds" and "Paging Mr. Superman." The latter tells us of the magic effect of this name even when pronounced in a dreary hotel lobby by a pageboy more familiar with comic strips than with Nietzsche or Shaw:

> This was the cocktail hour when love
> Is poured over ice-cubes and executives
> Lay their shrewdest plans for the birth of twins
> With silver spoons. . . .

The general point of view in the book is Nietzschean: the conception of the "outsider," however vulgarized it may have been recently, is still a real conception, and to Mr. Layton the poetic imagination leads one outside society, where one can turn back and see the world writhing in its own hell of selfishness and malice:

> How the loonies hate each other
> How they jeer & grunt & swear,
> Their sullen faces happy
> When another's wound they tear.

The way of "Jesus and Buddha," whose symbol is the "leprosarium," is to return to this world and work in it; the way of the poet is to keep clear of it, at least imaginatively. The reward of keeping clear of it is joy, the result of accepting life without a death-wish in it. Joy is not created by merely releasing one's sexual inhibitions, as the irony of "Obit" and "Enigma" warns us; and it is something very different from pleasure. It is what the poet calls, in the Yeatsian "Parting":

> A laughter in the mind
> For the interlocking grass
> The winds part as they pass;
> Or fallen on each other,
> Leaf and uprooted flower.

"I must bone up on Parmenides," the poet says: in the mean-time his imagery is Heraclitean. Fire and dry light are the symbols of the laughter of the mind, watching the world burn up its rubbish; mist and damp are the symbols of the dying and life-hating world. Thus in "Love is an Irrefutable Fire" we have the contrasting images of moon and cloud, street-lamp and black air. The two symbols come together in the fine opening poem, where the mist is the poet's mortality, like the waves that reminded Canute of the limits of his power. In this poem the poet is a clown, buffoon, or starving minstrel, for in Mr. Layton genuine dignity is closely allied to the ridiculous.

Raymond Souster's *Crêpe-Hanger's Carnival: Selected Poems, 1955–58* (Contact, pp. 65, $1.00) is a mimeographed collec-tion of poems in his usual epigram form. As compared with his earlier collections, the rhythm is tighter, and there are fewer poems that read like prose *collage*; the imagery is more accurate and objective, a little poem called "The Cobra" being evidence of Mr. Souster's awareness that his chief virtue is in objectivity. It is still true that the most emphatic poems are also the most perfunctory ones, and there is still a good deal of the moral exasperation that paralyses every comment except the most obvious one. But, as the title suggests, there are a good many poems about death, some of them, especially "The Deaths," very eloquent, and they help to deepen and give seriousness to the book. On the other hand, "The Grey Cup," "Cat on the Back Fence," and "The Goat Island Poetry Conference" show a gift for sardonic fantasy that Mr. Souster does not indulge in nearly often enough, and many sparks and crackles in the imagery suggest that for this poet the act of writing has become less of a relief and more fun:

> Why, he treated that hound
> Better than his wife,
> Or so she tells me.

Occasionally, as in "The American in Montreal," or "Two Pictures of Bay Street," a brief sketch has emotional ripples that spread into a much larger area of significance, as has a

curious little poem called "The Switch," depicting a Utopia in which the *parents* have to search for eggs on Easter morning. There are also — rare in Mr. Souster — flashes of verbal wit, like his reference to the spear thrust into the side of Christ "For Auld Lang Synne." He will even desert his social conscience long enough for an occasional metaphysical conceit, as in "Summer Evening," or "That Shape in the Fog," which is apparently the fog itself.

However, the main impact of the book is to be found in Mr. Souster's study of the dereliction in a modern city: old men muttering to themselves or snatching cigarette butts from snow-cleaning machines, drunks, suicides, patients in hospitals, a blind beggar on a street corner "Watching the darkness flash by," prostitutes, neglected children. They are nearly always inarticulate or silent, for they live in a world of submerged consciousness which they share not only with animals but with trees, buildings, and litter like the old tin kettle which has, the poet says:

> . . . that discarded look which moves me to pity
> In people, animals, things.

Such a conceit might seem faked, but in Mr. Souster's world, where human beings are on so rudimentary a level of consciousness, it is more plausible that subhuman life, or human artifacts like wrecked buildings, should express a good deal of human feeling. Hence such poems as "Sucker Run," "The Wreckers," "The Tree," and "Shea's Coming Down."

Louis Dudek's *En Mexico* (Contact, pp. 78, $1.50) is a long fragmented poem, less ambitious than *Europe*, but in my opinion more successful and better unified. It gets away to a slow start: the impact of a new country, like nostalgia, can often be a ready-made substitute for genuine poetic feeling, and, again like nostalgia, may produce only a facile reminder of experience, like a colourful label plastered on a suitcase. The comments about life and death which intervene are not much more rewarding, for Mr. Dudek has little to add to the eternal verities. But he soon picks up his main theme:

> How the temple came out of the heart of cruelty
> and out of the jungle the singing birds!

Nature is an organic process out of which man evolves, and the process itself is full of unconscious art:

> Study the way of breaking waves
> for the shape of ferns,
> fire and wind
> for whatever blows or burns.

Man's life forms a history, which "Begins from the place we're in," out of which his art evolves. Art is therefore, for man, the key to reality, for "Form is the visible part of being." The whole poem leads up to this recognition of art in the final pages, and the observations on the jungle, the Aztec temples, Christianity with its man of sorrows, the modern class-conscious students of Mexico, the frogs and crabs and snakes and "all the gentle mechanical creatures that we kill" fall into place as integral parts of the total vision. In the middle is the simple human act, the routine work on which all history turns, symbolized by women washing laundry in a stream. In this poem Mr. Dudek has matured his technique of indented lines and parenthetical rhythms, and the gentle rocking sway of this meditative poem is full of a contemplative charm.

Mr. Dudek's other book, *Laughing Stalks* (Contact, pp. iv, 113, $1.50), is a collection of light verse. Some of the poems are about nothing except the poet's own self-consciousness: these are expendable, even though some of them proclaim the virtues of expendability. The reflections on scholarship and criticism illustrate a highly confused state of mind that may be called pseudo-anti-intellectualism. But when Mr. Dudek is not pretending to be a simple soul, and is his natural complex self, he can be witty and amusing. He has some good parodies of other Canadian poets, the best of them being a "Composite Poem by Six Leading Canadian Poets," a pastiche of thefts from Eliot and Thomas. There is also a vigorous explosion in Skeltonics called "Sunday

Promenade," a nightmarish vision of a crowd of children. There are some free-verse political poems in the manner of F. R. Scott, but Mr. Dudek in a satiric mood seems, unlike Mr. Scott, to be more at ease in a strict satiric metre:

> The Farmby Program fills the soul,
> Telling the folks how many cows
> Were burned last night while chewing chows,
> Who had a birthday, who ate hash
> And died of piles in St. Eustache.

There are sharp images of a bird returning to his cage and "the fictions defining life and its limits," of radio commentators "looking through the glass at the sad Sardou comedy";there are well-turned epigrams in "The Cure," "Make It New," "Good Literature Teaches," and "Reality." The third of these poems explains very clearly how the conception "beauty," if used in its proper sense as an attribute of good art, has nothing whatever to do with the conception "attractive subject-matter," in spite of the fact that most people, including most of the cultivated Canadian public, are firmly convinced that it has. This opposition of beauty to sentimentality is a central issue in Mr. Dudek's poetry, and is what gives most of the real bite to his lighter verse.

Miriam Waddington's *The Season's Lovers* (Ryerson Press, pp. viii, 56, $2.50) continues with the subjects and qualities of her earlier collection *The Second Silence*. Much of it is concerned, like Mr. Souster's book, with dereliction in the city, but in the more direct context of social work the derelicts are less inarticulate, and consequently less pathetic. We hear their splutters of self-justification, their whimpering screen memories, and all the rhetoric of human nature under duress. Naturally such sounds are not confined to the unfortunate or criminal, and we hear them also from old women in Toronto scheming to get a best room or chair, and from the crowds on Montreal street-cars who form the family background of the city's thieves and prostitutes:

> From the same parish, aunts in hats,
> Green and painted loud as parrots,
> Have issued forth to board the buses;
>
> Between their words, small cries, and fusses,
> I've heard their false teeth click and clamor
> And answered with my English stammer.

Not that the poet is merely amused by all this: there is a fine flash of sympathy in her comment on the lonely woman who has "nothing to buy that's personal to her," and there is a good deal of old-fashioned moralizing: one poem is entitled "My Lessons in the Jail."

The main theme of the book is the sense of the difficulty of communication, with its accompanying sense that on deeper levels of the mind, including some of the areas gingerly explored in analysis, there is far less isolation. In the love poems, which become more frequent towards the end of the book, this theme tightens up both in irony and intensity. Sometimes the irony predominates, as in the encounter with the young poet who comes to tea and finds that

> he has come too early
> to dine on answers, and I, ill-served by fate,
> dug up from scullery, have come too late.

Sometimes, as in "No Earthly Lover," there is rather the feeling that in love the sense of identity, or union in one flesh, may be something more than a metaphor. Occasionally winter symbolizes the isolation of ordinary human contacts, and spring the unity underlying them. In the title poem at the end we finally meet the "season's lovers," the poet's version of Adam and Eve, united in their hidden paradise, with an ironic echo of Milton in "He clung to self, and she to him."

Mrs. Waddington's two gifts, one for spontaneous lyricism and one for precise observation, are better integrated here than in *The Second Silence*, but are still not completely fused. In such poems as "Semblances" there is a kind of lilting melody

that springs over the diction, which in itself would hardly bear
too sustained analysis. But one pauses with pleasure over
better realized passages in "Jonathan Travels," in the song
beginning "Paint me a bird upon your wrist," and in "An Elegy
for John Sutherland."

Marya Fiamengo's *The Quality of Halves* (Vancouver: Klanak
Press, pp. 41, $1.50) is by a British Columbia writer who ap-
peared in *Poets 56* two years ago, but is essentially a newcomer.
The quality of halves, we are told, is expressed by the muted
sound of the vowel in the word "dusk." Miss Fiamengo is a
mythopoeic poet, and to her the world of myth is a night world
(or sometimes, as in "At the Lake," a world of mist), full of sym-
bols of aristocracy: imprisoned queens, peacocks, swans, and
jewels. This world is opposed to the "republican and sane" day-
light of a more tedious reality, which needs the mythical night
to complement itself. A strong Yeatsian influence on this myth-
ology is acknowledged in the title poem. There are lapses of
taste, especially in "These Faces Seen," and some muddy writ-
ing in "Song for Sunday," where it is difficult to sort out all the
mandalas and pieces of angels. But she manages her sonorous
elegiac rhythm very well; the particular kind of decorative love-
liness she aims at she often succeeds in getting, and one finds
some tense organization of sound here and there:

> A liquid whorl of lostness as when ducks
> Make suctions when they seek the sea.

The most consistently successful poem, I think, is "In the
Absence of Children," where, in spite of an elaborate symbolic
construct, a bit more of the republican daylight is allowed
into the poem than usual.

Peter Miller's *Meditation at Noon* (Contact, pp. 101, $2.00)
is an extremely interesting, if uneven, collection, with three
translations at the end that indicate an unusually thorough
knowledge of contemporary poetry in other languages. The
usual level is that of poetic rhetoric rather than fully realized
poetry, although the rhetoric is that of a lively and sharp mind
— some of his own poems read rather like translations too,

where the form has been abstracted from the content. Poems are often brilliant in conception but less satisfying in execution, as in "Photographer in Town," or well started and finished only by repetition, as in "Samson of the Arts." Most of the poems are in free verse, and in a rhythm that is well handled, though the title poem and one or two others have a more strongly accented beat. Formal metrical schemes, as in "Total War" and "Christmastide at the Pornographers," tend to lead to forced rhymes, though even those are sometimes appropriate, as in "Resignation."

Mr. Miller generally tends to be metaphysical, his conceits varying from the pendantry of "Tangential Girl" to the witty and ingenious "Abstraction." In the latter the versatility of behaviour shown by human character is compared with the capacity of an abstract painting to be a reservoir of subjects instead of a single one. The general mood is that of a good-humoured detachment, sharpening to intellectual satire in "Sensationalist," "Synthetic You" (a poem that might well have been called "History of Canadian Poetry"), and "The Eyes," this last dealing with the effect of executive staring on intellectual diffidence. The title poem shows a strong interest in the theme of the mental landscape, which reappears in three other poems, all among his best, "The Open Season," "The City, Then," and "A City Refound." These are based on the theme of a mental or ideal city as contrasted with an actual one: a concrete abstract, so to speak, as compared with the abstract concrete of Yonge Street or Manhattan . . .

Thomas Saunders' sober unpretentious studies of rural life in Saskatchewan are always welcome, and I like *Something of a Young World's Dying* (pp. 20, $1.00) better than his two previous chapbooks. Here the comparison with Robert Frost would have more point than it would for Mr. Glassco, yet here too the differences are more important. The poems, which look like blank verse at first glance, are actually in surprisingly elaborate rhyme schemes, and the rhymes have a harsh obtrusiveness that distresses the ear and yet seems curiously appropriate. Mr. Saunders gives us a Wordsworthian illusion of the language of real life by coming close to doggerel and

yet skilfully avoiding it. The main theme of the book, too, as expressed in the title, is quite different from Frost, being purely Western. Mr. Saunders is fascinated by the curiously uneasy relationship between man and nature on the prairie. In "Coyote's Howl," a very simple, even obvious poem, yet a haunting and effective one, a farmer, as his wife is dying in childbirth, hears in the howl of a coyote the latent hostility of the land to him and his life. "The Mill" (a title which makes one look twice at the poem) tells of an early pioneer who remains on the prairie because he has never known any other home, and yet does not really feel at home there. "Poplar Hollow," from which the book's title is quoted, describes a ghost town, struck with a kind of precocious senility, "growth in its first decay." "Sandy Bowles" and "Empty House" deal with the desperate effort to maintain a continuum of identity in this flat world where "No third dimension rises but the dreams Of man," and "Adjustment" and "An Old Man and the Land" with the spirit of resignation that up to a point succeeds in achieving it.

John Heath's *Aphrodite* (pp. 23, $1.00) is a posthumous collection of poems by a writer who was killed in Korea at the age of thirty-four. There is a foreword by Henry Kreisel, who is apparently the editor of the collection. The effect of these poems is like that of a good jazz pianist, who treats his piano purely as an instrument of percussion, whose rhythm has little variety but whose harmonies are striking and ingenious. There is a group of poems in quatrains, split in two by the syntax, where most of the protective grease of articles and conjunctions is removed and subject, predicate, object, grind on each other and throw out metaphorical sparks:

> Red razor dawn shears shadow beard
> Along jawline of head turned earth
> The seaweed dream stalks dessicate
> As mind tides back to daylight berth.

The vigour and liveliness of the style have all the characteristics of light verse: polysyllabic diction in "Sleep" and

"The Season," rollicking rhymes in "Superscriptions," and a limerick-like stanza in "Burdens." In "Northern Spring" the sound is more carefully organized:

> The outspace looking, stark, star bitten
> Pole slopes back into the sun,
> The white owl haunted, gray wolf daunted
> Winter world hears rivers run.

In several poems one feels that the poet has no real theme: he is observing and describing with great wit, but does not know where to *take* all his cleverness, and hence the poem sags after a promising beginning. I think this happens for instance in "Fun Fair," a curious anticipation of Mr. Reaney's September eclogue. In the title poem, on the other hand, there is a real theme: Aphrodite's complacent reflection that as long as the cycle of nature continues to turn on copulation she will be "still queen":

> I have outlasted them,
> Poor peacock Hera petulant at Zeus
> And Attica's longnose divinity
> And some young moonfaced chit of Bethlehem
> Bouncing a second Eros on her knee.

This poem in particular indicates what we have lost by the poet's death.

Jay Macpherson's Emblem Books series continues with two more chapbooks this year. Violet Anderson's *The Ledge* (n.p., $.50) is at its best in close description and observation of "Poet's Minutiae," the title of one of her poems. "The Well," "Sea Piece," and "Under the Juniper" have a good deal of charm, with a murmuring pleasant rhythm and sound as well as careful imagery. Mrs. Anderson is most successful when she is not *saying* anything: when she states her theme before drawing a moral or making reflective comments. "Collectivist World" is an example of this: it sags into talk, but only after an excellent image, which is really the whole poem, of:

the shape of a committee meeting
varnished about the circumference
with the usual chairs,
and cloudy at the core
with the jargon of cigarette smoke.
The windows stick.

Heather Spears's *Asylum Poems and Others* (n.p., $.50) are much more ambitious, and have a strident power in them which does not depend on their success, though I hasten to add that it does not depend either on the automatic shock of the subject-matter. The percussive vocabulary and wrenched syntax, the pounding and clanging of monosyllables, the use of such phrases as "on bed to lie me" that suggest a dissociation of personality, have all been deliberately adopted to give the sense of a mind at breaking point. A strong Hopkins influence comes into view in an extraordinary "Sonnet," where there are only three rhymes for the whole fourteen lines, and even those repeated in inner rhymes. Miss Spears makes it clear that while an asylum may well be as close to hell as we can ordinarily get on earth, that is so partly because the madman's self-created hell demands an objective counterpart:

They took him back, when he could walk
To his own bed which he did not know
And left him drowsy and numb for a cure.
How bound and blasted week after week
He was, how watched — and now
He is building against them again, and is still obscure.

The title speaks of "other" poems, but we never get very far from the asylum, and even the religious poems still talk of severed minds, dragging chains, and screaming, only reaching some kind of troubled serenity at the very end. A most disconcerting and haunting little book.

A third chapbook series, Fiddlehead Poetry Books, contributes Alden A. Nowlan's *The Rose and the Puritan* (University of New Brunswick, pp. 16, $.50). These are mainly

vignettes of childhood on a farm, and are full of the sufferings of animals, which seem so much a part of the order of nature on farms as elsewhere. It is curious how often the themes of Mr. Reaney's book recur in the other verse of the year. All the poems are well written, pleasant, and carefully worked out. The low-keyed sensibility and lucid diction are a model of what at least most chapbook writing should be. The purely human subjects treated in "The Brothers and the Village" and "All Down the Morning" are a bit on the hackneyed side, and such themes as "The Egotist" are much more deeply felt and distinctive:

> A gushing carrousel, the cock
> Revolved around the axeman's block.
>
> Sweet Christ, he kicked his severed head
> And drenched the summer where he bled.
>
> And terrible with pain, the scream
> Of blood engulfed his desperate dream —
>
> He knew (and knowing could not die)
> That dawn depended on his cry.

The title poem is considerably more complex, and suggests that the gentle pastoral sympathy of the other poems is by no means Mr. Nowlan's only poetic quality. . . .

1959

There is nothing particularly "modern" about the gap between poetry and its reading public, or about the charge that poets are wilfully obscure, a charge levelled with great enthusiasm against (for example) Keats's *Endymion*. In every age the envious readers — a large group of every writer's contemporaries — have resented the humility that close attention requires, and poetry has never been popular except when it

provided some kind of middle distance, by telling stories or crystallizing into proverbs and slogans. But there are, perhaps, some additional hazards about our own age. Most people nowadays are accustomed to the double talk of journalism, and it is not the difficulty of poetry that they find baffling, but its simplicity. Vivid imagery and concrete language are too sharp for readers accustomed to the murkiness of dead words, and make them wince and look away. A recent Canadian book of verse was reviewed in an American journal devoted entirely to poetry, by a reviewer who kept protesting that he couldn't understand a word of it. The writing could not have been clearer or simpler: but that was the trouble. Again, lyrical poetry cannot be read quickly: it has no donkey's carrot like a whodunit, and the developing of "reading skills," which enable the reader to come to terms with his own sense of panic, has no relation to the reading of poetry. The reading of poetry is a leisurely occupation, and is possible only for that small minority which believes in leisure.

George Johnston's *The Cruising Auk* (Oxford, pp. 72, $2.50) should appeal to a wider audience than most books of poems surveyed in these reviews. Even the envious reader should be disarmed by the simplicity, which may make him feel that he could do as well if he set his mind to it, or that here at last is a "light" verse which "doesn't take itself too seriously," the favourite cliché of the culturally submerged. The critic, however, has to explain that the substance of Mr. Johnston's poery is not at all the image of the ordinary reader that is reflected from its polished surface. He must explain that seriousness is not the opposite of lightness, but of portentousness, and that genuine simplicity is always a technical *tour de force*. In short, he must insist that Mr. Johnston's most pellucid lyrics have to be read as carefully as the most baffling paper chase of E. E. Cummings.

The difference between the simple and the insipid, in poetry, is that while simplicity uses much the same words, it puts them together in a way that keeps them echoing and reverberating with infinite associations, rippling away into the furthest reaches of imaginative thought. It is difficult for a

critic to demonstrate the contrast between the simplicity that keeps him awake at night and the mediocrity that puts him to sleep in the day. In *The Cruising Auk*, however, there is one major clue to the simplicity. Like Mr. Reaney and Miss Macpherson before him, Mr. Johnston has produced a beautifully unified book, the apparently casual poems carrying the reader along from the first poem to the last in a voyage of self-discovery. We begin with a Narcissus image, a boy gazing into a pool and feeling an identity with "the abyss he gazes on," and we end with "O Earth, Turn!" (the echo of Miss Macpherson can hardly be an accident) where the abyss opens up again inside the adult:

> I love the slightly flattened sphere,
> Its restless, wrinkled crust's my here,
> Its slightly wobbling spin's my now
> But not my why and not my how:
> My why and how are me.

Between these two points, a state of innocence and a state in which all paradise is lost except a residual intuition, Mr. Johnston surveys the ages of man. He first explores the "pool" or pond, life or the objective side of existence, which remains the controlling image of the book. In "In the Pond" the poet lies beneath it; in "In It" he sails over it in a boat; in "The Queen of Lop" it enters a girl's dreams as a death symbol; in "Poor Edward" it forms the basis for a beautifully cadenced death-by-water poem of suicide; in "Wet" the death symbol modulates into rain. Human life is thus looked at as symbolically under water, hence the watching fish in "Rapture" and "Life from a Goldfish Bowl," and the fine "Eating Fish," where the fish disappears into the man, a quizzical analogue to Miss Macpherson's fisherman. The poet first discovers that the innocence of childhood is not self-contained but rebellious, a battle with invisible gods revealed in the noise of a small boy:

> Grievous energies of growth,
> Storms of pride and tides of sloth

> Sweep across his giant soul
> Against the gods, the small and whole.

As one gets older one comes to terms with experience, and the age of anxiety settles more or less contentedly into

> . . . this excellent street-scattered city,
> This home, this network, this great roof of pity.

The cosiness of domestic life among family and friends occupies much of Mr. Johnston's foreground: he depicts it without rancour and without insisting, like so many more obsessed intellectuals, that only a damned soul can remain absorbed in it:

> My pleasures, how discreet they are!
> A little booze, a little car,
> Two little children and a wife
> Living a small suburban life.

For if one can be deeply moved (in "Cathleen Sweeping") by a three-year-old daughter struggling with a broom, one can appreciate that a small suburban life, even as lived by adults, may have something equally pathetic and dauntless about it. Thus Mr. Murple's mother, who gets a bottle of gin from her son on Mother's Day but defiantly buys her own flower:

> "A nice red rose to show I'm still alive:
> Fifty cents they asked me for it, thieves!
> Yellow to show you're dead is fifty-five
> All done up in ferny things and leaves."

In fact Mr. Johnston has a Dickensian sense of the violence of the life force in drab or even squalid surroundings, a sense not many modern poets show, apart from Thomas's *Under Milk Wood*. He admires his gigantic aunts and the vast pregnancy of Bridget, and wonders why Eternity should be too stuffy for the "bugs and bottles and hairpins" of Mrs. McWhirter's highly unsanitary existence and should reduce

her instead to a more impersonal dust.

Yet it is still the age of anxiety: the clock, a recurring image, keeps placidly ticking away the moments of life; the "spider's small eye" is watching and waiting, and all around is a sinister and conspiratorial darkness, of a kind that scares Edward reading "Light Literature" and eventually pulls him into it, and that forms the background of the very lovely "A Little Light." Actual ghosts appear in "A Happy Ghost" and the demure parody of Yeats's "All Souls' Night." Part of this world is a cheerfully murderous nature: a cat stalking a squirrel reminds us that

> Life is exquisite when it's just
> Out of reach by a bound
> Of filigree jaws and delicate paws

and Miss Beleek is visited by "Moments almost too bright to bear" when she thinks of shooting the children who trample over her garden. A darker ferocity appears on the horizon in "War on the Periphery," in the marching of

> The violent, obedient ones
> Guarding my family with guns.

Part of it again is the sense of a submerged communion in nature, like the dogs reconnoitering at posts in "Noctambule," or the "ecstatic edge of pain" in "After Thunder." Part of it is the hidden private world that everyone retires into in sleep, the world so prominent in sexual love, with its hard narcist core of self-absorption represented by "Elaine in a Bikini," by the Lorelei figure in "Music on the Water," and by the woman in "Home Again" who returns from a night on the tiles with this inner core almost, but not quite, violated:

> Now I am a bent doll, I shed my silky stuff
> And soon I'll be a sleeping heart. The gods got enough.

Even altruism may be expressed by the same kind of ego, like

the contracting heart of Boom the "saint," or the pity that the poet feels for his other friend Goom.

And as we go on we feel less reassured by "the savoir faire of doom" and by the poet's insistence, sailing his crowded boat on the sea of life, that "Important people are in it as well." Life is not going anywhere except into death, and its minor pleasures of beer and love and sleep are all rehearsals for death. In "Smilers" something of the bewilderment of Willy Loman appears in the successful extrovert surrounded by what he is beginning to realize are fixed and glassy grins:

> After all, I made some dough,
> By and by I made some more;
> Anywhere I like to go
> Friends, my goodness, friends galore!

And eventually one begins to see that the "pond" has a bottom, familiarly known as death and hell, and that perhaps the "airborne" career of the cruising auk, an absurd and extinct bird that nevertheless manages somehow to get above himself, may have something to be said for it. At any rate it, or something like it, inspires Mrs. McGonigle into the stratosphere, frightens Mr. Smith, her protégé, into a coffin-like telephone booth, and sends Mr. Murple into a tree, where, in the curious Orpheus poem at the end of the second part, he sits charming the local frogs and bugs (in contrast to the crow at the end of the first part, who can only choose "Empty tree for empty tree"). Even a much rarer event, the "apocalyptic squawk" of the great dufuflu bird, does not pass wholly unheeded.

If I have not demonstrated how simplicity reverberates, at any rate I have shown that Mr. Johnston is an irresistibly readable and quotable poet. His finest technical achievement, I think, apart from his faultless sense of timing, is his ability to incorporate the language of the suburbs into his own diction. He does not write in the actual vulgate, but be manages to suggest with great subtlety the emotional confusions behind the pretentious diction and vague syntax of ordinary speech:

Mrs. Belaney has a son
— Had, I should say, perhaps —
Who deeds of gallantry has done,
Him and some other chaps.

Or the elusiveness of large ideas as their shadows pass over an inarticulate mind:

And as it happened we agreed
On many things, but on the need
Especially of mental strife
And of a whole new source of life.

It is this controlled portrayal of the ineffectual that gives Mr. Johnston his unique bittersweet flavour, and a "disconsolate" tone, to use one of his favourite words, that would be merely coy if it were less detached, or merely brittle if it were more so.

Ronald Bates's *The Wandering World* (Macmillan, pp. vi, 60, $2.75) is another voyage of discovery, this time of Canada. We begin with a section called "Histories," dealing with early voyages of exploration, with the sense of vast spaces in front and the illusion of some ineffably glamorous Cathay in the distance that has given its name to Lachine. In "Parallels in a Circle of Sand" the poet describes how the oppressiveness of the lack of tradition, the feeling of time cut off at the roots, pulls the Canadian back into Europe, only to make him realize how his real traditions are those of the explorers, and that the mutilation of time in his experience is hereditary. The next section, "Myths," deals with the huge mythological figures in which an imagination first tries to conquer a new land, some of them assimilated to modern life, like "Overheard in the Garden," very Audenesque in its linking of the immemorial lost garden symbol to a detective story. Next are the "Interiors," where the themes are drawn from ordinary civilized life, and the "Landscapes," the corresponding images of nature outside. Finally we come to "Constructions," where the poet reaches the end of his journey in his own mind, the one fixed point of the wandering world, not only

the world of space but of time also:

> Each man must come at last upon that point,
> Where all roads meet, all currents cross,
> Where past and future are valid,
> And now.

Thus we go from the open world of endless space to the contained world of the mind, and from exploration to self-knowledge.

As this brief summary indicates, an extraordinary variety of themes, moods, and techniques are attempted in the book. The histories employ what might be called a documentary style, much of it in unrhymed verse, which imitates historical narrative:

> What one cannot remember
> Concerning the customary rites,
> Prayers, plans and polymorphous
> Duties, can be improvised.
> Some died of scurvy, the first winter,
> Some were tried for theft and shot.

In the "Landscapes" there are more lyrical measures, stanzas in fairly strict metrical patterns; the "Interiors" are longish descriptive poems in an irregular meditative rhythm approximating blank verse. I find the poems in the tighter stanzaic patterns more consistently successful. Mr. Bates seems to me a romantic poet, in the sense that he often uses abstract and unvisualized language but is keenly sensitive to evocative sound. Thus the forsaken god Pan whispers in his sleep:

> Chill as the night air is
> In the garden
> Still I will not be their guardian
> Still.

Mr. Bates's Canadian landscapes are mainly of winter, and

he is eloquent about the delicate cruelty of winter, the feel-
ings of menace it can arouse in a child which are "not of cold
or fear," and the way that it seems to make visible the hidden
death-world of primary qualities, where colour and warmth
are gone and only measurable remains. Winter also seems to
symbolize for him both the source of imaginative energy in
Canada and that curious offbeat rhythm of modern life where
sterility has priority, so that one somehow never seems to have
time for the important experiences, like love. In the fine
"Ornithomachy" both of these are symbolized by the swan-
song:

> But far away where the swans belong,
> In fields of iridescent snow,
> The songs of flesh and blood are blown
> Like leaves about the cold, the shrill
> Throat where all the singing starts.

In "The Fall of Seasons" the same association of winter and a
failure of experience recurs in the life of a married couple,
studied under the imagery of the seasons. Courtship comes in
the springtime, where "Nobody came to bother them"; summer
brings an oscillation of love and routine worries, the former
growing increasingly furtive as the latter take over the mind
and an ironic refrain recurs in the autumn of old age:

> They stand together in dusty photo albums,
> The last repository of dreams.
> But nobody bothers to look at them.
> Nobody bothers at all.

There is nowhere in *The Wandering World* that we do not feel
a contact with a richly suggestive intelligence. It sometimes
happens that a poem succeeds by the interest of its controlling
idea even when the texture of writing is unsatisfactory: I am
thinking in particular of "I Skjaergaarden III." I find, especially
in the histories and myths, a good deal of talk, I and too ready
a satisfaction with such phrases as "all and sundry," "meticulous

care," "fall from grace," or "absolutely certain." There are inor-
ganic adjectives, like the "chthonic" and "powerful" which
make "After Pan Died" more pedantic than it should be; bleak
allegory in "Industrious Revolutions," where the fly-wheel of
pride meshes with the cog-wheel of man; vague words like the
"pawn" which weakens the otherwise lovely "Bestiary," and
rhymes like those in "The Unimaginable Zoo" which seem to
be dictating the thought. But there is much to return to, from
the meditation on memory as a cable laid along "The ancient
mountain ranges of the sea" near the beginning to the poet
building himself a tower, like Yeats, and feeling that he can
"put my hand on my hand's hidden power" near the end. In
a first volume we can have all this and promise too.

Irving Layton's *A Red Carpet for the Sun* (McClelland &
Stewart, pp. xxii, 212, $1.95 paper, $3.50 cloth) is a collection,
according to the author, of "all the poems I wrote between
1942 and 1958 that I wish to preserve." As such, it is, of course,
a volume of great importance, and if it is not examined in
detail here, that is because the poems in it have been com-
mented on before. It needs a full-length separate review and
another reviewer. The introduction, in the first place, is Mr.
Layton's first articulate statement in prose, and shows that,
although he still admires the energy of his own reaction to
modern life, he has become more detached from it. Hence
his refusal to be content with the merely poetic, to make aes-
thetic pearls out of his irritations, has not landed him out-
side poetry but into the realization that "all poetry . . . is
about poetry itself."

All Layton is here: there is the satire based, like Swift's, on
the conception of man as characterized less by reason than by
an ability to rationalize ferocity which makes him the only
really cruel animal ("Paraclete," "Abel Cain"). There are the
recurring symbols of this cruelty: the tormenting and mas-
sacring of animals ("Cain," "The Bull Calf," "The Mosquito"),
the desire for castration of those with more life ("Mr. Ther-
Apis," "Letter to a Librarian," "The Puma's Tooth"), the
refined efforts to ignore the democracy of the body ("Seven
o'Clock Lecture," "Imperial," "Anti-Romantic"), the passion

for envy and backbiting and every form of murder that can-
not be punished ("The Toy Gun," "Now That I'm Older,"
"The Improved Binoculars"). There are the "atheistic" reflec-
tions on those who hope for eternal life but have never come
alive ("Rose Lemay," "Two Ladies at Traymore's"), the refusals
to make the compromises of pity and gregarious love ("New
Tables," "Family Portrait," "For Mao Tse-Tung"), and the
sense of the interpenetration of love and death ("Orpheus,"
"Thanatos and Eros"). There are the images of the
Heraclitean fire that will burn up all the human rubbish of
the world ("Love is an irrefutable Fire," "The Poet Entertains
Several Ladies"), and of the sensuous and relaxing water that
will drown it ("The Swimmer," "The Cold Green Element,"
"Thoughts in the Water," "Sacrament by the Water"). There is
the figure of poet, outcast ("The Black Huntsman"), madman
("The Birth of Tragedy," "I Would for Your Sake Be Gentle"),
"Jewboy" ("Gothic Landscape," "The Statuettes of Ezekiel and
Jeremiah"), Chaplinesque clown ("Whatever Else Poetry Is
Freedom"), yet with the prophet's lion voice ("Woman," "Rain
at La Minerve"), who occasionally disappears into a strange
world where all the expected associations come loose and get
reassembled ("It's All in the Manner," "The Poetic Process,"
"Winter Fantasy"). It is all here, and a great deal more, and as
rich an experience as ever.

Yet Mr. Layton seems tired of his present achievement, and
one wonders if there is anything in his work so far that a read-
er might tire of too. In all genuine poetry we can hear the
voice of a distinctive personality; but this is the poetic person-
ality, not the ordinary one — nobody's ordinary personality
can write a poem. Neither is it the deliberately assumed stage
personality with which one meets the public. Mr. Layton's
stage personality has recently been embalmed in the clichés
of the *Star Weekly*, which carefully refrains from quoting any-
thing from him except *obiter dicta* of the "sex is here to stay"
variety. This stage personality has much the same relation to
the poet that the begorra-and-bejabers stage Irishman has to
Synge or O'Casey, and Mr. Layton clearly takes this view of it
himself, as anyone may see who compares the poems in this

collection with what has been rejected from the twelve volumes out of which it was made. Some writers have to kill themselves with drink and apoplexy before those who cannot read poetry will believe that anyone is writing it: Mr. Layton has been more ingenious. He has satisfied the public with an image of its own notion of what a genius should be like, and has thereby set himself free for his serious work.

But if one's stage personality is separable, the poetic personality may be too. Minor poets have only one voice; major ones speak with the gift of tongues, the multitudinous voices of sea and forest and swarming city. If one tires of anything in Mr. Layton's book, it is, perhaps, the sense of too insistent a speaking voice, and of being never out of listening range of it. One is grateful for such poems as "Song for Naomi," where the poet is talking to someone else and the reader has only to eavesdrop. There is great variety of theme and imagery and mood, always touched with distinction, but little variety of tone. I imagine that Mr. Layton's future work will show a greater impersonality, which means a larger stock of poetic *personae*, as he becomes less afraid of not being sincere and less distrustful of the merely poetic.

Fred Cogswell's *Descent from Eden* (Ryerson, pp. x, 38, $2.50) contains, in the first place, a good many vignettes of New Brunswick life of the type that he has done hitherto. He has an excellent eye for this genre, and one wishes that his ear always matched it. I don't see why they all have to be clumping sonnets with rhymes like typewriter bells, and the two in a freer form, "In These Fall Woods" and "Lefty," I like better, as the form gives him more scope to tell his story. But he catches very well the prurient wistfulness of a small community for whom the beautiful, the sinful, and the ridiculous are so closely linked that every pretty girl ill-advised enough to grow up in it has to run away and go into burlesque, like "Rose" and the mother of Lefty, or else remain and take it, like "Beth" with her miscarriage, whom the poet compares to an angleworm squirming "As some one shoves a fish-hook up her gut."

Of the epigrams and satires, there is a pungent "Ode to Fredericton," and a quatrain which ends:

A poem is a watch designed
To tick forever in the mind.

There are also two ballads, plaintive and melodious, "The Ballad of John Armstrong" being the odyssey of a sailor who has a response of indifference in every port. In mood the theme has some resemblance to Patrick Anderson's "Summer's Joe." There is a lively fantasy called "The Jacks of History," too well integrated to quote from, and as well realized a poem as any in the book. There are several fine lyrics turning on well worked out conceits, including "The Water and the Rock" and "Displaced."

The title poem and a few others that go with it add a new mythopoeic dimension to Mr. Cogswell's poetry. Eden is presented as the life in the trees enjoyed by our simian ancestors before famine forced them on the ground to become "the scourge and terror of the earth," and which still survives as a kind of social memory of a paradisal tree "With fruit and innocence among its boughs." "The Dragon Tree" continues this theme of the lost garden which children can still enter but which a dragon guards against adults, and in "The Idiot Angel" and "The Fool" we are brought closer to the perversity of mind that makes us lose it. A most eloquent poem, "The Winter of the Tree," sets up the opposing symbol of a tree dying in winter "Caught in the body of its death." This last is a Biblical phrase, and links the poem with a number of religious poems ("The Web: for Easter," "A Christmas Carol," and "For Good Friday") which associate the dead tree with the cross as a central image of the post-paradisal world. So far the versatility of Mr. Cogswell's talents has been more in evidence than their concentration, but the present volume is a remarkable achievement, and the general impression is one of slow and rich growth.

The title poem of Peter Miller's *Sonata for Frog and Man* (Contact, pp. 82, $2.00) contrasts the bullfrogs spontaneity of song with the curse laid upon "man, greedy for meaning," which makes him "seek the symbolism of nightbirds." I find it hard to understand why one should look for sermons

in stones when the inability to preach is so attractive a feature of stones. But there are bullfrogs who loaf and invite their souls with Whitman, and men like Emerson who explain that they are not really wasting time picking flowers because every one "Goes home loaded with a thought." Mr. Miller is on the side of Emerson in this matter. For a poet, he seems curiously insensitive to the sound and movement of words: poem after poem bogs down in shapeless free verse and gabbling polysyllables. His poetic interest is mainly in allegory, and most of the poems are fables, based on conceits of comparison like "The Thaw" or "Railroad Perspective," or on moralized emblems like "Past President" or "The Bracelet." When the conceit is good and consistently worked out, the poem makes its point. "People are 8 Parts Deep" compares the visible part of an iceberg to the eyes which focus the consciousness in the body; "Private Eye" reflects on the smugness inspired by the thrillers that identify one with the hunter instead of the victim, and "Lemmings," of course, comments on the human analogies to the death-march of those lugubrious rodents.

Mr. Miller appears to have travelled widely, and many of the poems with Mexican, Continental, and Levantine settings are full of sharp observation, as are some of the Ontario countryside. I find, however, the more reflective poems like "Passage to Thule" more arresting, and "The Prevention of Stacy Miller," based on a theme like Lamb's "Dream Children," is, to me, much the most moving poem in the book. But "The Capture of Edwin Alonzo Boyd" is a skilful adaptation of the idiom of the naive ballad, and in some of the later poems, such as "Your Gifts," the rhythm picks up and the lines start to swing. "Hour in the Warren" is based on a sharp contrast of semantic and metrical rhythms, a little like Marianne Moore, and the third "Murder Jury" poem reaches a carefully muted conclusion:

> From this turret, vision is vast,
> all heaviness lifts at the last
> and certainty, as an aerial thing,
> takes wing.

George Walton's *The Wayward Queen* (Contact, pp. 64, $1.50) is light but highly cultivated verse, much of it in an idiom of familiar address rare in Canadian poetry. It is a retrospective collection, some of the poems being dated as far back as 1919. The poems are least successful when adhering to certain literary stereotypes, as in the Falstaff poems, and occasionally, as in "Prairie Village," a poem talks all around a theme without finding the central words. They are most successful when the poet realizes that the lightness of light verse is a matter of rhythm and diction and not of content. Thus in the title poem:

> The Queen of Cilicia slept with Cyrus —
> Xenophon says they said,
> now, dust is Xenophon, scattered Cyrus,
> the Wayward Queen is dead.

The content is deliberately commonplace, which, when the rhythmical lilt is so attractive, is a positive virtue: one gets the feeling of popular song, as one often does in Housman, whom Mr. Walton seems to be echoing in "Isolt the Queen." Similarly the poems with refrains or repetitive sound patterns, like "Madrigal" or the opening "Security," which begins with the jingle "No noise annoys an oyster," often give an effect of rising from talk into singing. Such increased intensity gives a well rounded conclusion to an otherwise less interesting "Borrowed Themes."

Mr. Walton is a well read poet, who delicately calls a politician a jackass by means of a reference to Apuleius, and gets Panurge into a poem about the female sexual appetite. Once in a while he exploits the opportunities of light verse for a casual treatment of solemn themes, as in "Dies Irae," which tells how "Through the clear aether Gabriel flew horning," and, more frequently, its ability to express anger or contempt, as in "November II." But on the whole his range is more domestic and familiar: whether satire or love song, the tone is quiet and controlled. Thus "For My Daughters" ends with the mixture of truth and detachment from truth that such a poem requires:

> Disregard advance, accept
> not the proffered rose —
> there's a door he'd open
> Time will never close.

("He" is Love.) Similarly "Miranda's Mirror" ends with an irony which has enough sympathy in it to keep clear of glibness, and "Where I Go," again close to popular song, has the emotional resonance that an unresolved situation often produces when abandoned at the right point.

Anerca (Dent, unpaged, illus., $2.00 paper, $2.75 cloth) is a collection of Eskimo poems edited by Edmund Carpenter, and illustrated with delightful little drawings by Enooesweetok, an otherwise unknown Eskimo artist whose work was preserved by the late Robert Flaherty. Mr. Carpenter has collected the poems from a variety of sources, and has added a few bits of prose comment which have the same kind of expectancy about them that the printed introductions to Flaherty's silent documentaries had. For one poem Mr. Carpenter supplies the Eskimo text, which indicates that the originals are intensely repetitive in sound, and have a kind of murmuring magical charm about them that no translator could reasonably be asked to recapture.

It is difficult for us to imagine a life in which the fight to keep alive is so intense, in which the will to live is as constant and palpable as the heartbeat. One ghoulish story in prose tells how a party comes upon a starving hag who has eaten her husband and children, most of her clothes, and finally, as she confesses, "I have eaten your fellow-singer from the feasting." The response is only "You had the will to live, therefore you live." The same will is strong enough to make an old man hurl defiance at the Eskimo Cerberus who comes for him on his deathbed:

> Who comes?
> Is it the hound of death approaching?
> Away!
> Or I will harness you to my team.

What is still more difficult to imagine is that when life is reduced to the barest essentials of survival, poetry should turn out to be one of those essentials. "Anerca," Mr. Carpenter tells us, means both "to make poetry" and "to breathe." Its primitive rhythm, which we interpret as "magic," is part of the physical energy with which the living man maintains his life as he seeks for his food:

> Beast of the Sea,
> Come and offer yourself in the dear early morning!
> Beast of the Plain!
> Come and offer yourself in the dear early morning!

Nature cannot exterminate such a people: only civilization, with its high-powered death-wish, can do that. It is very comfortable in the settled parts of Canada, and hard to hear such things as the screams of trapped animals, much less the thin delicate cry, faint as a wisp of snow and yet as piercing as the revelation by word itself, that comes to us in this — a song to ensure fine weather, Mr. Carpenter says:

> Poor it is: this land,
> Poor it is: this ice,
> Poor it is: this air,
> Poor it is: this sea,
> Poor it is. . . .

Perhaps the most distinguished of all this year's chapbooks is Dorothy Roberts' *In Star and Stalk* (Emblem Books, unpaged, $.50). This is poetry in a sombre and heavily churning rhythm, showing a unified imagination of unusual power. It is an imagination for which the spoiled word "mystical" still has some relevance. In the background of her imagery are the free-wheeling rhythms of nature, the spinning earth and the setting sun, the stream of time that carries away the childhood memories of grandparents, the violence of storm and the fragility of birth. In the foreground is the image of the "shell," the home occupied by the lonely and uncertain self in the

"almighty sea" of nature. Its products are the body itself, the house, and the stone buildings of civilization, the bus clinging to the white line of the highway, the memories of the past, and finally the gravestones of a cemetery. What matters, of course, is the intensity with which these images are realized. In "Our Shells" the birth of a child is set against the two backgrounds at once, making what is perhaps the most impressive and memorable poem of the group:

> In this pattern of silent homes and heavenly bodies
> The walls have been pushed out to a vast wandering —
> How many stars to lead me to this child?
> Only the constellations house with fables
> Like brilliant parables upon church windows,
> Making of night a high roof for the spirit.

With this review I complete a decade of observing Canadian poetry, and retire from the scene. The fifties have been a rich and fruitful time: no other decade in our history has seen such variety of originality. *Towards the Last Spike, Trial of a City, In the Midst of My Fever, The Boatman, A Suit of Nettles, The Cruising Auk*: this is an extraordinary range of new discoveries in technique and sensibility, created at every age level from the veteran to the newcomer. *Victorian House, The Colour as Naked, The Net and the Sword, Friday's Child, The Selected Poems* (Souster), *The Transparent Sea*, and many others represent what may be called the resonance of tradition. This does not mean that they follow after the other group, necessarily: in literature it is the traditional book that pioneers, the new settler who has his roots elsewhere. There are also a number of poets — I think particularly of Eli Mandel and Margaret Avison — who have not received their due of attention only because no published volume has been available to the present writer.

The reviewer knows that he will be read by the poets, but he is not addressing them, except indirectly. It is no part of the reviewer's task to tell the poet how to write or how he should have written. The one kind of criticism that the poet himself, *qua* poet, engages in — the technical self-criticism which leads

to revision and improvement — is a criticism with which the reviewer has nothing to do. Nor is it his task to encourage or discourage poets. To encourage a genuine poet is impertinence, and to encourage a mediocre one is condescension. Discouragement is an even more dubious practice. To say that no one should write poetry except good poets is nearly as silly as saying that no one should read it except teachers of English. There are some who write poetry not because they care about poetry but for more devious reasons, but such people can be discouraged only by implication, by showing from the real poets that an ignorant or anti-intellectual mind can never be good enough.

The reviewer's audience is the community of actual and potential readers of poetry. His task is to show what is available in poetic experience, to suggest that reading current poetry is an essential cultural activity, at least as important as keeping up with current plays or concerts or fiction. He has the special problem, too, of bridging the gap between poetry and its public, already mentioned. I have spent a great deal of my space in trying to explain as clearly as I can what the poet is saying, and what is characteristic about his handwriting, so to speak, in imagery and rhythm. I have felt that it is well worth insulting the intelligence of some readers if one can do anything to breach the barriers of panic and prejudice in others.

The ordinary reader of poetry may exercise a preference. He may have a special feeling for religious poetry or landscape poetry or satire and light verse or narrative; he may like poetry that expresses involvement in society, or poetry written in certain technical forms, or poetry that is dense in texture, or poetry that is loose in texture. The reviewer must take poetry as he finds it, must constantly struggle for the standards of good and bad in all types of poetry, must always remember that a preference for any one kind of poetry over another kind is, for him, laziness and incompetence. The poets themselves are sometimes eager to tell him that if he thinks less of their poetry than they do, it is because he underestimates the importance of their kind of poetry, being too Philistine or modern or *bourgeois* or academic or intellectual

or prudish — I list only a few of the things I have been called myself. Assuming a certain amount of technical competence, the reviewer can be satisfied with his efforts only if he feels that he has tried to be honest: no batting average of hits and errors is either attainable or relevant.

Finally, the community that I have been addressing is the Canadian community. As Canada is a small country, that fact raises the problem: do you estimate Canadian poets in Canadian proportions or in world proportions? I have considered this question carefully, and my decision, while it may have been wrong, was deliberate. I have for the most part discussed Canadian poets as though no other contemporary poetry were available for Canadian readers. The reviewer is not concerned with the vague relativities of "greatness," but with the positive merits what is before him. And every genuine poet is entitled to be read with the maximum sympathy and concentration. When he is, an astonishing amount of imaginative richness may be obtained from him, and without reading into him what is not there. Shakespeare is doubtless an infinitely "greater" poet, but there is a limit to what a limited mind can get out of Shakespeare, and — if one continually tries to break through one's limitations in reading one's contemporaries, one may also achieve a clearer vision of greatness. In the context of their importance for English-reading posterity as a whole, many poets may have been considerably over-praised in these reviews. But I am not writing for an invisible posterity anxious to reduce the bulk of its required reading. The better poets of every age seem all the same size to contemporaries: it takes many years before the comparative standards become clear, and contemporary critics may as well accept the myopia which their nearsighted perspective forces on them. Then again, poetry is of major importance in the culture, and therefore in the history, of a country, especially of a country that is still struggling for articulateness. The appearance of a fine new book of poems in Canada is a historical event, and its readers should be aware that they are participating in history. To develop such awareness it is an advantage to have a relatively limited cultural

horizon. *Ubi bene, ibi patria*: the centre of reality is wherever one happens to be, and its circumference is whatever one's imagination can make sense of.

The last ten reviews have recorded what T. S. Eliot calls the horror, the boredom, and the glory of their subject: writing them has been of immense profit to me, and some, I hope, to my readers. But if I could go on doing such a job indefinitely it would not have been worth doing in the first place. At a certain point diminishing returns set in for both reviewer and reader. No poet has written more good poetry in Canada in the last decade than Irving Layton, yet Mr. Layton has just announced that he is dead, and that a new Mr. Layton is to rise from his ashes. If so, new critics should welcome him, as well as other newcomers, should find different reasons for helping established poets to defend their establishments, should respond to new currents in imaginative life and to new needs in society. The critic to whom falls the enviable task of studying Canadian poetry in the sixties will, I trust, be dealing with a fully matured culture, no longer preoccupied with the empty unpoetics of Canadianism but with the genuine tasks of creative power. For the poets of the next decade will have the immense advantage of the tradition set up by the poets of the last one, whose imaginative feats, as far as this critic is concerned, have been, like the less destructive efforts of Milton's Samson, "not without wonder or delight beheld."

Canada and Its Poetry

THE APPEARANCE OF Mr. A. J. M. Smith's new anthology* is an important event in Canadian literature. For instead of confining his reading to previous compilations, as most anthologists do, he has made a first-hand study of the whole English field with unflagging industry and unfaltering taste. A straightforward research job is simple enough to do if one has the time: but Mr. Smith has done something far more difficult than research. He had to read through an enormous mass of poetry ranging from the lousy to the exquisite, the great bulk of which was that kind of placid mediocrity which is always good verse and just near enough to good poetry to need an expert to detect its flat ring. He had to pronounce on all this not only with a consistent judgment but also with historical sense. He had to remember that a modern poet may hold deeply and sincerely to the more enlightened political views and become so gnarled and cryptic an intellectual that he cannot even understand himself, and still be just as conventional a minor poet as the most twittering Victorian songbird. In dealing with many of the older writers, Campbell for instance, or Carman, he had to trace the thin gold vein of real imagination through a rocky mass of what can only be called a gift of metrical gab.

*The Book of Canadian Poetry. A. J. M. Smith, Editor; W. J. Gage & Co. (University of Chicago Press); pp. 452; 1943.

He had to remember that ~~occasionally a bad~~ poem is of all the greater cultural significance for being bad, and therefore should go in. In judging his younger contemporaries he had to remember both that a flawed talent is better than a flawless lack of it and that still it is performance and not "promise" that makes the poet, of whatever age.

It is no easy job; but Mr. Smith has, on the whole, done it. Of course there are omissions, of which he is probably more acutely aware than his readers. In any case anthologies ought to have blank pages at the end on which the reader may copy his own neglected favorites. In my judgment, a few people are in who might well have been out, and a few out who might well have been in: some dull poems are included and many good ones are not; and one or two poets have been rather unfairly treated — including, I should say, one A. J. M. Smith. But no kind of book is easier to attack than an anthology; and in any case the importance of this one is not so much in the number or merits of the poems included as in the critical revaluations it makes.

Mr. Smith's study of the pre-Confederation poets is the only one that has been made from anything like a modern point of view. In Charles Heavysege he has unearthed — the word will not be too strong for most of his readers — a genuine Canadian Beddoes, a poet of impressive power and originality: and he has given Isabella Crawford enough space to show that she is one of the subtlest poets that Canada has produced. The more famous writers of the so-called Maple Leaf school come down to a slightly more modest estimate, and, though Mr. Smith is scrupulously fair to them, he cannot and does not avoid saying that they talked too much and sang too little, or sang too much and thought too little. In any case the supremacy of Lampman over the whole group comes out very clearly. In the next period Pratt gets his deserved prominence, and the younger poets are generously represented. Here is, in short, what Canada can do: the reader who does not like this book simply does not like Canadian poetry, and will not be well advised to read further. Of course, as Mr. Smith says in his Preface, French-Canadian poetry is a separate job — still to be

done, I should think, for Fournier's *Anthologie des poètes canadiens* is, as its editor Asselin frankly admits, more a collection of poets than of poems. But we cannot leave the French out of our poetry any more than we can leave Morrice or Gagnon out of our painting, and one can only hope for some French-speaking philanthropist to produce a companion volume.

The thing that impresses me is the unity of tone which the book has, and to which nearly all the poets in various ways contribute. Of course any anthologist can produce a false illusion of unity by simply being a critic of limited sympathies, responding only to certain kinds of technique or subject-matter. But Mr. Smith is obviously not that: his notes and introduction show a wide tolerance, and his selections, though bold and independent, are certainly not precious. No: the unity of tone must come from the material itself, and the anthology thus unconsciously proves the existence of a definable Canadian genius (I use this word in a general sense) which is neither British nor American but, for all its echoes and imitations and second-hand ideas, peculiarly our own.

Now admittedly a great deal of useless yammering has been concerned with the "truly Canadian" qualities of our litera-ture, and one's first instinct is to avoid the whole question. Of course what is "peculiarly our own is not what is accidentally our own, and a poet may talk forever about forests and prairies and snow and the Land of the North and not be any more Canadian than he will be Australian if he writes a sonnet on a kangaroo. One of F. R. Scott's poems included by Mr. Smith notes a tendency on the part of minor poets to "paint the native maple." This is like saying that because the quintuplets are Canadian, producing children in litters is a Canadian char-acteristic. Nevertheless, no one who knows the country will deny that there is something, say an attitude of mind, distinc-tively Canadian, and while Canadian speech is American, there is a recognizable Canadian accent in the more highly orga-nized speech of its poetry.

Certainly if a Canadian poet consciously tries to avoid being Canadian, he will sound like nothing on earth. For whatever may be true of painting or music, poetry is not a

citizen of the world: it is conditioned by language, and flour-
ishes best within a national unit. "Humanity" is an abstract idea,
not a poetic image. But whether Canada is really a national unit
in any sense that has a meaning for culture I could not decide
myself until I saw Mr. Smith's book; and even then one has mis-
givings. The patriotic avarice that claims every European as
"Canadian" who stopped off at a Canadian station for a ham
sandwich on his way to the States is, no doubt, ridiculous; but
apart from that, does not any talk about Canadian poetry lead
to some loss of perspective, some heavy spotlighting of rather
pallid faces? Every Canadian has some feeling of sparseness
when he compares, for example, Canada's fifth largest city,
which I believe is Hamilton, with the fifth largest across the
line, which I believe is Los Angeles. And the same is true of
poetry. Every issue of the *New Yorker* or *New Republic*, to say noth-
ing of the magazines which really go in for poetry, contains at
least one poem which is technically on a level with five-sixths of
Mr. Smith's book. With so luxuriant a greenhouse next door,
why bother to climb mountains to look for the odd bit of edel-
weiss? The only answer is, I suppose, that in what Canadian
poems have tried to do there is an interest for Canadian read-
ers much deeper than what the achievement in itself justifies.

The qualities of our poetry that appear from this book to
be distinctively Canadian are not those that one readily thinks
of: a fact which was an additional obstacle in Mr. Smith's path.
For Canada is more than most countries a milieu in which
certain preconceived literary stereotypes are likely to inter-
pose between the imagination and the expression it achieves.
What a poet's imagination actually can produce and what the
poet thinks it ought to produce are often very different
things. They never should be, but they sometimes are; and it
is hard to judge accurately the work of a man who is a genuine
poet but whose poetry only glints here and there out of a mass
of verse on conventional themes he has persuaded himself
he should be celebrating. If a poet is a patriot, for instance,
there may be two natures within him, one scribbling ready-
made patriotic doggerel and the other trying to communicate
the real feelings his country inspires him with. If he is religious,

the poet in him may reach God in very subtle ways; but the man in him who is not a poet may be a more commonplace person, shocked by his own poetic boldness. If he is revolutionary, the poet in him may have to argue with a Philistine materialist also in him who does not really see the point of poetry at all. This is at least one reason so much patriotic, religious and revolutionary verse is bad.

Now this creative schizophrenia is, we have said, common in Canada, and the most obvious reason for it is the fact that Canada is not only a nation but a colony in an empire. I have said that culture seems to flourish best in national units, which implies that the empire is too big and the province too small for major literature. I know of no poet, with the very dubious exception of Virgil, who has made great poetry out of what Shakespeare calls "the imperial theme": in Kipling, for instance, this theme is largely a praise of machinery, and of the Robot tendencies within the human mind. The province or region, on the other hand, is usually a vestigial curiosity to be written up by some nostalgic tourist. The imperial and the regional are both inherently anti-poetic environments, yet they go hand in hand; and together they make up what I call the colonial in Canadian life.

This colonial tendency has been sharpened by the French-English split, the English having tended to specialize in the imperial and the French in the regional aspects of it. The French are on the whole the worse off by this arrangement, which has made Quebec into a cute tourist resort full of ye quainte junke made by real peasants, all of whom go to church and say their prayers like the children they are, and love their land and tell folk tales and sing ballads just as the fashionable novelists in the cities say they do. True, I have never met a French-Canadian who liked to be thought of as an animated antique, nor do I expect to: yet the sentimental haze in which the European author of *Maria Chapdelaine* saw the country is still quite seriously accepted by Canadians, English and French alike, as authentic. A corresponding imperial preoccupation in English poets leads to much clearing of forests and planting of crops and tapping vast natural

resources: a grim earnestness of expansion which seems almost more German than British. The more naive expressions of this do not get into Mr. Smith's book. Instead, he sets Isabella Crawford's song, "Bite Deep and Wide, O Axe, the Tree," in its proper context, a viciously ironic one; and Anne Marriott's *The Wind Our Enemy* and Birney's "Anglo-Saxon Street" are also there to indicate that if we sow the wind of empire with too little forethought we shall reap a dusty whirlwind of arid squalor.

The colonial position of Canada is therefore a frostbite at the roots of the Canadian imagination, and it produces a disease for which I think the best name is prudery. By this I do not mean reticence in sexual matters: I mean the instinct to seek a conventional or commonplace expression of an idea. Prudery that keeps the orthodox poet from making a personal recreation of his orthodoxy: prudery that prevents the heretic from forming an articulate heresy that will shock: prudery that makes a radical stutter and gargle over all realities that are not physical: prudery that chokes off social criticism for fear some other group of Canadians will take advantage of it. One sees this perhaps most clearly in religion, because of the fact that the division of language and race is approximately one of religion also. Mr. Smith has included a religious poem called "Littlewit and Loftus," which, though in some respects a bad poem, is at any rate not a prudish one in the above sense: it ends with the authentic scream of the disembodied evangelical banshee who has cut herself loose from this world and who has the sense of release that goes with that, even if she is not wholly sure what world she is now in. It is a prickly cactus in a desert of bumbling platitude and the pouring of unctuous oil on untroubled waters; or else, as in Bliss Carman, prayers of a stentorian vagueness addressed to some kind of scholar-gipsy God.

I wish I could say that the tighter grip of religion on the French has improved matters there; but it has done nothing of the kind. In French poetry too one feels that the Church is often most vividly conceived not as catholic but as a local palladium to be defended for political reasons: as a part of the

parochial intrigue which is given the title of "nationalism." The type of prudery appropriate to this is a facile and mawkish piety. In short, the imperial tendency may call itself "Protestant" and the regional one "Catholic"; but as long as both are colonial, both will be essentially sectarian. Similarly, the imperial tendency may call itself British and the regional one French; but as long as both are colonial, these words will have only a sectional meaning. It is an obvious paradox in Canadian life that the more colonial the English or French-speaking Canadian is, and the more he distrusts the other half of his country, the more artificial his relation to the real Britain or France becomes. The French-Canadian who translates "British Columbia" as "Colombie canadienne" and flies the tricolor of the French Revolution on holidays, and the English-Canadian who holds that anything short of instant acquiescence in every decision of the British Foreign Office is treason, are the furthest of all Canadians from the culture of what they allege to be their mother countries.

But even when the Canadian poet has got rid of colonial cant, there are two North American dragons to slay. One is the parrotted cliché that this is a "new" country and that we must spend centuries cutting forests and building roads before we can enjoy the by-products of settled leisure. But Canada is not "new" or "young": it is exactly the same age as any other country under a system of industrial capitalism; and even if it were, a reluctance to write poetry is not a sign of youth but of decadence. Savages have poetry: the Pilgrim Fathers, who really were pioneers, started writing almost as soon as they landed. It is only from the exhausted loins of the half-dead masses of people in modern cities that such weary ideas are born.

The other fallacy concerns the imaginative process itself, and may be called the Ferdinand the Bull theory of poetry. This theory talks about a first-hand contact with life as opposed to a second-hand contact with it through books, and assumes that the true poet will go into the fields and smell the flowers and not spoil the freshness of his vision by ruining his eyesight on books. However, practically all important poetry has been the fruit of endless study and reading, for poets as a

class are and must be, as an Elizabethan critic said, "curious universal scholars." There are exceptions to this rule, but they prove it; and it is silly to insist on them.

In looking over Mr. Smith's book one is struck immediately by the predominance of university and professional people; and it is in the classical scholarship of Lampman, the encyclopaedic erudition of Crémazie which is said to have included Sanskrit, and the patient research and documentation of Pratt's *Brébeuf* and sea narratives, that Canadian poetry has become most articulate. There is nothing especially Canadian about this, but one point may be noted. To an English poet, the tradition of his own country and language proceeds in a direct chronological line down to himself, and that in its turn is part of a gigantic funnel of tradition extending back to Homer and the Old Testament. But to a Canadian, broken off from this linear sequence and having none of his own, the traditions of Europe appear as a kaleidoscopic whirl with no definite shape or meaning, but with a profound irony lurking in its varied and conflicting patterns. The clearest statement of this is in that superb fantasy *The Witches' Brew*, Pratt's first major effort, a poem of which apparently I have a higher opinion than Mr. Smith. It is also to be found, I think, in the elaborate Rabbinical apparatus of Klein.

American even more than Canadian poetry has been deeply affected by the clash between two irreconcilable views of literature: the view that poets should be original and the view that they should be aboriginal. Originality is largely a matter of returning to origins, of studying and imitating the great poets of the past. But many fine American poets have been damaged and in some cases spoiled by a fetish of novelty: they have sought for the primitive and direct and have tried to avoid the consciously literary and speak the language of the common man. As the language of the common man is chiefly commonplace, the result has been for the most part disastrous. And here is one case where failing to achieve a virtue has really warded off a vice. There has on the whole been little Tarzanism in Canadian poetry. One is surprised to find how few really good Canadian poets have thought that

getting out of cities into God's great outdoors really brings one closer to the sources of inspiration. One reason for this is that there has been no revolution in Canada, and less sense of building up a new land into what the American Constitution calls a more perfect state. A certain abdication of political responsibility is sharply reflected in our poetry, and is by no means always harmful to it. We can see this clearly if we compare Bliss Carman with his American friend Hovey, who sang not only of freedom and the open road but also of America's duty to occupy the Philippines and open up the Pacific. The Canadian likes to be objective about Americans, and likes to feel that he can see a bit of Sam Slick in every Yankee: as a North American, therefore, he has a good seat on the revolutionary sidelines, and his poetic tendencies, reflective, observant, humorous, critical and quite frankly traditional, show it.

The closest analogy to Canadian poetry in American literature is, as one would expect, in the pre-1776 period: in Anne Bradstreet and Philip Freneau and the Hartford Wits. We have many excellent counterparts to these, and to the tradition that runs through Emerson, but few if any good counterparts to Whitman, Sandburg, Lindsay, Jeffers or MacLeish. Early American poetry is traditional, but its tradition is a great one: and when the Americans gained maturity in government they lost some in poetry; for there is an assurance and subtlety in Bradstreet and Freneau that Longfellow and Whittier and many of those mentioned above do not possess. This is not to say that the best American poetry appeared before 1776, but as we seem to be stuck with at least some colonial characteristics, we may as well appreciate what virtues they have.

Nature in Canadian poetry, then, has little of the vagueness of great open spaces in it: that is very seldom material that the imagination can use. One finds rather an intent and closely focussed vision, often on something in itself quite unimportant: in Birney's slug, Finch's station platform, the clairvoyance of hatred in MacKay's "I Wish My Tongue Were a Quiver," Hambleton's sharply etched picture of salmon fishing. The first poet Mr. Smith includes, the Canadian Oliver Goldsmith, makes an accurate inventory of a country

store, and he sets a tone which the rest of the book bears out.
The vocabulary and diction correspond: the snap and crackle of
frosty words, some stiff with learning and others bright with con-
creteness, is heard wherever there is the mental excitement of
real creation, though of course most obviously where the subject
suggests it: in, for instance, Charles Bruce's "Immediates":

> An ageless land and sea conspire
> To smooth the imperfect mould of birth;
> While freezing spray and drying fire
> Translate the inexplicit earth.

or in P. K. Page's "Stenographers":

> In the felt of the morning, the calico minded,
> sufficiently starched, insert papers, hit keys,
> efficient and sure as their adding machines.

But, according to Mr. Smith's book, the outstanding achieve-
ment of Canadian poetry is in the evocation of stark terror. Not
a coward's terror, of course; but a controlled vision of the
causes of cowardice. The immediate source of this is obviously
the frightening loneliness of a huge and thinly settled country.
When all the intelligence, morality, reverence and simian
cunning of man confronts a sphinx-like riddle of the indefinite
like the Canadian winter, the man seems as helpless as a
trapped mink and as lonely as a loon. His thrifty little heaps of
civilized values look pitiful beside nature's apparently mean-
ingless power to waste and destroy on a superhuman scale, and
such a nature suggests an equally ruthless and subconscious
God, or else no God. In Wilfred Campbell, for instance, the
Canadian winter expands into a kind of frozen hell of utter
moral nihilism:

> Lands that loom like spectres, whited regions of winter,
>> Wastes of desolate woods, deserts of water and shore;
> A world of winter and death, within these regions who enter,
>> Lost to summer and life, go to return no more.

And the winter is only one symbol, though a very obvious one, of the central theme of Canadian poetry: the riddle of what a character in Mair's *Tecumseh* calls "inexplicable life." It is really a riddle of inexplicable death: the fact that life struggles and suffers in a nature which is blankly indifferent to it. Human beings set a high value on their own lives which is obviously not accepted in the world beyond their palisades. They may become hurt and whimper that nature is cruel to them; but the honest poet does not see cruelty: he sees only a stolid unconsciousness. The human demands that Patrick Anderson's Joe hurls at nature are answered by "a feast of no"; a negation with neither sympathy nor malice in it. In Birney's *David* a terrible tragedy of wasted life and blasted youth is enacted on a glacier, but there is no "pathetic fallacy" about the cruelty of the glacier or of whatever gods may be in charge of it. It is just a glacier. D. C. Scott's "Piper of Arll" is located in an elusive fairyland, but the riddle of inexplicable death is still at the heart of the poem. The same theme is of course clearer still in Pratt's sea narratives, especially *The Titanic*.

Sometimes this theme modulates into a wry and sardonic humour. In the laughter of that rare spirit Standish O'Grady, who in his picture of freezing Canadians huddling around "their simpering stove" has struck out one of the wittiest phrases in the book, something rather sharper sounds across the laughter:

> Here the rough Bear subsists his winter year,
> And licks his paw and finds no better fare.

In Drummond's finest poem, "The Wreck of the Julie Plante," the grim humour of the ballad expresses the same tragedy of life destroyed by unconsciousness that we find in Pratt and Birney:

> For de win' she blow lak hurricane,
> Bimeby she blow some more.

Tom MacInnes has the same kind of humour, though the

context is often fantastic, and his "Zalinka" is a parody of Poe which somehow manages to convey the same kind of disturbing eeriness. But whether humorous or not, even in our most decorous poets there are likely to be the most startling flashes of menace and fear. A placid poem of Charles G. D. Roberts about mowing is suddenly punctured by the line "The crying knives glide on; the green swath lies." Archdeacon Scott writes a little poem on Easter Island statues which ends in a way that will lift your back hair.

But the poetic imagination cannot remain for long content with this faceless mask of unconsciousness. Nature is not all glacier and iceberg and hurricane; and while there is no conscious cruelty in it, there is certainly a suffering that we can interpret as cruelty. Hence the poet begins to animate nature with an evil or at least sinister power: night in Heavysege becomes a cacodemon, and spring in Dorothy Livesay a crouching monster. Mr. Smith's book is full of ghosts and unseen watchers and spiritual winds: a certain amount of this is faking, but not all: Lampman's "In November," with its ghastly dead mullens and the wonderful danse macabre in which it closes, is no fake. The "crying in the dark" in Lampman's "Midnight," the dead hunter in Eustace Ross's "The Death," the dead "lovely thing" in Neil Tracey's poem, the married corpses in Leo Kennedy's "Epithalamium": all these are visions, not only of a riddle of inexplicable death, but of a riddle of inexplicable evil. Sometimes, of course, this evil takes an easily recognized form: the Indians in Joseph Howe's spirited narrative and the drought wind in Anne Marriott have no spectral overtones. But it is obvious that man must be included in this aspect of the riddle, as it is merely fanciful to separate conscious malice from the human mind. Whatever sinister lurks in nature lurks also in us; and Tom MacInnes's "tiger of desire" and the praying mantis of a remarkable poem by Anne Dalton have been transformed into mental demons.

The unconscious horror of nature and the subconscious horrors of the mind thus coincide: this amalgamation is the basis of symbolism on which nearly all Pratt's poetry is founded. The fumbling and clumsy monsters of his "Pliocene

Armageddon," who are simply incarnate wills to mutual destruction, are the same monsters that beget Nazism and inspire *The Fable of the Goats*; and in the fine "Silences," which Mr. Smith includes, civilized life is seen geologically as merely one clock-tick in eons of ferocity. The waste of life in the death of the Cachalot and the waste of courage and sanctity in the killing of the Jesuit missionaries are tragedies of a unique kind in modern poetry: like the tragedy of Job, they seem to move upward to a vision of a monstrous Leviathan, a power of chaotic nihilism which is "king over all the children of pride." I admit that "Tom the Cat from Zanzibar" in *The Witches' Brew* is good fun, but when Mr. Smith suggests that he is nothing more, I disagree.

In the creepy ambiguity of the first line of Malzah's song in Heavysege, "There was a devil and his name was I," the same association of ideas recurs, and it recurs again in what is perhaps the most completely articulate poem in the book, Lampman's "City of the End of Things"; which, though of course it has no room for the slow accumulation of despair that *The City of Dreadful Night* piles up, is an equally terrifying vision of humanity's Iron Age. In the younger writers the satire on war and exploitation is more conventional and anonymous, but as soon as they begin to speak with more authority they will undoubtedly take their places in the same tradition — Patrick Anderson especially.

To sum up Canadian poetry is at its best a poetry of incubus and *cauchemar*, the source of which is the unusually exposed contact of the poet with nature which Canada provides. Nature is seen by the poet, first as unconsciousness, then as a kind of existence which is cruel and meaningless, then as the source of the cruelty and subconscious stamped-ings within the human mind. As compared with American poets, there has been comparatively little, outside Carman, of the cult of the rugged outdoor life which idealizes nature and tries to accept it. Nature is consistently sinister and menacing in Canadian poetry. And here and there we find glints of a vision beyond nature, a refusal to be bullied by space and time, an affirmation of the supremacy of intelligence and humanity over

stupid power. One finds this in Kenneth Leslie:

> Rather than moulds invisible in the air
> into which petals pour selective milk
> I seem to sense a partnered agony
> of creature and creator in the rose.

One finds it in Dorothy Livesay's apostrophe to the martyred Lorca:

> You dance. Explode
> Unchallenged through the door
> As bullets burst
> Long deaths ago, your breast.

One finds it in Margaret Avison's very lovely "Maria Minor" and her struggle to divine "the meaning of the smashed moth" in a poem which makes an excellent finale to the book. And one begins thereby to understand the real meaning of the martyrdom of Brébeuf, the theme of what with all its faults is the greatest single Canadian poem. Superficially, the man with the vision beyond nature is tied to the stake and destroyed by savages who are in the state of nature, and who represent its mindless barbarity. But there is a far profounder irony to that scene: the black-coated figure at the stake is also a terrifying devil to the savages, *Echon*, the evil one. However frantically they may try to beat him off, their way of savagery is doomed; it is doomed in their Nazi descendants; it is doomed even if it lasts to the end of time.

This is not, I hope, a pattern of thought I have arbitrarily forced upon Canadian poetry: judging from Mr. Smith's book and what other reading I have done this seems to be its underlying meaning, and the better the poem the more clearly it expresses it. Mr. Smith has brought out this inner unity quite unconsciously because it is really there: just as in his "Ode on Yeats" he has, again quite unconsciously, evoked a perfect image of the nature of poetic feeling in his own country:

An old thorn tree in a stony place
Where the mountain stream has run dry,
Torn in the black wind under the race
Of the icicle-sharp kaleidoscopic white sky,
 Bursts into sudden flower.

(1943)

The Narrative Tradition in English-Canadian Poetry

THE CANADIAN POET cannot write in a distinctively Canadian language; he is compelled to take the language he was brought up to speak, whether French, English, or Icelandic, and attempt to adjust that language to an environment which is foreign to it, if not foreign to himself. Once he accepts a language however, he joins the line of poets in the tradition of that language, at the point nearest to his immediate predecessors. A nineteenth-century Canadian poet writing in English will be emulating Keats and Tennyson; writing in French, he will be emulating Victor Hugo or Baudelaire. It may be thought that it would be a pure advantage to the Canadian poet to put an old tongue into a new face; that the mere fact of his being a Canadian would give him something distinctive to say, and enable him to be original without effort. But it is not as simple as that. His poetry cannot be "young," for it is written in a European language with a thousand years of disciplined utterance behind it, and any attempt to ignore that tradition can only lead to disaster. Nor is Canada a "young" country in the sense that its industrial conditions, its political issues, or the general level of its civilization, are significantly different from contemporary Europe. Nevertheless, to the imaginative eye of the creative artist, whether painter or poet, certain aspects of Canada must, for a long time yet, make it appear young. Its landscape does not have, as that of Europe has, that

indefinable quality which shows that it has been lived in by civilized human beings for millennia. Its villages do not "nestle"; they sprawl awkwardly into rectangular lines along roads and railways. Its buildings do not melt into their backgrounds; they stand out with a garish and tasteless defiance. It is full of human and natural ruins, of abandoned buildings and despoiled countrysides, such as are found only with the vigorous wastefulness of young countries. And, above all, it is a country in which nature makes a direct impression on the artist's mind, an impression of its primeval lawlessness and moral nihilism, its indifference to the supreme value placed on life within human society, its faceless, mindless unconsciousness, which fosters life without benevolence and destroys it without malice. There is, of course, much more to be said about nature than this, even by the Canadian artist, but this is an aspect of nature which the sensitive Canadian finds it impossible to avoid. It is all very well for a European poet to see nature in terms of a settled order which the mind can interpret, like Wordsworth, or even in terms of oracular hints and suggestions, like Baudelaire in "*Correspondances*"; but the Canadian poet receives all his initial impressions in the environment of Rimbaud's *Bateau Ivre*.

What the poet sees in Canada, therefore, is very different from what the politician or businessman sees, and different again from what his European contemporaries see. He may be a younger man than Yeats or Eliot, but he has to deal with a poetic and imaginative environment for which, to find any parallel in England, we should have to go back to a period earlier than Chaucer. In certain Old English poems, notably "The Wanderer" and "The Seafarer," there is a feeling which seems to a modern reader more Canadian than English: a feeling of the melancholy of a thinly-settled country under a bleak northern sky, of the terrible isolation of the creative mind in such a country, of resigning oneself to hardship and loneliness as the only means of attaining, if not serenity, at least a kind of rigid calm. It is a feeling which in later centuries becomes very rare, though there is something of it in some romantic poems, such as Keats's "La Belle Dame Sans Merci."

Now of course modern Canadian life is far less simple and homogeneous than Old English life. The Canadian poet, though he must try to express something of what the Old English poet felt, cannot afford to forget either that a highly sophisticated civilization is as much a part of Canadian life as deep snow and barren spaces. If we can imagine a contemporary of the *Beowulf* poet, with equal genius and an equally strong urge to write an archaic epic of the defeat of a monster of darkness by a hero of immense strength and endurance — a theme which should appeal powerfully to a Canadian — yet writing for the same public as Ovid and Catullus, and forced to adapt their sophisticated witticisms and emotional refinements to his own work, we shall begin to get some idea of what the Canadian poet is up against.

This is why nearly all good Canadian poets have much less simple poetic natures than they appear to have at first glance. The "framework" of Lampman, for instance, is that of a placid romantic nature poet beating the track of Wordsworth and Keats. But there are also in Lampman many very different characteristics. He has, for instance, a spiritual loneliness, a repugnance to organized social life, which goes far beyond mere discontent with his provincial environment. This is a quality in Lampman which links him to the great Canadian explorers, the solitary adventurers among solitudes, and to the explorer-painters like Thomson and Emily Carr who followed them, with their eyes continually straining into the depths of nature. And in the terrible clairvoyance of "The City of the End of Things," a vision of the Machine Age slowly freezing into idiocy and despair, something lives again of the spirit of the Old English Wanderer, who, trudging from castle to castle in the hope of finding food and shelter in exchange for his songs, turned to the great Roman ruins, the "eald enta geweorc" (the ancient work of giants), to brood over a greater oppression of man by nature than his own.

Similarly, the "framework" of Isabella Crawford is that of an intelligent and industrious female songbird of the kind who filled so many anthologies in the last century. Yet the "South Wind" passage from *Malcolm's Katie* is only the most

famous example of the most remarkable mythopoeic imagination in Canadian poetry. She puts her myth in an Indian form, which reminds us of the resemblance between white and Indian legendary heroes in the New World, between Paul Bunyan and Davy Crockett on the one hand and Glooscap on the other. The white myths are not necessarily imitated from the Indian ones, but they may have sprung from an unconscious feeling that the primitive myth expressed the imaginative impact of the country as more artificial literature could never do.

Some of the same affinities appear in those aspects of our literature that a poet would naturally be most interested in, though very few of them have received adequate poetic treatment. The martyrdom of the Jesuit missionaries, the holding of the Long Sault against the Iroquois, the victories over incredible odds in the War of 1812, the desperate courage of the Indians who died with Tecumseh and Riel, the 1837 outbreak, the fight without gasmasks against gas at St. Julien, the spear-heading of the plunge into Amiens, the forlorn hope at Dieppe — there is a certain family resemblance among all these events which makes each one somehow typical of Canadian history. Is there not something in the character of such themes that recalls the earliest poetry of our mother countries, of the lost battle of Maldon where courage grew greater as the strength ebbed away, or of the reckless heroism at Roncesvalles which laid the cornerstone of French literature? It is perhaps not an accident that the best known of all Canadian poems, "In Flanders' Fields," should express, in a tight, compressed, grim little rondeau, the same spirit of an inexorable ferocity which even death cannot relax, like the old Norse warrior whose head continued to gnash and bite the dust long after it had been severed from his body.

Hence it is at least possible that some of the poetic forms employed in the earlier centuries of English literature would have been more appropriate for the expression of Canadian themes and moods than the nineteenth-century romantic lyric or its twentieth-century metaphysical successor. It is inevitable that Canadian poetry should have been cast in the conventional forms of our own day; but though the bulk of it

is lyrical in form, a great deal of it is not lyrical in spirit, and when a Canadian poem has failed to achieve adequate expression, this may often be the reason. It has been remarked, for instance, that sexual passion is a theme that our poets have not treated very convincingly. This emotion is also lacking in Old English poetry, and perhaps for some of the same reasons. But sexual passion is one of the essential themes of the lyric: Canadian poetry is lyrical in form and Old English poetry is not, hence the failure to deal with sexual passion is felt as a lack in Canadian poetry but is not missed in Old English. On the other hand, it occasionally happens that a successful Canadian poem has owed its success to its coincidence, deliberate or otherwise, with one of the forms of pre-Chaucerian literature. Thus Drummond's best poem, "The Wreck of the Julie Plante," is not merely a modern imitation of the ballad; it has the tough humour and syncopated narrative of the authentic ballad at its best. Consider too the subjects of many of D. C. Scott's finest poems, the lovers destroyed in a log jam, the lonely Indian murdered in the forest for his furs, the squaw who baits a fish hook with her own flesh to feed her children. These are ballad themes; and his longest poem *Dominique de Gourges*, a narrative filled with the sombre exultation of revenge, is curiously archaic in spirit for the author of a poem on Debussy. Something medieval has also crept in to the religious emotions of A. J. M. Smith and to Leo Kennedy's exercises in the macabre.

All this may help to explain a phenomenon of our poetry which must have puzzled many of its students. In looking over the best poems of our best poets, while of course the great majority are lyrical, we are surprised to find how often the narrative poem has been attempted, and attempted with uneven but frequently remarkable success. I say surprised, because good narratives are exceedingly rare in English poetry — except in the period that ended with the death of Chaucer. And this unusual prominence of the narrative is one of the things that makes Canadian poetry so hard to criticize with the right combination of sympathy and judgement. We tend to form our canons of criticism on carefully polished poetry,

but such standards do not always apply to the narrative, for the test of the great narrative is its ability to give the flat prose statement a poetic value. And as there has been no connected tradition of narrative in English literature since 1400, the Canadian poet who attempts the form has to depend largely on his own originality, and no one except Pratt has worked hard enough and long enough at the form to discover its inherent genius. Hence among Canadian narratives there are many failures and many errors of taste and stretches of bad writing, but to anyone who cares about poetry there may be something more interesting in the failure than in a less ambitious success.

At the outset of Canadian literature we find many long poems, Goldsmith's *Rising Village*, O'Grady's brilliant but unfinished *Emigrant*, Howe's *Acadia*, also unfinished, and two dramatic poems by Duvar, *The Enamorado* and *De Roberval*, the last of which illustrate the fact that the Canadian narrative is frequently cast in the form of dialogue or literary drama. All of these follow well established European conventions, and so do the first two productions of the clumsy but powerfully built genius of Heavysege. *Saul* belongs to the tradition of the Victorian leviathan, the discursive poem combining a Biblical subject with middle-class morality, represented by the better known Bailey's *Festus*. *Count Filippo*, too, is in the manner of nineteenth-century reactions to Jacobean drama and the Italian Renaissance, and might almost have served as the model for Max Beerbohm's *Savonarola Brown*. But *Jephthah's Daughter*, his third effort, strikes its roots deeply into Canada, and is the real commencement of a distinctively Canadian form of the narrative poem.

Heavysege begins by saying that the story of Jephthah's daughter is very similar to the story of Iphigenia, and that he has chosen the Hebrew legend because there is a spiritual loneliness about it which attracts him more profoundly. Iphigenia was sacrificed in the midst of great bustle and excitement, and was, as Samuel Johnson said of the victim at a public hanging, sustained by her audience: Jephthah's daughter is destroyed by the mute anguish of uncomprehending superstition. To

Heavysege, a man who, like Jephthah, worships a God who demands fulfilment of a rash vow of sacrifice even if it involves his own daughter, is really a man in the state of nature: he has identified his God, if not with nature, at any rate with a mindless force of inscrutable mystery like nature, and all Jephthah's questionings and searchings of spirit are the looks of intelligence directed at blankness, the attempts of a religious pioneer to find a spiritual portage through the heart of darkness. The passage in which Heavysege described this most clearly cannot be beaten in James Thomson for the sheer starkness of its mood, a grimness that is far deeper than any ghost-haunted horrors. Jephthah prays to be delivered from the blood of his daughter, and asks for a sign of divine mercy. There is a slight pause, then Jephthah hears:

> The hill-wolf howling on the neighbouring height,
> And bittern booming in the pool below.

That is all the answer he gets.

In this poem Heavysege has put together certain essential ideas: the contrast of human and civilized values with nature's disregard of them in a primitive country, the tendency in the religion of such a country for God to disappear behind the mask of nature, and the symbolic significance, when that happens, of human sacrifice and the mutilation of the body (a theme already elaborated by Heavysege in the episode in *Saul* about the hewing of Agag in pieces). Once one has carefully read this narrative, the essential meaning of many fine Canadian poems leaps out of its derivative and conventional context. Thus in Isabella Crawford's *Malcolm's Katie* there is a superbly ironic scene in which the hero sings of the irresistible advance of capitalist civilization and its conquest of nature, symbolized by the axe, and links his exuberant belief in the enduring power of the nation he is building with his belief in the enduring power of his love for the heroine. He is answered by the villain, in a passage of far greater eloquence, who points out the cyclic progress of all empires from rise to decline and the instability of woman's love. As the hero turns

indignantly to refute his slanders, the tree which he has not quite chopped down falls on him and crushes him. True, he recovers and marries the heroine and forgives the villain and lives happily ever after and love conquers all and nature is grand, but somehow the poem reaches an imaginative concentration in that scene which it never afterwards recaptures. In the same poem the heroine is caught in a log jam, and, though of course she is rescued, the sudden glimpse of the trap of nature, the endless resources it has for suddenly and unconsciously destroying a fragile and beautiful human life, is far more effective without the rescue, and is so developed in D. C. Scott's "At the Cedars."

Mair's *Tecumseh* and Lampman's "At the Long Sault" apply the same pattern to Canadian history. The former has been charged with lack of unity, but the theme of the drama is the sacrifice of Tecumseh, to which everything else leads up, the various conflicts between his own fierce loyalties and the vacillations of his friends and enemies being merely the struggles of a doomed victim who now arouses and now disappoints our hopes for his escape. Lampman, too, seems most deeply impressed, not only by the sacrificial nature of what the Long Sault heroes did, which is obvious enough, but by its symbolic connection with, again, a state of nature in which the higher forms of life are so often destroyed by the lower. That is why he introduces the beautiful picture of the moose pulled down by wolves, the symbol of the exceptional and unblemished hero who falls a victim to the agents of a careless fate.

Pratt has studied the technique and resources of the narrative form more carefully than his predecessors, and so it is not surprising to find the themes we have been tracing much more explicitly set forth in his work. He delights in describing big and even monstrous things, and whenever he can he shows them exulting in their strength. In the antics of Tom the Cat from Zanzibar in *The Witches' Brew*, in the almost equally feline sense of relaxed power in "The 6000," in the ferocious but somehow exuberant massacres in *The Great Feud*, there is more enthusiasm than in his other works, for naturally

he greatly prefers the Othellos of this world to the Iagos, and hates to see the latter victorious. But the Canadian narrative demands a tragic resolution. *The Cachalot* is not perhaps a tragic poem, but is there really so much moral difference between the whale caught by men and the moose in Lampman pulled down by wolves? In *The Titanic* the mindlessness of the agent of destruction is the imaginative centre of the poem: the tragic theme of hybris, the punishment of man by fate for his presumption in defying it, is, though a very obvious and in fact ready-made aspect of the theme, deliberately played down. If *Dunkirk* seems less wholly convincing than some of his other narratives, it may well be because the absence of the theme of wasted life gives it a resolutely optimistic quality which seems rather forced, more the glossed and edited reporter's story than the poet's complete and tragic vision.

Brébeuf is not only the greatest but the most complete Canadian narrative, and brings together into a single pattern all the themes we have been tracing. Here the mutilation and destruction of the gigantic Brébeuf and the other missionaries is a sacrificial rite in which the Indians represent humanity in the state of nature and are agents of its unconscious barbarity. It is curious that, just as the poet minimizes the theme of hybris in *The Titanic,* so in *Brébeuf* he minimizes the awareness of the Indians, their feeling that they are disposing of a real enemy, a black-coated emissary of an unknown God and an unknown race that may soon wipe them out. In any case, Indians, even Iroquois, are not merely wolves; and while the conflict of mental and physical values is certainly present, there is a greater range of suggestiveness. In the first place, the scene is related to its universal archetype: Brébeuf is given the courage to endure the breaking of his body because the body of God was in a very similar way broken for him. Thus the essential tragedy of Jephthah's daughter, as a pointless and useless waste of life, ceases to exist. In the second place, the Indians represent the fact that the unconscious cruelty of nature is recreated by the partly conscious cruelties of ignorant and frightened men. This point is already implicit in *Jephthah's Daughter*; we have seen that Jephthah is really

sacrificing his daughter to nature. But it is clearer here, and it is clear too that the monsters of *The Great Feud*, who are animated only by an impulse to mutual destruction, prefigure the stampeding and maniacal fury of Nazism as much as their descendants in *The Fable of the Goats* do.

In *Brébeuf* the poet makes a comment which may well be prophetic for the future of Canadian poetry:

> The wheel had come full circle with the visions
> In France of Brébeuf poured through the mould of St. Ignace.

For a wheel does come full circle here: a narrative tradition begotten in the nineteenth century, and heir to all the philosophical pessimism and moral nihilism of that century, reaches its culmination in *Brébeuf* and is hardly capable of much future development. True, Birney's *David* is a fine example of the same sort of tragedy that is in "At the Cedars" or even *The Titanic*, and in the phrase "the last of my youth" with which the poem ends there is even a faint suggestion of a sacrificial symbolism. And in Anne Marriott's *The Wind Our Enemy*, it is significant that the enemy is still the wind rather than the forces of economic breakdown that helped to create the wind. But neither of these poets seem likely to go on with this theme, and in such poems as "The Truant," where man confronts the order of nature undismayed, it is evident that Pratt is abandoning it too. The poet's vision of Canada as a pioneer country in which man stands face to face with nature is bound to be superseded by a vision of Canada as a settled and civilized country, part of an international order, in which men confront the social and spiritual problems of men. That this development is now taking place and will greatly increase in future needs no detailed proof: but it is to be hoped that the poets who do deal with it will maintain an interest in the traditional narrative form. For the lyric, if cultivated too exclusively, tends to become too entangled with the printed page: in an age when new contacts between a poet and his public are opening up through radio, the narrative, as a form peculiarly well adapted for public reading, may play an impor-

tant role in reawakening a public respect for and response to poetry. There are values in both tradition and experiment, and in both the narrative has important claims as Canadian poetry hesitates on the threshold of a new era.

(1946)

Turning New Leaves

THIS IS THE FIRST COLLECTION of Canadian folk songs* which attempts to cover the whole country and is designed for the general public. To have produced such a book at all is a public service; to produce it with such competence is a feat that leaves a reviewer (unless he has the special knowledge of the field that the present one has not) little to say that is not better said in the two introductions.

To come at it from the outside, the book is an attractive physical object, illustrated with drawings and end papers by Elizabeth Wilkes Hoey which are cheerful without being cute. The printing of both words and music is clear, and the editor's comments, printed in a box at the end, tell you exactly what you want to know. Mrs. Fowke's knowledge of her subject is almost as complete as the average Canadian's ignorance of it, yet her scholarship is quiet and unobtrusive. She has humour but no condescension; she is appreciative but never writes advertising copy. Dr. Johnston's settings are simple and unpretentious, partly because he has the guitar as well as the piano in mind. The piano scores nearly always contain the tune, so that the reader can try them out on a piano without having to struggle with three lines of music. The French songs are given

*Folk Songs of Canada; edited by Edith Fulton Fowke and Richard Johnston; Waterloo Music Company; pp. 198; 1954.

both in the French and in English translations, the latter being better than most of the translations we know, especially when Mrs. Fowke does them. The book deserves a long career in Canadian schools and homes, and future editions can improve it in the way that it can best be improved, by enlarging it.

The term "folk song" in the title has been most hospitably interpreted. Drummond's "Wreck of the Julie Plante," Tom Moore's "Canadian Boat Song'" and the "Huron Carol" are all included, quite properly, because the ordinary reader would expect to find them there. The silly and pedantic cliché that all true folk songs must be anonymous has been ignored. The cliché itself is based on a conception of ballads and folk songs as "communal" compositions which has been defunct for half a century. (One leading Canadian authority on the ballad who repudiated this view of it was Dr. John D. Robins, to whom the book is dedicated.) As Mrs. Fowke says, Canada affords an admirable opportunity to watch the folk song going through its various stages, from original composition to pure oral transmission.

So we have in this book variants of the canon of great ballads, traditional tunes set to new words, traditional themes reshaped on a new historical event, such as a shipwreck or the death of a lumberjack, individual contributions to the folk song idiom (several songs from Newfoundland by identified authors, such as "The Squid-Jiggin' Ground," are included), broadsides and naive newspaper verse ("The Badger Drive"), commercial songs that have stuck in the popular memory, intellectuals' parodies of folk themes ("The Day Columbus Landed Here," "Unfortunate Miss Bailey") — in short, the real unselected complex of genuine popular song. The tunes are equally various — the tight, precise little French tunes, hardly moving out of a major third in range, the lovely modal melodies like the mixolydian "The Blooming Bright Star of Belle Isle" and the swinging dorian "Lumber Camp Song," the six-eight Irish jig tunes from Newfoundland, the Western patter songs, and the more stretchy and lugubrious nineteenth-century tunes of the *Heart Songs* persuasion ("The Red River Valley," and "Bury Me Not on the Lone Prairie").

Naturally the book is based on the systematic collections of folk songs that have already been made. It is regrettable that the three thousand transcribed Indian and Eskimo tunes are so sparsely represented here, though one can see the reason for it in a book designed for the general public. Elsewhere, the collecting of ballads has been confined to Newfoundland, Nova Scotia and French Canada. "No systematic collecting of songs from any region west of Quebec has yet been under-taken," says Mrs. Fowke, but her book indicates a surprising richness in the Ontario field, chiefly in the northern lumber camps. The Western songs, as she also says, are largely American imports, though some of her specimens are still uncollected in the States ("Smoky Mountain Bill," for instance, can only have come from the Smokies in Tennessee).

It is not easy to see any "distinctively Canadian" quality to the Canadian folk song, particularly as the most distinctive thing about the folk song is its ability to travel over all cultural, and even linguistic, barriers. (One is startled to learn that an American authority assigns "The Jam on Gerry's Rock" to Canada on the ground that it portrays lumberjacks as unwilling to break a log jam on Sunday.) Newfoundland and Nova Scotia have preserved many fine variants of the standard English ballads (see "The False Young Man" and an excellent version of the Riddle Song in this book), and occasionally an ancient ballad has survived only in Canada (three of these, "The Bonny Banks of Virgie O," "The Morning Dew" and "She's Like the Swallow" are worth the price of admission in themselves to anyone seriously interested in ballads). The whole colonial phase of Canada's history, its invasion by English and French cultures, is of course fully represented in its folk song. One wonders how many Canadians know the "Brave Wolfe" song, with its delicate romantic theme and its lovely aeolian tune that sounds almost Hebridean. The War of 1812, the Rebellion of 1837, Confederation (from an unreconstructed Newfoundland point of view), the Negro slave refugees, and various tales of logging, shipping, fishing and ranching are all included. Another important aspect of our history is here too: Canadian life and climate as they

appeared to disgruntled outsiders. In our poetry we have Standish O'Grady; in our prose Susanna Moodie; in our folk song (we may call it ours by reversion) we have:

> And now the winter's over, it's homeward we are bound,
> And in this cursed country we'll never more be found.
> Go back to your wives and sweethearts, tell others not to go
> To that God-forsaken country called Canaday-I-O.

Presumably those who remained were of sterner stuff, and we are not surprised to find so much tough humour and realism. The reason for this is partly that folk song is essentially a public and dramatic genre: the most subjective emotion it admits is sexual love. Here the unpredictable genius of oral transmission occasionally turns into a breathtaking beauty, as in the last line of:

> She's like the swallow that flies so high,
> She's like the river that never runs dry,
> She's like the sunshine on the lee shore,
> I love my love and love is no more.

But this kind of felicity is very rare, and the sense of isolation and loneliness, the feeling of the waste and indifference of nature, which is so marked in the more urban poetry, is largely absent from the folk song. There is tragedy, heroism and pathos, but what loneliness there is arises simply from want of company (as in "The Little Old Sod Shanty"), or from rejected love (as in the Housman-like "The Stormy Scenes of Winter") or from premature death (as in "Peter Amberley") — all socially-directed feelings. The most notable poetic feature is a kind of grim irony that falls just short of satire.

This takes various forms — it is simplest, of course, in the sagas of the bucked-off Western tenderfoot and the unfortunate bumpkin José Blais (in "Le Bal Chez Boulé"). Occasionally, though not often in this deadpan northern country, it turns into fantasy or riddle, and it would be interesting to know what a future historian would make of this:

Were you ever in Quebec
Stowing timber on the deck,
Where there's a king with a golden crown,
 Riding on a donkey?

But the real basis of the irony is something that we rarely have in the poetry that is published in books, as books form part of a money economy. Newfoundland, Nova Scotia and French Canada are food-producing communities where money is an alien, sinister, intrusive thing, controlled by crafty foreigners with a vicious knack of making more of it for themselves and less of everything for everybody else. We meet this situation in the very first song in the book:

"Marchand, marchand, combien ton blé?"
"Trois francs l'avoin', six francs le blé."
"C'est bien trop cher d'un' bonn' moitié."

We meet it again in a delightful bit that could only have come from one place in the world, south-eastern Newfoundland:

"Oh mother dear, I wants a sack
With beads and buttons down the back . . .
Me boot is broke, me frock is tore,
But Georgie Snooks I do adore . . .
Oh, fish is low and flour is high,
So Georgie Snooks he can't have I."

And hence even love is expressed in ironic terms. There is no Sehnsucht or Leidenschaft or Weltschmerz in this, but there is something much more permanent:

Oh, had I but a flask of gin
 With sugar here for two,
And a great big bowl for to mix it in,
 I'd pour a drink for you, my dear, Mary Ann!

Now that the log-jam has been broken, so to speak, by the

efforts of Mrs. Fowke and Dr. Johnston, one looks for an
increase of public interest in Canadian folk song, and hence,
not only for other popular collections, but for further editions
of this one that will not be restricted to seventy-seven titles.
There are still quantities of wonderful stuff in the Creighton,
Greenleaf and Barbeau collections, as no one knows better
than these editors. It is particularly in the French section that
the present books shows a tendency to stick to somewhat
hackneyed favorites — though again a collection for the gen-
eral public could not leave out "A la Claire Fontaine" or "En
Roulant Ma Boule," to say nothing of "Alouette." Again, there
is an enormous amount of work still to be done in the field,
and to foster public interest is the best way of insuring that it
will be done. Meanwhile, when the blurb calls this book "a
major contribution to Canadian culture," one can only agree.

(1954)

Preface to an Uncollected Anthology

The author imagines that he has collected his ideal anthology of English Canadian poetry, with no difficulties about permissions, publishers, or expense, and is writing his preface.

CERTAIN CRITICAL PRINCIPLES are essential for dealing with Canadian poetry which in the study of English literature as such are seldom raised. Unless the critic is aware of the importance of these principles, he may, in turning to Canadian poets, find himself unexpectedly incompetent, like a giraffe trying to eat off the ground. The first of these principles is the fact that the cultivated Canadian has the same kind of interest in Canadian poetry that he has in Canadian history or politics. Whatever its merits, it is the poetry of his own country, and it gives him an understanding of that country which nothing else can give him. The critic of Canadian literature has to settle uneasily somewhere between the Canadian historian or social scientist, who has no comparative value-judgments to worry about, and the ordinary literary critic, who has nothing else. The qualities in Canadian poetry which help to make Canada more imaginatively articulate for the Canadian reader are genuine literary values, whether they coincide with other literary values or not. And while the reason for collecting an anthology can only be the merit of the individual poems, still, having made such a collection, one may

legitimately look at the proportioning of interests, at the pattern of the themes that seem to make Canadian poets eloquent.

It is not a nation but an environment that makes an impact on poets, and poetry can deal only with the imaginative aspect of that environment. A country with almost no Atlantic seaboard, which for most of its history has existed in practically one dimension; a country divided by two languages and great stretches of wilderness, so that its frontier is a circumference rather than a boundary; a country with huge rivers and islands that most of its natives have never seen; a country that has made a nation out of the stops on two of the world's longest railway lines: this is the environment that Canadian poets have to grapple with, and many of the imaginative problems it presents have no counterpart in the United States, or anywhere else.

In older countries the works of man and of nature, the city and the garden of civilization, have usually reached some kind of imaginative harmony. But the land of the Rockies and the Precambrian Shield impresses painter and poet alike by its raw colours and angular rhythms, its profoundly unhumanized isolation. It is still "The Lonely Land" to A. J. M. Smith, still "A Country without a Mythology" to Douglas LePan. The works of man are even more imaginatively undigested. A Canadian village, unlike an English one, sprawls awkwardly along a highway or railway line, less an inhabited centre than an episode of communication. Its buildings express an arrogant defiance of the landscape; its roads and telephone wires and machinery twist and strangle and loop. Irving Layton says, looking at an abstract picture,

> When I got the hang of it
> I saw a continent of railway tracks
> coiling about the sad Modigliani necks
> like disused tickertape, the streets
> exploding in the air
> with disaffected subway cars.

The Wordsworth who saw nature as exquisitely fitted to the human mind would be lost in Canada, where what the poets

see is a violent collision of two forces, both monstrous. Earle
Birney describes the bulldozers of a logging camp as "iron
brontosaurs"; Klein compares grain elevators to leviathans.

Poets are a fastidious race, and in Canadian poetry we have
to give some place, at least at the beginning, to the anti-
Canadian, the poet who has taken one horrified look at the
country and fled. Thus Standish O'Grady, writing of *The
Emigrant*:

> Here forests crowd, unprofitable lumber,
> O'er fruitless lands indefinite as number;
> Where birds scarce light, and with the north winds veer
> On wings of wind, and quickly disappear,
> Here the rough Bear subsists his winter year,
> And licks his paw and finds no better fare. . . .
> The lank Canadian eager trims his fire,
> And all around their simpering stoves retire;
> With fur clad friends their progenies abound,
> And thus regale their buffaloes around;
> Unlettered race, how few the number tells,
> Their only pride a cariole and bells. . . .
> Perchance they revel; still around they creep,
> And talk, and smoke, and spit, and drink, and sleep!

There is a great deal of polished wit in these couplets of the
modern ambiguous kind: the word "lumber," for example, has
both its Canadian meaning of wood and its English meaning
of junk. We notice that "Canadian" in this poem means French
Canadian habitant: O'Grady no more thinks of himself as Can-
adian than an Anglo-Indian colonel would think of himself as
Hindu. Here is an American opinion, the close of a folk song
about a construction gang that spent a winter in Three Rivers:

> And now the winter's over, it's homeward we are bound,
> And in this cursed country we'll never more be found.
> Go back to your wives and sweethearts, tell others not to go
> To that God-forsaken country called Canaday-I-O.

Thanks to the efforts of those who remained, this particular theme is now obsolete, although Norman Levine in 1950 spoke of leaving the land of "parchment summers and merchant eyes" for "the loveliest of fogs," meaning England. Still, it will serve as an introduction to two central themes in Canadian poetry: one a primarily comic theme of satire and exuberance, the other a primarily tragic theme of loneliness and terror.

It is often said that a pioneering country is interested in material rather than spiritual or cultural values. This is a cliché, and it has become a cliché because it is not really true, as seventeenth-century Massachusetts indicates. What is true is that the imaginative energy of an expanding economy is likely to be mainly technological. As a rule it is the oppressed or beleaguered peoples, like the Celts and the Hebrews, whose culture makes the greatest imaginative efforts: successful nations usually express a restraint or a matter-of-fact realism in their culture and keep their exuberance for their engineering. If we are looking for imaginative exuberance in American life, we shall find it not in its fiction but in its advertising; not in Broadway drama but in Broadway skyscrapers; not in the good movies but in the vista-visioned and technicoloured silly ones. The extension of this life into Canada is described by Frank Scott in "Saturday Sundae," by James Reaney in "Klaxon," a fantasy of automobiles wandering over the highways without drivers, "Limousines covered with pink slime/Of children's blood," and by many other poets.

The poet dealing with the strident shallowness of much Canadian life is naturally aware that there is no imaginative change when we cross the American border in either direction. Yet there is, I think, a more distinctive attitude in Canadian poetry than in Canadian life, a more withdrawn and detached view of that life which may go back to the central fact of Canadian history: the rejection of the American Revolution. What won the American Revolution was the spirit of entrepreneur capitalism, an enthusiastic plundering of the natural resources of a continent and an unrestricted energy of

manufacturing and exchanging them. In *A Search for America*, which is quite a profound book if we take the precaution of reading it as a work of fiction, Grove speaks of there being two Americas, an ideal one that has something to do with the philosophy of Thoreau and the personality of Lincoln, and an actual one that made the narrator a parasitic salesman of superfluous goods and finally a hobo. At the end of the book he remarks in a footnote that his ideal America has been preserved better in Canada than in the United States. The truth of this statement is not my concern, but some features of my anthology seem to reflect similar attitudes.

In the United States, with its more intensively indoctrinated educational system, there has been much rugged prophecy in praise of the common man, a tradition that runs from Whitman through Sandburg and peters out in the lugubrious inspirationalism of the Norman Corwin school. Its chief characteristics are the praise of the uncritical life and a manly contempt of prosody. One might call it the Whitmanic-depressive tradition, in view of the fact that it contains Robinson Jeffers. It seems to me significant that this tradition has had so little influence in Canada. I find in my anthology a much higher proportion of humour than I expected when I began: a humour of a quiet, reflective, observant type, usually in a fairly strict metre, and clearly coming from a country which observes but does not act a major role in the world.

A song from a poem by Alexander McLachlan called, like O'Grady's, "The Emigrant," will illustrate what I mean:

> I love my own country and race,
>> Nor lightly I fled from them both,
> Yet who would remain in a place
>> Where there's too many spoons for the broth.
>
> The squire's preserving his game.
>> He says that God gave it to him,
> And he'll banish the poor without shame,
>> For touching a feather or limb. . . .

> The Bishop he preaches and prays,
>> And talks of a heavenly birth,
> But somehow, for all that he says,
>> He grabs a good share of the earth.

In this poem there is nothing of the typically American identi-
fication of freedom with national independence: the poet is still
preoccupied with the old land and thinks of himself as
still within its tradition. There is even less of the American
sense of economic competition as the antidote to social
inequality. The spirit in McLachlan's poem is that of a tough
British radicalism, the radicalism of the Glasgow dock worker
or the Lancashire coal miner, the background of the Tom
Paine who has never quite fitted the American way of life.

It is not surprising to find a good deal of satiric light verse
in this imaginative resistance to industrial expansion and the
gum-chewing way of life. Frank Scott we have mentioned: his
"Canadian Social Register" is a ferocious paraphrase of an
advertising prospectus, and his "Social Notes" are also some-
thing un-American, social poems with an unmistakably social-
ist moral. The observations of Toronto by Raymond Souster
and of Montreal by Louis Dudek, Miriam Waddington, and
Irving Layton have much to the same effect: of golfers Layton
remarks "that no theory of pessimism is complete/Which
altogether ignores them." But of course it is easy for the same
satiric tone to turn bitter and nightmarish. Lampman's
terrible poem, "The City of the End of Things," is not only
social but psychological, and warns of the dangers not simply
of exploiting labour but of washing our own brains. There are
other sinister visions in A. J. M. Smith's "The Bridegroom," in
Dudek's "East of the City," in Dorothy Livesay's "Day and
Night," in P. K. Page's "The Stenographers," and elsewhere.
Canadian poems of depression and drought, like Dorothy
Livesay's "Outrider" or Anne Marriott's *The Wind Our Enemy*,
often have in them the protest of a food-producing
community cheated out of its labour not simply by hail
and grasshoppers but by some mysterious financial finagling
at the other end of the country, reminding us of the man in

Balzac's parable who could make his fortune by killing some-
body in China.

There are of course more positive aspects of industrial
expansion. In Canada the enormous difficulties and the cen-
tral importance of communication and transport, the tremen-
dous energy that developed the fur trade routes, the empire of
the St. Lawrence, the transcontinental railways, and the north-
west police patrols have given it the dominating role in the
Canadian imagination. E. J. Pratt is the poet who has best
grasped this fact, and his *Towards the Last Spike* expresses the
central comic theme of Canadian life, using the term "comic"
in its literary sense as concerned with the successful accom-
plishing of a human act.

The imagery of technology and primary communication is
usually either avoided by poets or employed out of a sense of
duty: its easy and unforced appearance in Pratt is part of the
reason why Pratt is one of the few good popular poets of our
time. Technology appears all through his work, not only in
the poems whose subjects demand it, but in other and more
unexpected contexts. Thus in "Come Away, Death":

> We heard the tick-tock on the shelf,
> And the leak of valves in our hearts.

In "The Prize Cat," where a cat pounces on a bird and
reminds the poet of the deliberately summoned-up brutality
of the Fascist conquest of Ethiopia, the two themes are
brought together by the inspired flash of a technical word:

> Behind the leap so furtive-wild
> Was such ignition in the gleam
> I thought an Abyssinian child
> Had cried out in the whitethroat's scream.

As a student of psychology, before he wrote poetry at all, he
was preoccupied with the problems of sensory response to sig-
nals, and the interest still lingers in the amiable joggle of
"No. 6000," one of the liveliest of all railway poems:

A lantern flashed out a command,
A bell was ringing as a hand
Clutched at a throttle, and the bull,
At once obedient to the pull,
Began with bellowing throat to lead
By slow accelerating speed
Six thousand tons of caravan
Out to the spaces — there to toss
The blizzard from his path across
The prairies of Saskatchewan.

In *Behind the Log*, Canadians undertake a mission of war in much the spirit of an exploration: there is a long journey full of perils, many members of the expedition drop off, and those that reach the goal feel nothing but a numb relief. Nothing could be less like the charge of the Light Brigade. Yet perhaps in this poem we may find a clue to the fact that Canada, a country that has never found much virtue in war and has certainly never started one, has in its military history a long list of ferocious conflicts against desperate odds. Douglas LePan's "The Net and the Sword," the title poem of a book dealing with the Italian campaign of the Second World War, mentions something similar:

In this sandy arena, littered
And looped with telephone wires, tank-traps, mine-fields,
Twined about the embittered
Debris of history, the people whom he shields
Would quail before a stranger if they could see
His smooth as silk ferocity.

LePan finds the source of the ferocity in the simplicity of the Canadian soldier's vision: "Skating at Scarborough, summers at the Island," but perhaps it is also a by-product of engineering exuberance. We notice that the looped litter of telephone wires and the like belongs here to Europe, not to Canada, and the same kind of energy is employed to deal with it.

The tragic themes of Canadian poetry have much the same

origin as the comic ones. The cold winter may suggest tragedy, but it may equally well suggest other moods, and does so in Lampman's sonnet "Winter Evening," in Patrick Anderson's "Song of Intense Cold," in Roberts' "The Brook in February," in Klein's "Winter Night: Mount Royal," and elsewhere. Other seasons too have their sinister aspects: none of Lampman's landscape poems is finer than his wonderful Hallowe'en vision of "In November," where a harmless pasture full of dead mullein stalks rises and seizes the poet with the spirit of an eerie witches' sabbath:

> And I, too, standing idly there,
> With muffled hands in the chill air
> Felt the warm glow about my feet,
> And shuddering betwixt cold and heat,
> Drew my thoughts closer, like a cloak,
> While something in my blood awoke,
> A nameless and unnatural cheer,
> A pleasure secret and austere.

Still, the winter, with its long shadows and its abstract black and white pattern, does reinforce themes of desolation and loneliness, and more particularly, of the indifference of nature to human values, which I should say was the central Canadian tragic theme. The first poet who really came to grips with this theme was, as we should expect, Charles Heavysege. Heavysege's first two long poems, *Saul* and *Count Filippo*, are Victorian dinosaurs in the usual idiom: *Count Filippo*, in particular, like the Albert Memorial, achieves a curious perverted beauty by the integrity of its ugliness. His third poem, *Jephthah's Daughter*, seems to me to reflect more directly the influence of his Canadian environment, as its main themes are loneliness, the indifference of nature, and the conception of God as a force of nature. The evolutionary pessimism of the nineteenth century awoke an unusual number of echoes in Canada, many of them of course incidental. In a well-known passage from Charles Mair's *Tecumseh*, Lefroy is describing the West to Brock, and Brock comments: "What charming solitudes! And life was

there!" and Lefroy answers: "Yes, life was there! inexplicable
life,/Still wasted by inexorable death"; and the sombre
Tennysonian vision of nature red in tooth and claw blots out
the sentimental Rousseauist fantasy of the charming solitudes.

In the next generation the tragic theme has all the more
eloquence for being somewhat unwanted, interfering with the
resolutely cheerful praise of the newborn giant of the north.
Roberts, Wilfred Campbell, Wilson Macdonald, and Bliss
Carman are all romantics whose ordinary tone is nostalgic,
but who seem most deeply convincing when they are darkest
in tone, most preoccupied with pain, loss, loneliness, or waste.
We notice this in the poems which would go immediately into
anyone's anthology, such as Campbell's "The Winter Lakes,"
Wilson Macdonald's "Exit," Carman's "Low Tide on Grand
Pré." It is even more striking when Carman or Roberts writes
a long metrical gabble that occasionally drops into poetry, like
Silas Wegg, as it is almost invariably this mood that it drops
into. Thus in Roberts' "The Great and the Little Weavers":

> The cloud-rose dies into shadow,
> The earth-rose dies into dust.

The "great gray shape with the paleolithic face" of Pratt's
Titanic and the glacier of Birney's *David* are in much the same
tradition as the gloomy and unresponsive nature of *Jephthah's
Daughter*. In fact the tragic features in Pratt mainly derive from
his more complex view of the situation of Heavysege's poem.
Man is also a child of nature, in whom the mindlessness of the
animal has developed into cruelty and malice. He sees two
men glare in hatred at one another on the street, and his
mind goes

> Away back before the emergence of fur or feather, back to the
> unvocal sea and down deep where the darkness spills its
> wash on the threshold of light, where the lids never close
> upon the eyes, where the inhabitants slay in silence and are
> as silently slain.

From the very beginning, in *Newfoundland Verse*, Pratt was fascinated by the relentless pounding of waves on the rocks, a movement which strangely seems to combine a purpose with a lack of it. This rhythm recurs several times in Pratt's work: in the charge of the swordfish in *The Witches' Brew*; in the "queries rained upon the iron plate" of *The Iron Door*; in the torpedo launched from "The Submarine"; in the sinking of the *Titanic* itself, this disaster being caused by a vainglorious hybris which in a sense deliberately aimed at the iceberg. In *Brébeuf* the same theme comes into focus as the half-mindless, half-demonic curiosity which drives the Iroquois on through torture after torture to find the secret of a spiritual reality that keeps eluding them.

It is Pratt who has expressed in *Towards the Last Spike* the central comic theme, and in *Brébeuf* the central tragic theme, of the Canadian imagination, and it is Pratt who combines the two in "The Truant," which is in my anthology because it is the greatest poem in Canadian literature. In it the representative of mankind confronts a "great Panjandrum," a demon of the mathematical order of nature of a type often confused with God. In the dialectic of their conflict it becomes clear that the great Panjandrum of nature is fundamentally death, and that the intelligence that fights him, comprehends him, harnesses him, and yet finally yields to his power is the ultimate principle of life, and capable of the comedy of achievement only because capable also of the tragedy of enduring him:

> We who have learned to clench
> Our fists and raise our lightless sockets
> To morning skies after the midnight raids,
> Yet cocked our ears to bugles on the barricades,
> And in cathedral rubble found a way to quench
> A dying thirst within a Galilean valley —
> No! by the Rood, we will not join your ballet.

We spoke at the beginning of certain principles that become important in the study of Canadian poetry. One of

these is the fact that while literature ~~may have life, reality, experience, nature~~ or what you will for its content, the forms of literature cannot exist outside literature, just as the forms of sonata and fugue cannot exist outside music. When a poet is confronted by a new life or environment, the new life may suggest a new content, but obviously cannot provide him with a new form. The forms of poetry can be derived only from other poems, the forms of novels from other novels. The imaginative content of Canadian poetry, which is often primitive, frequently makes extraordinary demands on forms derived from romantic or later traditions. Duncan Campbell Scott, for instance, lived in Ottawa as a civil servant in the Department of Indian Affairs, between a modern city and the Ungava wilderness. If we think of an Old English poet, with his head full of ancient battles and myths of dragon-fights, in the position of having to write for the sophisticated audience of Rome and Byzantium, we shall have some parallel to the technical problems faced by a Lampman or a Scott who had only the elaborate conventions of Tennysonian romanticism to contain his imaginative experience. Pratt's attempt to introduce the imagery of dragon-killing into a poem about the Canadian Pacific Railway is another good example; and I have much sympathy for the student who informed me in the examinations last May that Pratt had written a poem called Beowulf and his Brothers.

It is more common for a Canadian poet to solve his problem of form by some kind of erudite parody, using that term, as many critics now do, to mean adaptation in general rather than simply a lampoon, although adaptation usually has humorous overtones. In Charles Mair's "Winter" some wisps of Shakespearean song are delicately echoed in a new context, and Drummond's best poem, "The Wreck of the Julie Plante," is an admirable parody of the ballad, with its tough oblique narration, its moralizing conclusion, and its use of what is called incremental repetition. According to his own account, Pratt, after his college studies in theology, psychology, literature, and the natural sciences, put everything he knew into his first major poetic effort, an epic named "Clay,"

which he promptly burnt. Soon afterwards all this erudition
went into reverse and came out as the fantasy of *The Witches'
Brew*, in which parody has a central place. Since then, we have
parody in Anne Wilkinson and Wilfred Watson, who use
nursery rhymes and ballads as a basis; Birney's *Trial of a City* is
among other things a fine collection of parodied styles; and
Klein's devotion to one of the world's greatest parodists,
James Joyce, has produced his brilliant bilingual panegyric on
Montreal:

> Grand port of navigations, multiple
> The lexicons uncargo'd at your quays,
> Sonnant though strange to me; but chiefest, I,
> Auditor of your music, cherish the
> Joined double-melodied vocabulaire
> Where English vocable and roll Ecossic,
> Mollified by the parle of French
> Bilinguefact your air!

Much of Canada's best poetry is now written by professors or
others in close contact with universities. There are disadvan-
tages in this, but one of the advantages is the diversifying of the
literary tradition by a number of scholarly interests. Earle
Birney's "Anglo-Saxon Street" reminds us that its author is a
professor of Anglo-Saxon. Louis MacKay, professor of Classics,
confronts an unmistakably Canadian landscape with a myth of
Eros derived from Virgil:

> The hard rock was his mother; he retains
> Only her kind, nor answers any sire.
> His hand is the black basalt, and his veins
> Are rocky veins, ablaze with gold and fire.

Robert Finch, professor of French, carries on the tradition of
Mallarmé and other *symbolistes*; one of his most successful
poems, "The Peacock and the Nightingale," goes back to the
older tradition of the medieval *débat*. Klein, of course, has
brought echoes from the Talmud, the Old Testament, and the

whole range of Jewish thought and history; and the erudition necessary to read Roy Daniells and Alfred Bailey with full appreciation is little short of formidable. It may be said, however, that echoes and influences are not a virtue in Canadian poetry, but one of its major weaknesses. Canadian poetry may echo Hopkins or Auden today as it echoed Tom Moore a century ago, but in every age Echo is merely the discarded mistress of Narcissus. This question brings up the most hackneyed subject in Canadian literature, which I have left for that reason to the end.

Political and economic units tend to expand as history goes on; cultural units tend to remain decentralized. Culture, like wine, seems to need a specific locality, and no major poet has been inspired by an empire, Virgil being, as the *Georgics* show, an exception that proves the rule. In this age of world-states we have two extreme forms of the relationship between culture and politics. When cultural developments follow political ones, we get an anonymous international art, such as we have in many aspects of modern architecture, abstract painting, and twelve-tone music. When a cultural development acquires a political aspect, we frequently get that curious modern phenomenon of the political language, where a minor language normally headed for extinction is deliberately revived for political purposes. Examples are Irish, Norwegian, Hebrew, and Afrikaans, and there are parallel tendencies elsewhere. I understand that there is a school of Australian poets dedicated to putting as many aboriginal words into their poems as possible. As the emotional attachments to political languages are very violent, I shall say here only that this problem has affected the French but not the English part of Canadian culture. As we all know, however, English Canada has escaped the political language only to become involved in a unique problem of self-identification, vis-à-vis the British and American poets writing in the same tongue. Hence in every generation there has been the feeling that whether poetry itself needs any defence or manifesto, Canadian poetry certainly does.

The main result of this has been that Canadian poets have been urged in every generation to search for appropriate

themes, in other words to look for content. The themes have been characterized as national, international, traditional, experimental, iconic, iconoclastic: in short, as whatever the propounder of them would like to write if he were a poet, or to read if he were a critic. But the poet's quest is for form, not content. The poet who tries to make content the informing principle of his poetry can write only versified rhetoric, and versified rhetoric has a moral but not an imaginative significance: its place is on the social periphery of poetry, not in its articulate centre. The rhetorician, Quintilian tells us, ought to be a learned and good man, but the critic is concerned only with poets.

By form I do not of course mean external form, such as the use of a standard metre or convention. A sonnet has form only if it really is fourteen lines long: a ten-line sonnet padded out to fourteen is still a part of chaos, waiting for the creative word. I mean by form the shaping principle of the individual poem, which is derived from the shaping principles of poetry itself. Of these latter the most important is metaphor, and metaphor, in its radical form, is a statement of identity: this is that, A is B. Metaphor is at its purest and most primitive in myth, where we have immediate and total identifications. Primitive poetry, being mythical, tends to be erudite and allusive, and to the extent that modern poetry takes on the same qualities it becomes primitive too. Here is a poem by Lampman, written in 1894:

> So it is with us all; we have our friends
> Who keep the outer chambers, and guard well
> Our common path; but there their service ends,
> For far within us lies an iron cell
> Soundless and secret, where we laugh or moan
> Beyond all succour, terribly alone.

And here is a poem by E. W. Mandel, published in 1954:

> It has been hours in these rooms,
> the opening to which, door or sash,

> I have lost. I have gone from room to room
> asking the janitors who were sweeping up
> the brains that lay on the floors,
> the bones shining in the wastebaskets,
> and once I asked a suit of clothes
> that collapsed at my breath and bundled
> and crawled on the floor like a coward.
> Finally, after several stories,
> in the staired and eyed hall,
> I came upon a man with the face of a bull.

Lampman's poem is certainly simpler, closer to prose and to the direct statement of emotion. All these are characteristics of a highly developed and sophisticated literary tradition. If we ask which is the more primitive, the answer is certainly the second poem, as we can see by turning to the opening pages of the anthology to see what primitive poetry is really like. Here is a Haida song translated by Hermia Fraser:

> I cannot stay, I cannot stay!
> I must take my canoe and fight the waves,
> For the Wanderer spirit is seeking me.
>
> The beating of great, black wings on the sun,
> The Raven has stolen the ball of the sun,
> From the Kingdom of Light he has stolen the sun. . . .
>
> The Slave Wife born from the first clam shell
> Is in love with the boy who was stolen away,
> The lovers have taken the Raven's fire.

When we look for the qualities in Canadian poetry that illustrate the poet's response to the specific environment that we call approximately Canada, we are really looking for the mythopoeic qualities in that poetry. This is easiest to see, of course, when the poetry is mythical in content as well as form. In the long mythopoeic passage from Isabella Crawford's *Malcolm's Katie*, beginning "The South Wind laid his

moccasins aside," we see how the poet is, first, taming the landscape imaginatively, as settlement tames it physically, by animating the lifeless scene with humanized figures, and, second, integrating the literary tradition of the country by deliberately re-establishing the broken cultural link with Indian civilization:

> . . . for a man
> To stand amid the cloudy roll and moil,
> The phantom waters breaking overhead,
> Shades of vex'd billows bursting on his breast,
> Torn caves of mist wall'd with a sudden gold,
> Reseal'd as swift as seen — broad, shaggy fronts,
> Fire-ey'd and tossing on impatient horns
> The wave impalpable — was but to think
> A dream of phantoms held him as he stood.

And in the mythical figures of Pratt, the snorting iron horses of the railways, the lumbering dinosaurs of *The Great Feud*, the dragon of *Towards the Last Spike*, and above all Tom the Cat from Zanzibar, the Canadian cousin of Roy Campbell's flaming terrapin, we clearly have other denizens of the monstrous zoo that produced Paul Bunyan's ox Babe, Paul Bunyan himself being perhaps a descendant of the giants who roamed the French countryside and were recorded by the great contemporary of Jacques Cartier, Rabelais.

We are concerned here, however, not so much with mythopoeic poetry as with myth as a shaping principle of poetry. Every good lyrical poet has a certain structure of imagery as typical of him as his handwriting, held together by certain recurring metaphors, and sooner or later he will produce one or more poems that seem to be at the centre of that structure. These poems are in the formal sense his mythical poems, and they are for the critic the imaginative keys to his work. The poet himself often recognizes such a poem by making it the title poem of a collection. They are not necessarily his best poems, but they often are, and in a Canadian poet they display those distinctive themes we have been looking for which reveal his

reaction to his natural and social environment. Nobody but a genuine poet ever produces such a poem, and they cannot be faked or imitated or voluntarily constructed. My anthology is largely held together by such poems: they start approximately with D. C. Scott's "Piper of Arll," and continue in increasing numbers to our own day. I note among others Leo Kennedy's "Words for a Resurrection," Margaret Avison's "Neverness," Irving Layton's "Cold Green Element," Douglas LePan's "Idyll," Wilfred Watson's "Canticle of Darkness," P. K. Page's "Metal and the Flower," and similar poems forming among a younger group that includes James Reaney, Jay Macpherson, and Daryl Hine. Such poems enrich not only our poetic experience but our cultural knowledge as well, and as time goes on they become increasingly the only form of knowledge that does not date and continues to hold its interest for future generations.

(1956)

Silence in the Sea

IT IS A GENUINE PLEASURE, and of course a great privilege, to inaugurate this series of annual lectures in honour of E. J. Pratt. As I understand that it is intended to devote the series to modern poetry in general, it seems logical to speak in this opening lecture about Pratt, but about Pratt in the context of modern poetry, and in the further context of the relation of modern poetry to modern civilization.

Pratt's life, like an ellipse, revolved around two centres. One centre was where I am, in Victoria College in the University and city of Toronto. The other centre was of course where you are, in south-eastern Newfoundland. I shall start with my centre, and then try to establish the connexion with yours.

The fact that so many important modern poets are professional men as well — Eliot a banker and publisher, Williams a doctor, Stevens an insurance executive — suggests that the ability to write poetry often goes with an unusual ability to organize one's time and social schedule. Similarly Pratt was in a university, not as a "writer in residence," but as a full-time teacher and scholar, with the same load of graduate and undergraduate teaching as any other colleague of his seniority, and he had come into English after completing graduate degrees in theology and psychology. It is true that his erudition, his love of technical language, and the careful research he did for each of his

long narratives, are presented in a humorous and sometimes deprecating way. The lumbering polysyllables of *The Great Feud* remind us of Wyndham Lewis's remark that writers, unless they are bluffing, use their full vocabularies only for comic purposes. Nevertheless he is one of our scholarly poets. It is also true that Pratt diligently cultivated an image of himself as an incompetent and hopelessly absent-minded duffer. This is what poets and professors are popularly supposed to be, and so the image was accepted by those who did not notice that he was for years carrying on, quite without secretarial assistance, a formidable teaching, speaking and social schedule, in addition to his writing. The reason for the duffer image was that it enabled him to escape the vast accumulation of committee and paper work (or pseudo-work) which causes the real fatigue in the modern university. In the background of Victoria was the city of Toronto itself, where he carried on his legendary parties and golf games. And Toronto, according to Morley Callaghan, who should know, is a good place for a writer to work: he can have all the friends he likes, but there is something in the Canadian reserve that allows him to write without feeling that anyone is breathing down his neck.

I have often been asked why I went into English teaching, with a second half of the question, "when there were better things you might have done," sometimes being obviously suppressed. But no one who knew the teachers I had at Victoria: Pelham Edgar, Pratt himself, and J. D. Robins, would be in the least surprised at any student's wanting to pursue the careers they were so brilliant an advertisement for. This extraordinary trio had two qualities in common. One was an unusually fresh and detached interest in the contemporary literary scene. I say unusually, because such an interest could by no means be taken for granted among English professors in the nineteen-twenties. As few contemporary writers were on any course, this often meant digression and self-interruption in order to mention them at all, which is good testimony to the genuineness of the interest. But Robins would interrupt a lecture on the ballad to read us a story by Hemingway — not a household word among Canadian undergraduates in

1929 — and Edgar would digress from Shakespeare to tell us something about the narrative techniques of Virginia Woolf. Pratt was a more conventional teacher, but any interested student could get vast stores of information about contemporary poetry out of him. And I say detached, because at a time when many professors were still telling their students that Joyce and D. H. Lawrence were degenerates wallowing in muck, these three would discuss them seriously and (considering that Joyce and Lawrence were by no means favorite authors of theirs) sympathetically. What they also had in common was a keen and generous (often very practically generous, as many could testify) interest in younger Canadian writers, and a desire to do what they could to foster the creative talent around them.

What they did not have in common was a set of scholarly interests that complemented one another in a way very profitable for their students, Pratt's knowledge of modern poetry being rounded out by Edgar's knowledge of modern fiction. I doubt if I should really have got to appreciate Pratt properly if it had not been for Robins. Robins' special fields were the ballad and oral literature, along with folktales and popular literature in that orbit, and Old English. This combination of interests was not an accident: through him I began to understand something of the curious affinity between the spirit of Canadian poetry, up to and including Pratt, and the spirit of Anglo-Saxon culture. In both the incongruity between a highly sophisticated imported culture and a bleakly primitive physical environment is expressed by familiar, even ready-made, moral and religious formulas which raise more questions than they answer. And what I think would have fascinated me in Pratt's poetry, even if I had never known him, is the way in which, unlike any other modern poet I know, he takes on so many of the characteristics of the poet of an oral and pre-literate society, of the kind that lies immediately behind the earliest English poetry. There was no reason for Pratt to be this kind of poet except the peculiar influence of his Newfoundland and Canadian environment on him: I am quite sure that he was unconscious of this aspect of his work.

In an oral culture, which has to depend so much on memory, the poet is the teacher, the one who remembers. (I am speaking here of the professional oral poet, there are of course other kinds.) It is he who knows the traditions of his people, its great heroic legends, the names of its kings, its proverbial philosophy, its rudimentary sciences in which there is still a great deal of magic, the stories and myths of its gods, the details of correct ritual in religious and social life, the calendar with its lucky and unlucky days, the mysteries of taboo and the complexities of family and class relationships. The poet knows these things because verse, by which I mean poetry with a relatively simple metrical or alliterative structure, is the obvious way of organizing words so that verbal information can be easily remembered. The fact that names of Anglo-Saxon kings so often begin with the same letter has, or had originally, much to do with Old English alliterative verse. Such a poet is a profoundly impersonal poet. He does not write love poetry or cultivate his private emotions; he hardly thinks of himself as having a personality separate from his public. Homer, and the surviving poems of the heroic age of the North, give us some notion of what the vast corpus of oral poetry, lost because not written down, must have been like. The name of Homer, along with more legendary names, survived for centuries as symbols of a remote past in which the poet had a central social function from which he has since been dispossessed.

As time goes on, and literature assumes different functions, we may come to feel rather condescending about this early function of poetry; but poets and readers alike impoverish their literary experience if they underestimate it. W. H. Auden remarks that if we really *like* lists and catalogues in poetry, such as the roll-call of ships in the second book of the *Iliad*, that liking is probably the sign of a serious interest in poetry. This principle, which so obviously applies to, for instance, Whitman, could also be applied to such catalogue features in Pratt as the brands of liquor in *The Witches' Brew*. Similarly Pratt has a primitive sense of the responsibility of the poet for telling the great stories of his people. At first his

stories are typical stories, like *The Roosevelt and the Antinoe* or *The Cachalot*, then they become such central stories as the martyrdom of the Jesuits and the building of the Canadian Pacific Railway, to which, most unfortunately, the story of the Franklin expedition was never added. It is in *Brébeuf* particularly that Pratt shows his affinity to the oral poets in his respect for his sources. He does not use the Jesuit Relations as a basis for fine writing: his whole effort is to let the Relations tell their own story through his poem. His genre is the narrative poem, and the narrative has a unique power of dry impersonal statement which makes sophisticated or clever writing look ridiculous.

A pre-literate culture is a highly ritualized one, where doing things decently and in order is one of the most essential of all social and moral principles. The care that Pratt expends on a sequence of physical movements meets us everywhere in his work: in the throwing of the harpoon in *The Cachalot*, in the getting out of the lifeboats in *The Roosevelt and the Antinoe*, in the manoeuvring of ships in *Behind the Log* that forms so ironic a contrast to the bland strategic directives at the beginning. Such delight in sequential detail shows his sense of a mode of life where safety, or even survival, depends not simply on activity, but on the right ordering of activity. At the other extreme are the first-class passengers on the Titanic, who have, literally, nothing to do, and so ritualize their lives by a poker game. In religion, we notice how clearly Pratt, himself a Nonconformist Protestant, understands the immense importance, for a Catholic, of the unbroken repetition of the mass at Ville Marie, which he makes the conclusion of his poem on Brébeuf. And certainly no poet without so intensely ritualistic a feeling would have symbolized the end of the "depression" (*i.e.*, human history) by an "apocalyptic dinner." There is also the beautiful evocation of the sense of ritual surrounding death, some of it the sacrament of extreme unction, some of it going back to pre-Christian times, but in every age assimilating the dramatic moments of life to the recurring rhythm that gives a sense of spaciousness and dignity to the individual consciousness:

> There was a time he came in formal dress,
> Announced by Silence tapping at the panels
> In deep apology.
> A touch of chivalry in his approach,
> He offered sacramental wine,
> And with acanthus leaf
> And petals of the hyacinth
> He took the fever from the temples
> And closed the eyelids,
> Then led the way to his cool longitudes
> In the dignity of the candles.

I spoke of the poetry of an oral culture as simple in rhythmical structure, however subtle the effects of which it is capable. Verse is a much simpler and more obvious way of conventionalizing ordinary speech than prose is, which accounts for the cultural priority of verse to prose. It is consistent with Pratt's general attitude to poetry, not merely that he should be conservative in his diction, which never plays any syntactical tricks, and in his standard metres, but that his poetry should reflect the pleasure of linear movement, whether directly physical, as in "The 6000," or subtilized into following the swift pace of a story-teller's narrative. It is normally only the standard metres (especially, perhaps, Pratt's beloved octosyllabic couplet) that can convey this particular kind of poetic pleasure, one of the most ancient that poetry can give. Even some of the poems that are technically in free verse, such as "Newfoundland" and "Silences," express something of the recurring wash of the sea on rocks. Another ancient and primitive pleasure of poetry is the sententious utterance that gives epigrammatic form to a familiar but deeply held idea, and the tight stanzaic patterns of Pratt's lyrics are well adapted to give this too.

When the poet has so central a relation to his society, there is no break between him and his audience: he speaks for, as much as to, his audience, and his values are their values. Even if a professional poet, he is popular in the sense that he is the voice of his community. Shakespeare, who is still essentially an

oral poet, shows a similar identification with the assumptions of his audience. It is particularly this empathy between poet and listening audience that is broken by the rise of a writing culture. In a writing culture, philosophy develops from proverb and oracle into systematic concept and logical argument; religion develops from mythology into theology; magic fades out and is absorbed into science. All these speak the language of prose, which now becomes fully developed, and capable of a conceptual kind of utterance that poetry resists. It is the discursive writer or thinker who is assumed to have the primary verbal keys to reality; the norms of meaning become the norms of a prose sense external to poetry. As a result the poet becomes increasingly isolated in spirit from much of the thought of his time, even though he continues, as a rule, to be a scholarly and erudite person, aware of what is going on in the rational disciplines. As the structures of philosophy and science become more complete, the poet retreats from large-scale cosmological and epic themes summing up the learning of his time, and partakes of a growing fragmentation of experience. He tends more and more to convey his meaning indirectly, through imagery and metaphor, and the surface of explicit statement that he shares with other writers becomes increasingly opaque. He is sometimes difficult to read — Eliot even suggests that difficulty is a moral necessity for writers of his time — and above all, originality, saying things in one's own way instead of simply saying them in the way that they have always been said, becomes accepted as part of the convention of serious literature.

This means that the serious poet is likely to have a restricted audience of cultivated people — "fit audience find, though few," as Milton said of *Paradise Lost* — and that the importance of social function is not widely recognized or understood. Shelley called the poet an "unacknowledged legislator," in a "Defence of Poetry" which was an answer to a brilliant and paradoxical essay of his friend Peacock, in which Peacock had noted a primitive, even an atavistic, quality in the poet's mind, and its affinity with an earlier type of civilization. The poet, Peacock remarked, had had for his chief social function the

flattering of barbarians, whom he called "heroes," and such a person was utterly lost in a developed society. Peacock's essay points, among other things, to the growing estrangement of the poet from the values of a conformist and materialistic society which a great majority of important modern poets share, however great the variety of kinds of opposition they may display.

Pratt was a Romantic poet in the Romantic tradition, and, like his older colleague Pelham Edgar, had a particular affection for Shelley. It was seldom that he admitted to a specific influence, but he did tell me once of how he had been haunted by Shelley's *Julian and Maddalo,* that strange, wonderful poem in which two poets discuss the reasons for the continuing captivity of human intelligence, while that intelligence itself is symbolized by a madman unable to escape from the fixations of broken love. Yet Pratt certainly did not follow Shelley in the latter's repudiation of the religious and political organizations of his time, although he understood and sympathized with Shelley's attitude. Pratt's relation to the Romantics indicates a different and somewhat contradictory tendency in Roman-ticism from the one we have been discussing.

For Romanticism also featured the revival of oral poetry and the ballad. One would expect, then, some revival in the popularity of the poet: one would think that some poets might become, once again, spokesmen for their communities, their tales and proverbial philosophies becoming a part of ordinary verbal culture. Burns became such a poet for one group, though for somewhat exceptional reasons; Wordsworth, across the border, and writing quite as simply and intelligibly, hardly did. But in the next century the few popular poets with more than a documentary interest, such as Longfellow or Kipling, make it obvious that, paradoxical as it sounds, the popular tradition from Romantic times on has been mainly a submerged tradition. The intense desire of a community to have a poet of its own as a cultural possession cannot be doubted; neither can the desire of many poets to achieve this kind of relation to a community. Pratt has been, in Canada, a kind of unofficial poet laureate; this was an office that Whitman would have

been delighted to hold for America, and that Tennyson, who did hold it in Great Britain, worked hard to maintain in dignity. With the twentieth century the tension between the desire to be popular and the necessity to be restricted in audience takes some grotesque forms. One thinks of Eliot, ending his *Waste Land* with a quotation in Sanskrit, yet speaking of the advantage, for the dramatist, of an audience that could not read or write; or of Yeats trying to bring drama to communities that often could hardly read or write, yet filling his poems with recondite Cabbalism. But the idioms of popular and serious poetry remain inexorably distinct. Popular poems tend to preserve a surface of explicit statement: they are often sententious and proverbial, like Kipling's "If" or Longfellow's "Psalm of Life" or Burns' "For A' That," or they deal with what for their readers are conventionally poetic themes, like the pastoral themes of James Whitcomb Riley or the adventurous themes of Robert W. Service. Affection for such poets is apt to be anti-intellectual, accompanied by a strong resistance to the poetry that the more restricted audience I spoke of finds interesting.

One of the chief barriers to the appreciation of Pratt in many quarters is the tendency in him to be a popular poet. Like Kipling, and like Longfellow in a different way, he writes in a style that steers close to the perilous shallows of light verse. He is ready to linger over rather self-indulgent nostalgic or whimsical themes, as in "Reverie on a Dog" (not reprinted in his second edition), or in "Magic in Everything," or in "Putting Winter to Bed." Again, he tends to accept the values of his society without much questioning. His assumptions about the Second World War, the Jesuit-Iroquois conflict, the relation of officers to men in war and of bosses to workers in peace, are those of an ordinary conservative citizen who reads the morning paper and believes, on the whole, what it says. In his poetry, as in his personal life, Pratt is someone who quite frankly wants to be liked, and liked immediately, not after a generation or two. To some extent he has succeeded: his readiness to disarm the suspicions of the ordinary reader has gained him an unusually large number of ordinary readers, at least in Canada. But he has raised other suspicions in other

readers, not accustomed to poets who expect them to be complaisant, and who consequently feel that *this* poet must be simple-minded in a way that, say, Ezra Pound is not.

Perhaps this means only that, like the seventeenth-century British poets who wrote in Latin instead of English, Pratt has had his reward of recognition in his life, and is likely to be neglected in future for having backed the wrong horse. I think there are other factors to be considered, however. When I edited Pratt's poems in 1958, I remarked that, if to be "modern" is a virtue, Pratt looked more modern and up to date in 1958 than he did in 1938. I was thinking then mainly of the growing tendency to write in more conventional metres and to provide a more explicit surface of direct statement. I now feel that it is possible to update the remark to 1968, though for somewhat different reasons. In the last few years there has been a startling social development which makes all my talk about oral and pre-literate poets much more relevant both to Pratt and to the contemporary scene. The rise of communications media other than the book has brought back some of the characteristics of oral culture, such as the reading of poetry to a listening public, often with some musical accompaniment, the employing of topical themes, the tendency to the direct statement of a social attitude which the audience is expected to share, and many other features of oral literature that have not been genuinely popular for centuries. True, most of such poetry is associated with a dissenting or protesting social attitude, and from its point of view Pratt's poetry would look like a defence of establishment values. But the dissenting values of today are the establishment values of tomorrow, and perhaps Pratt will come into an even clearer focus in 1978.

II

Many modern poets seem to strike their roots in a small and restricted locality. Thus Frost is a poet of northern New England, Stevens of southern New England, Yeats of Sligo, Eliot of the City of London (it has even been asserted that

Eliot's London allusions are within a single postal district), Dylan Thomas of Southern Wales, Jeffers of the Monterey and Carmel region of California. They may live in and write poetry about many other places, but the relation to a specific environment is still there. And Pratt's fundamental environment was the Avalon peninsula, the area of St. John's and the outports adjoining it. Like all poetic environments, his was a mixture of memory and literary convention, and many of you might not recognize it as the place that you actually live in. But it would certainly never have existed without this actual place.

Pratt's immediate contact with this community was through religion, as exemplified in his father's profession, which he followed. Perhaps his training as a preacher, which certainly influenced his admiration for the rhetoric of Spurgeon, and, later, of Churchill, also had something to do with his attitude to poetry as a kind of rhetorical friendly persuasion, the winning over of an audience. In any case the rigours of the life in the Newfoundland outports, the hard fight to survive and the frequency of violent death, threw into strong relief a fundamental cleavage in Christianity which runs all through his work and is the theme of his profoundest poem, "The Truant."

Christianity has always been both a revolutionary and an institutionalized religion: subversive and repressive social movements have both appealed to its principles. The revolutionary core of Christianity is its identifying of God with a suffering, persecuted, and enduring man. It was in the sign of the cross, a ridiculous and shameful emblem, that an outcast religion conquered the world's greatest empire. But the conquest itself began to shift the attention of Christianity to an establishment God, one who created and governed the order of nature. What Pratt's poetic vision first seized on was the contrast, in the life he saw around him, between the human heroism and endurance, in which the divine inheritance and destiny of man was so clearly reflected, and the moral unconsciousness of nature. Whatever the source of the latter, it is there, and there is little point in trying to see it as somehow reflecting a will or providence or intelligence that has

planned it all quite coherently and has foreseen all difficulties. Such a Supreme Arranger of order and authority may be called God or Nature — it makes little difference which — but invoking it affects us as a complacent denial of the reality of human feeling:

> The doctor spoke
> Of things like balance, purpose — balance? Yes,
> We got that from a dory in a gale,
> From weights and springs and piling rock in holds
> Through lack of cargo. Purpose? Faith — we knew that;
> Assumed it in the meshes of a net,
> Or else denied it when a child was drowned.
> But these were matters past the doctor's mind —
> "Sharks too had purpose for the sea would rot
> Without them." This too strong a dose for us . . .

Many arguments of the "what are sharks good for?" type were in Pratt's cultural background, the efforts of intellectual conservatism to fit the facts of its existence into some prearranged scheme. Such conservatives would often have taken a religious line, but the man who, like the man in an unreprinted poem in *Newfoundland Verse*, "sticks by Moses" is more likely to be sticking by some kind of Stoic universal governor imported into Christianity to rationalize its adherence to established authority. For the Stoic is the most impressive example of the man who tries to find some kind of moral order behind nature, and so tries to keep neutral in the struggle of human heroism and natural indifference: a neutrality always dubious and in the twentieth century entirely impossible:

> What are the Stoic answers
> To those who flag us at the danger curves
> Along the quivering labyrinth of nerves?

We notice how it is the enduring, resisting and suffering Christ of "Gethsemane" who is at the centre of Pratt's religion. Over against him is the dead God of fatality, the mindless,

pointless world of the wheeling stars and the crashing seas. In "The Highway" the poet speaks of nature in terms of an evolutionary scheme which seems to indicate some kind of purpose, even if a very slow-moving one; but we cannot accept this scheme without the feeling expressed by the myth of the fall of man, glanced at in the last stanza. Man's essential heritage is spiritual rather than natural: he is cut off from nature by his own consciousness, and has to turn for his loyalties to an ideal which (or rather who: the "Son of Man") is human and yet qualitatively different from human life as we know it. Such an ideal is not in nature, where visions of apocalyptic human cities like the one in "The Mirage" are only illusions destroyed by "the darker irony of light," and where the struggle to survive knows no more of ultimate purpose than a coral insect knows of a coral island, developing as it did

> Away back before the emergence of fur or feather, back
> to the unvocal sea and down deep where the darkness
> spills itswash on the threshold of light, where the lids
> never closeupon the eyes, where the inhabitants slay in
> silence and are as silently slain.

Students of the submarine world tell us that the sea is not silent, and that its creatures manage to make a fair amount of noise in spite of the impediment of water. But the silence in this poem is the symbolic silence of a moral chaos in which the creative word has not yet been spoken, the word of the conscious mind able to detach itself from a life wholly engaged in predatory aggression and see and judge of what it is doing. The door of the cottage closed against the storm in "The Weather Glass," "The Lee-Shore" and elsewhere is a simple but very central image of separation between conscious and mindless worlds.

But of course human life itself, as the "Silences" that we have just quoted from shows, exhibits the conflict between the spirit and the nature of man, between the unspoken ferocity which makes man the devil of nature, infinitely more evil than Tom the Cat from Zanzibar, and the speaking of the word,

which, even if a word of enmity, may still be the basis of community. The demonic in human life expresses itself in a peculiar form of mechanism: in the developing of a technology which symbolizes a will to merge human life into a vast destructive machine. The reason asks questions to which, as in quadratic equations, there are two answers. One answer is the fatalism which makes the total commitment to death in modern warfare consistent with the reason, one logical consequence of the relation of nature and man, and absurd only to the rebellious free spirit:

> Seven millions on the roads in France,
> Set to a pattern of chaos
> Fashioned through years for this hour.
> Inside the brain of the planner
> No tolerance befogged the reason.

There is another answer, less narrowly logical, and this takes us back to our discussion of the social function of the poet.

I have spoken of the primitive function of the oral poet as the teacher of his society, which sounds as though he were a mere repository of facts, an ambulatory Larousse. But, of course, the oral poet does not deal in facts at all, as such: what he deals in are myths, that is, stories of gods, historical reminiscences, and concepts founded on metaphors. Such myths are neither true nor false, because they are not verifiable. Myths are expressions of concern, of man's care for his own destiny and heritage, his sense of the supreme importance of preserving his community, his constant interest in questions about his ultimate coming and going. The poet who shapes the myth is thus entrusted with the speaking of the word of concern, which, even though in early times it may often have been a word of hostility and a celebrating of war and conquest, is still the basis of social action. Primitive myths are conservative because primitive societies are conservative, and last a long time without much change. But the myth-making impulse is recreated in each generation, as the wonder which Samuel Johnson called the effect of novelty

upon ignorance awakens in every child:

> We showed them pictures in a book and smiled
> At red-shawled wolves and chasing bruins —
> Was not the race just an incarnate child
> That sat at wells and haunted ruins?

With Romanticism, when the poet's sense of isolation from society reached an extreme and began to turn back again, poetry once more became mythopoeic. The new myths that came in with Romanticism, however, were often revolutionary, expressing hopes for greater freedom than man had hitherto had. At the centre of these revolutionary myths is Shelley's hero Prometheus, who is also the hero of many of Pratt's poems, including "Fire." Prometheus is the symbol of the technology which is developed by man in the interests of his own concern for a fuller human life. This is the technology which so fascinates Pratt and which he has celebrated in his work more eloquently, perhaps, than any other poet of his time. At the centre of this imaginative technology is the signal, the scientific extension of the human word, and around the signal all genuine science, science as a form of human life and achievement rather than as a death-wish, takes shape:

> He had an instrument in his control
> Attested by the highest signatures of science . . .
> And here, his head-phones on, this operator,
> Sleeve-rolled mechanic to the theorists,
> Was holding in his personal trust, come life,
> Come death, their cumulative handiwork.
> Occasionally a higher note might hit
> The ear-drum like a drill, bristle the chin,
> Involving everything from brain to kidneys,
> Only to be dismissed as issuing
> From the submerged foundations of an iceberg,
> Or classified as "mutual interference."

The operator gets only puzzling answers from nature, but

there is an answer from nature none the less. As soon as man splits his life-impulse off from his death-impulse, and stops thinking of his technology as primarily a way of making war, the nature around him also takes on a twofold aspect. The death-impulse is answered by the ferocity and destructiveness of nature, but the life-impulse is answered by the energy and the inner exuberance in nature — much the same phenomena, but seen from the inside as a living process rather than from the outside as something completed by death. The energy of life is nature's response to human concern: this is the reason for that curious identity between the pursuer and the pursued which John Sutherland has noted in his study of Pratt. Man being what he is, he often tries to dominate nature in ways that choke the life out of it, even if he is not actually engaged in war. The poet of Newfoundland, with its sparse soil, knows that the life of "The Good Earth" is precious, and that nature, being a part of man too, always makes the appropriate response, whether to love or to contempt:

> Hold that synthetic seed, for underneath
> Deep down she'll answer to your horticulture:
> She has a way of germinating teeth
> And yielding crops of carrion for the vulture.

The attitude I have been trying to trace in Pratt and associate with his Newfoundland origin is most clearly expressed, naturally, in the poem called "Newfoundland" which stands first in his collected poems. As the poet watches the sea beating on the Newfoundland shores, a possible ironic or fatalistic vision is dismissed and the vision of the unquenchable energy and the limitless endurance which unite the real man with real nature takes its place:

> Here the tides flow,
> And here they ebb;
> Not with that dull, unsinewed tread of waters
> Held under bonds to move
> Around unpeopled shores —

Moon-driven through a timeless circuit
Of invasion and retreat;
But with a lusty stroke of life
Pounding at stubborn gates,
That they might run
Within the sluices of men's hearts.

And just as the closed door separates the world of consciousness and feeling from the blind fury of storms, so the open door unites man and his world in a common vision. Even the "iron door" of death opens a crack to enable the poet to catch a fleeting glimpse

Of life with high auroras and the flow
Of wide majestic spaces

but fortunately it was to be a long time before that wider life claimed him. In this life he took his place at the centre of society where the great myths are formed, the new myths where the hero is man the worker rather than man the conqueror, and where the poet who shapes those myths is shaping also a human reality which is greater than the whole objective world, with all its light-years of space, because it includes the infinity of human desire. This greater universe is revealed to us in whatever poetry is founded on the vision expressed in the closing lines of "Newfoundland," a vision

Of dreams that survive the night,
Of doors held ajar in storms.

(1968)

Canadian and Colonial Painting

THE COUNTRIES MEN LIVE IN feed their minds as much as their
bodies: the bodily food they provide is absorbed in farms and
cities: the mental, in religion and arts. In all communities this
process of material and imaginative *digestion* goes on. Thus a
large tract of vacant land may well affect the people living near
it as too much cake does a small boy: an unknown but quite
possibly horrible Something stares at them in the dark: hide
under the bedclothes as long as they will, sooner or later they
must stare back. Explorers, tormented by a sense of the unre-
ality of the unseen, are first: pioneers and traders follow. But
the land is still not imaginatively absorbed, and the incubus
moves on to haunt the artists. It is a very real incubus. It glares
through the sirens, gorgons, centaurs, griffins, cyclops, pygmies
and chimeras of the poems which followed the Greek colonies:
there the historical defeat which left a world of mystery outside
the Greek clearing increased the imaginative triumph. In our
own day the exploration and settlement has been far more
thorough and the artistic achievement proportionately less: the
latter is typified in the novels of Conrad, which are so often
concerned with finding a dreary commonplace at the centre of
the unknown. All of which is an elaborate prologue to the fact
that I propose to compare Tom Thomson with Horatio Walker,
as suggested by a recent showing of them at the Art Gallery of

Toronto; still, when in Canadian history the sphinx of the unknown land takes its riddle from Frazer and Mackenzie to Tom Thomson, no one can say that there has been an anti-climax.

Griffins and gorgons have no place in Thomson certainly, but the incubus is there, in the twisted stumps and sprawling rocks, the strident colouring, the scarecrow evergreens. In several pictures one has the feeling of something not quite emerging which is all the more sinister for its concealment. The metamorphic stratum is too old: the mind cannot contemplate the azoic without turning it into the monstrous. But that is of minor importance. What is essential in Thomson is the imaginative instability, the emotional unrest and dissatisfaction one feels about a country which has not been lived in: the tension between the mind and a surrounding not integrated with it. This is the key to both his colour and his design. His underlying "colour harmony" is not a concord but a minor ninth. Sumachs and red maples are conceived, quite correctly, as a *surcharge* of colour: flaming reds and yellows are squeezed straight out of the tube on to an already brilliant background: in softer light ambers and pinks and blue-greens carry on a subdued cats' chorus. This in itself is mere fidelity to the subject, but it is not all. Thomson has a marked preference for the transitional over the full season: he likes the delicate pink and green tints on the birches in early spring and the irresolute sifting of the first snow through the spruces; and his autumnal studies are sometimes a Shelleyan hectic decay in high winds and spinning leaves, sometimes a Keatsian opulence and glut. His sense of design, which, of course, is derived from the trail and the canoe, is the exact opposite of the academic "establishing of foreground." He is primarily a painter of linear distance. Snowed-over paths wind endlessly through trees, rivers reach nearly to the horizon before they bend and disappear, rocks sink inch by inch under water, and the longest stretch of mountains dips somewhere and reveals the sky beyond. What is furthest in distance is often nearest in intensity. Or else we peer through a curtain of trees to a pool and an opposite shore. Even when there is no vista a long tree-trunk will lean away

from us and the whole picture will be shattered by a straining and pointing diagonal.

This focussing on the farthest distance makes the foreground, of course, a shadowy blur: a foreground tree — even the tree in "West Wind" — may be only a green blob to be looked past, not at. Foreground leaves and flowers, even when carefully painted, are usually thought of as obstructing the vision and the eye comes back to them with a start. Thomson looks on a flat area with a naive Rousseauish stare (see the "decorative panels"). In fact, of all important Canadian painters, only David Milne seems to have a consistent foreground focus, and even he is fond of the obstructive blur.

When the Canadian sphinx brought her riddle of unvisualized land to Thomson it did not occur to him to hide under the bedclothes, though she did not promise him money, fame, happiness or even self-confidence, and when she was through with him she scattered his bones in the wilderness. Horatio Walker, one of those wise and prudent men from whom the greater knowledges are concealed, felt differently. It was safety and bedclothes for him. He looked round wildly for some spot in Canada that had been thoroughly lived in, that had no ugly riddles and plenty of picturesque clichés. He found it in the Ile d'Orléans. That was a Fortunate Isle with rainbows and full moons instead of stumps and rocks: it had been cosily inhabited for centuries, and suggested relaxed easy-going narratives rather than inhuman landscapes. Pictures here were ready-made. There was Honest Toil with the plough and the quaint Patient Oxen; there were pastoral epigrams of sheep-shearing and farmers trying to gather in hay before the storm broke; there was the note of Tender Humour supplied by small pigs and heraldic turkeys; there was the Simple Piety which bowed in Childlike Reverence before a roadside *calvaire*. Why, it was as good as Europe, and had novelty besides. And for all Canadians and Americans under the bedclothes who wanted, not new problems of form and outlines, but the predigested picturesque, who preferred dreamy association-responses to detached efforts of organized vision, and who found in a

queasy and maudlin nostalgia the deepest appeal of art, Horatio Walker was just the thing. He sold and sold and sold.

(1940)

David Milne:
An Appreciation

THE PROBLEM OF HOW TO CREATE while living in the world is always difficult, and in painting two extreme solutions of it are currently fashionable, perhaps because they are extreme. One is that of the primitive or "naive" painter who remains isolated from the world until the time comes for him to be dug out and patronized. The other is that of the "engaged" painter who is preoccupied with schools and movements and trends and isms, and whose painting is full of quotations. David Milne's solution is nearer the golden mean: he lives a very retired life, and works out all his pictorial problems by himself; but he is well aware of what is going on in modern painting, and all his pictures look unaffectedly contemporary.

Painting is a two-dimensional art, and one would normally expect it to adopt, as other arts do, the conditions of its medium, and present a two-dimensional view of reality. Yet since 1400 painting has been largely concerned with creating the illusion of three dimensions, using mechanical rules of perspective and lighting to help that illusion along. This implies that painting for the last five centuries has been from one point of view stunt-painting, an enormous refinement of the trick-perspective and peep-show pictures popular in the Renaissance. Our painting, still from this point of view, has been rather like what our music would have been if it had been all programme music, confining itself to rearranging

the sounds heard in nature. It seems odd to speak of such painting in such terms, but there is a real fact involved. Western painting, from Masaccio to Cézanne, has consistently illustrated the dogma of the externality of the world, a dogma which, as it has not obsessed the Orient to the same degree, has not been incorporated in its painting. Our painting normally recedes from the observer, and is often judged by critics in terms of whether it takes flight precipitately enough: whether it "goes back," as the phrase is.

At the same time nobody wants perfectly flat painting, which still gives one an external world, though stripped of one dimension and of all the seeing in depth which is half the pleasure of using one's eyes. That is the painting world of advertisements, posters and other mentally invisible objects, and of those murals in which dead pasteboard figures glumly rehearse the progress of transportation from camel to jeep. Flat painting is tolerable only in genuinely childlike pictures, as the child's eye hardly seems to perceive in depth at all. But it is absurd to say that Oriental or medieval painting is flat in this sense, or that it has no perspective. The perspective is there all right, but it is a convex perspective which rolls up to the observer instead of running away from him. In some Oriental pictures the observer's eye seems to be at the circumference of the picture, so that it opens inward into the mind. Perspective in this kind of painting is not a mechanical handling of distance, but a proportioning of visual interest, which makes a man look smaller when further away because he is then pictorially less important.

It is an approach to perspective something like this which gives to those landscapes of Milne that depend on vista their extraordinary soap-bubble lightness. No emphasis is laid on the mass, volume, solidity, independence or elusiveness of things "out there": all the shapes and forms are drawn toward the eye, as though the whole picture were floating in the air detached from its rectangular frame. Milne's whole aim is apparently to present a pure visual experience, detached from all the feelings which belong to the sense of separation from the object, feelings which are mainly tactile in origin.

The studies in still life, on the other hand, and the landscapes that are done inside a forest, or (as often happens) a house, are perhaps closer to Milne's immediate context in Canada. In temperament Milne is possibly closer to Morrice than to any other Canadian painter, but he comes later on the Canadian scene and is more closely linked both with it and with the traditions of painting it than the friend of Matisse was. The Group of Seven felt that they were among the first to look at Canada directly, and much of their painting was based on the principle of confronting the eye with the landscape. This made a good deal of their work approach the flat and posterish, but that was a risk they were ready to take. Jackson, Lismer and Harris all found this formula exhaustible, and have all developed away from it. Thomson and Emily Carr represent a more conscious penetration of the landscape: they seem to try to find a centre of rhythm deep within their subject and expand from there. Milne combines these techniques in a way that is apt to confuse people who look at him for the first time. The flatness in his painting is not a remote or external flatness, but an absorption of the painter's (and beholder's) eye in the subject. The beholder is at once well inside the picture, where he finds that everything is on much the same pictorial level. In other words, he finds a certain amount of camouflage or dazzle-painting (notice how hard it is to see the human figure in the untitled landscape study). Little allowance is made for the customary selective activity of the eye, and in a still life like the "Water Lilies," foreground and background seem to merge in an elaborate interlocking pattern, as substance and shadow do when trees are reflected in "The Outlet of the Pond."

I happen to be personally more attracted by Milne's water-colours than by his oils, although his use of oil is very subtle and delicate, and in fact approximates his water-colour technique more closely than is usual with painters. (His drypoint etchings, which are of very great interest, have been discussed by himself in a recent issue of *Canadian Art.*) He has painted what must surely be some of the wettest water colours, both in technique and in subject-matter, ever done. In fact,

rain, fog, snow and mist play an important role in his work: their function is not to blur the outlines but to soften them down so as to increase the sense of a purified visual pattern. Rain, which is very difficult to paint, has the paradoxical quality of bringing objects nearer by partly veiling them: it decreases the sunlight sense of hard objective fact, not by making things look unreal, but by making them seem less conventionalized. It often plays a similar role in Oriental painting.

In more recent years Milne has brought his painting to the point at which it has become the pictorial handwriting, so to speak, of a genuinely simple but highly civilized mind. This has enabled him to detach himself further than ever from the picturesque object and develop a free fantasy which may remind some of Chagall. One may see something of this even in the sea-gulls that flap like unwanted thoughts across the foreground of a picture where the focus of vision is on the skyline. It is more fully developed in the Noah's Ark, with its unforced humour that appeals to the child in the adult without being itself synthetically childlike. And in the very lovely "Snow over Bethlehem" the idea suggested, which we can take or leave alone, that every snowflake is a new star, and hence, if one likes, a new sign of the presence of God, floats so easily out of the picture because it is an inference from the picture and not its organizing idea. The organizing idea is simply the exploiting of the possibilities of a subject usually considered inaccessible to painting — the crystallization of snowflakes. This expansion of meaning from the desire to paint, rather than from a desire to say something with paint, is typical of the way that Milne's art works. Few if any contemporary painters, in or outside Canada, convey better than he does the sense of painting as an emancipation of visual experience, as a training of the intelligence to see the world in a spirit of leisure and urbanity.

(1948)

Lawren Harris:
An Introduction

As a rule, when associations are formed by youthful artists, they break up as the styles of the artists composing them become more individual. But the Group of Seven, who did so much to revitalize Canadian painting in the twenties and later of this century, still retain some of the characteristics of a group. Seven is a sacred number, and the identity of the seventh, like the light of the seventh star of the Pleiades, has fluctuated somewhat, attached to different painters at different times. But the permanent six, of whom four are still with us, have many qualities in common, both as painters and in fields outside painting. For one thing, they are, for painters, unusually articulate in words. J. E. H. MacDonald and Lawren Harris wrote poetry; Harris, as this book shows,* wrote also a great deal of critical prose; A. Y. Jackson produced a most entertaining autobiography; Arthur Lismer, through his work as educator and lecturer, would still be one of the greatest names in the history of Canadian art even if he had never painted a canvas. For another, they shared certain intellectual interests. They felt themselves part of the movement towards the direct imaginative confrontation with the North American landscape which, for them, began in literature with Thoreau

Lawren Harris: edited by Bess Harris and R. G. P. Colgrove; Macmillan of Canada; pp. xii, 146; 1969.

and Whitman. Out of this developed an interest for which the word theosophical would not be too misleading if understood, not in any sectarian sense, but as meaning a commitment to painting as a way of life, or, perhaps better, as a sacramental activity expressing a faith, and so analogous to the practising of a religion. This is a Romantic view, following the tradition that begins in English poetry with Wordsworth. While the Group of Seven were most active, Romanticism was going out of fashion elsewhere. But the nineteen-sixties is once again a Romantic period, in fact almost oppressively so, so it seems a good time to see such an achievement as that of Lawren Harris in better perspective.

This remarkable book presents a fine selection of Lawren Harris's paintings in the context of the various speeches, essays, poems, letters, notebook jottings, and drafts of books by which he tried to express his conception of art as an activity of life, and not something separable from it. What he says forms the context of the paintings, and the paintings form the context of what he says. Much of what he says might seem over-general or lacking in applicability if we did not see it, with the expert and patient help of the editors, as specifically illustrated by the painting. An example is the placing of his painting "The Bridge" beside a number of statements about art as various forms of a bridge. Even so he has some difficulty in saying in words what he says so eloquently in the pictures. One reason for this is that our language is naturally Cartesian, based on a dualism in which the split between perceiving subject and perceived object is the primary fact of experience. For the artist, whatever may be true of the scientist, the real world is not the objective world. As Shelley, another Romantic, insisted, it is only out of laziness or cowardice that we take the objective world to be the real one. The attempt to produce a "realism" which is only an illusion of our ordinary objectifying sense leads to insincere painting, technique divorced from intelligence. But, says Harris, art is not caprice either. The artist, unlike the psychedelic, does not confuse the creative consciousness with the subjective or introverted consciousness. Fantasy-painting becomes insincere also whenever it

evades the struggle with the material which is the painter's immediate task. The genuine artist, Harris is saying, finds reality in a point of identity between subject and object, a point at which the created world and the world that is really there become the same thing.

In Harris's earlier works, the paintings of houses and streets in Toronto and the Maritimes and that extraordinary piece of Canadian Gothic, the portrait of Salem Bland, we are struck at once by the contemplative quality of the painting, by the intensity with which the painter's whole mind is concentrated on his object — or, as the curious vagaries of language have it, his "subject." Because of this meditative intensity, the painting is representational. But it is very far from what is often called photographic realism, although what this phrase usually refers to is just as bad in photography as it is in painting. The sombre, brooding miners' cottages and the bizarre lights and shadows of a Toronto street, with their unpredictable splashes of colour (deftly illustrated by the editors in placing one of the painter's poems beside a similar picture), stare at us with an emotional intensity which ordinary eyesight cannot give us. This intensity is, of course, the kind of thing we turn to pictures for. But neither do we have the feeling that this emotional power is simply there as a reflection of what the painter felt and was already determined to impose on whatever he saw. Such paintings are the painter's inventions, a word which means both something made and something found. There is tension and struggle between the act of seeing and the resistance of the thing seen: we who see the picture participate in the struggle, and so make our own effort to cross the *pons asinorum* of art, the "bridge" between the ordinary subject and the ordinary object.

Lawren Harris makes it clear that what drove him and his colleagues out to the northern part of Canada was their distrust of the "picturesque," that is, the pictorial subject which suggests a facile or conventional pictorial response. His paintings of Lake Superior and the Rockies are as much of an exploration as the literal or physical explorations of La Vérendrye or Mackenzie. Harris remarks on the "austerity"

of nature: she does not tell the artist what to do; she speaks in riddles and oracles, and the painter is an Oedipus confronting a sphinx. He also insists on how necessary it was for him, as for his associates, to seek a three-dimensional grasp of what MacDonald called the "solemn land," to avoid the merely decorative as he avoided all other forms of pictorial narcissism, the landscape which is merely in front, looked at but not possessed. A picture has to suggest three dimensions before it can suggest four, before the object can become a higher reality by becoming also an event, a moment suspended in time.

It has been said of some Canadian painters, notably Thomson, that their sketches are often more convincing than the worked-up picture. The former gives more of a sense of painting in process, as an event in time, as a recording of the act of vision, and the final picture, it is said, sometimes becomes monumental at the expense of vitality and immediacy. The editors have juxtaposed some paintings with their preparatory sketches so that the reader can judge for himself as regards Lawren Harris. But there is no doubt that this painter felt the tension between process and product of painting, and that his logical development from stylized landscape to abstraction was his way of escaping from it.

In the abstract paintings the rudiments of representation are still there, with triangle and circle replacing mountain and horizon; but the stylizing and simplifying of outline have been carried a step — perhaps one should say a dimension — further. The more dependent a picture is on representation, the more epigrammatic it is, and the more it stresses the immediate context, in space and time, of a particular sense experience. The effect of stylizing and simplifying is to bring out more clearly, not what the painter sees, but what he experiences in his seeing. Abstraction sets the painter free from the particular experience, and enables him to paint the essence of his pictorial vision, with each picture representing an infinite number of possible experiences. The units of the picture have become symbols rather than objects, and have become universal without ceasing to be particular.

Traditionally, the metaphor of the magician has often been used for the artist: the Orpheus whose music moved trees, the Prospero whose fancies are enacted by spirits. The kernel of truth in the metaphor is that the artist's mind seeks a responding spirit in nature (Harris speaks of "informing cosmic powers" in his landscapes). This responding spirit is not a ghost or a god or an elf like Puck, but the elemental spirit of *design*, the quality in nature which for the artist, as for the scientist in a different way, contains what can be identified with the searching intelligence. Such design is often quasi-geometrical in form — the "books" of Prospero that Caliban so feared and hated would have been, being magic books, full of geometrical and cabalistic designs. This geometrical magic has always been an informing principle of painting, though it was probably Cézanne who was most influential in stressing its importance for the modern painter. There are many kinds of abstract painting: those that are clear and sharp in outline emphasize the rigorous control of the object by the consciousness; others express rather a sense of the inner power of nature, the exploding energy that creates form. Both kinds are prominent in, for instance, Kandinsky. Most of Lawren Harris's abstractions reflect a strict conscious control of experience, as one would expect from the clarity of outline in the landscapes that preceded them. But in the two remarkable 1967 paintings reproduced near the end of the book, there is a sense of a relaxation of control, as though the informing cosmic powers themselves were taking over from the painter.

After the conservative stock responses to the Group of Seven ("hot mush school" and the like) were over, there followed radical and left-wing stock responses which accused them of the decadent bourgeois vice of introversion, turning their backs on society and its problems to develop their own souls in the solitudes of the north. One thing that will strike the reader of this book at once is the painter's social concern, a concern which actually increases as he goes further into abstract techniques. The first and most important of his "bridges" is the bridge between the artist and his society. He is missionary as well as explorer: not a missionary who wants to

destroy all faith that differs from his own, but a missionary who wants to make his own faith real to others. Just as a new country cannot become a civilization without explorers and pioneers going out into the loneliness of a deserted land, so no social imagination can develop except through those who have followed their own vision beyond its inevitable loneliness to its final resting place in the tradition of art. The record of an imaginative journey of remarkable integrity and discipline is what is commemorated in this book.

(1969)

Conclusion to a
Literary History of Canada

SOME YEARS AGO, a group of editors met to draw up the first
tentative plans for a history of English Canadian literature.
What we then dreamed of is substantially what we have got,
changed very little in essentials. I expressed at the time the
hope that such a book would help to broaden the inductive
basis on which some writers on Canadian literature were mak-
ing generalizations that bordered on guesswork. By "some
writers" I meant primarily myself: I find, however, that more evi-
dence has in fact tended to confirm most of my intuitions on
the subject.

To study Canadian literature properly, one must outgrow
the view that evaluation is the end of criticism, instead of its
incidental by-product. If evaluation is one's guiding principle,
criticism of Canadian literature would become only a debunk-
ing project, leaving it a poor naked *alouette* plucked of every
feather of decency and dignity. True, what is really remarkable
is not how little but how much good writing has been
produced in Canada. But this would not affect the rigorous
evaluator. The evaluative view is based on the conception of
criticism as concerned mainly to define and canonize the gen-
uine classics of literature. And Canada has produced no

Literary History of Canada: Carl F. Klinck, General Editor; University
of Toronto Press; pp. xiv, 945; 1965.

author who is a classic in the sense of possessing a vision greater in kind than that of his best readers (Canadians themselves might argue about one or two, but in the perspective of the world at large the statement is true). There is no Canadian writer of whom we can say what we can say of the world's major writers, that their readers can grow up inside their work without ever being aware of a circumference. Thus the metaphor of the critic as "judge" holds better for a critic who is never dealing with the kind of writer who judges him.

This fact about Canadian literature, so widely deplored by Canadians, has one advantage. It is much easier to see what literature is trying to do when we are studying a literature that has not quite done it. If no Canadian author pulls us away from the Canadian context toward the centre of literary experience itself, then at every point we remain aware of his social and historical setting. The conception of what is literary has to be greatly broadened for such a literature. The literary, in Canada, is often only an incidental quality of writings which, like those of many of the early explorers, are as innocent of literary intention as a mating loon. Even when it is literature in its orthodox genres of poetry and fiction, it is more significantly studied as a part of Canadian life than as a part of an autonomous world of literature.

So far from merely admitting or conceding this, the editors have gone out of their way to emphasize it. We have asked for chapters on political, historical, religious, scholarly, philosophical, scientific, and other non-literary writing, to show how the verbal imagination operates as a ferment in all cultural life. We have included the writings of foreigners, of travellers, of immigrants, of emigrants — even of emigrants whose most articulate literary emotion was their thankfulness at getting the hell out of Canada. The reader of this book, even if he is not Canadian or much interested in Canadian literature as such, may still learn a good deal about the literary imagination as a force and function of life generally. For here another often deplored fact also becomes an advantage: that many Canadian cultural phenomena are not peculiarly Canadian at all, but are typical of their wider North American

and Western contexts.

This book is a collection of essays in cultural history, and of the general principles of cultural history we still know relatively little. It is, of course, closely related to political and to economic history, but it is a separate and definable subject in itself. Like other kinds of history, it has its own themes of exploration, settlement, and development, but these themes relate to a social *imagination* that explores and settles and develops, and the imagination has its own rhythms of growth as well as its own modes of expression. It is obvious that Canadian literature, whatever its inherent merits, is an indispensable aid to the knowledge of Canada. It records what the Canadian imagination has reacted to, and it tells us things about this environment that nothing else will tell us. By examining this imagination as the authors of this book have tried to do, as an ingredient in Canadian verbal culture generally, a relatively small and low-lying cultural development is studied in all its dimensions. There is far too much Canadian writing for this book not to become, in places, something of a catalogue; but the outlines of the structure are clear. Fortunately, the bulk of Canadian non-literary writing, even today, has not yet declined into the state of sodden specialization in which the readable has become the impure.

I stress our ignorance of the laws and conditions of cultural history for an obvious reason. The question: why has there been no Canadian writer of classic proportions? may naturally be asked. At any rate it often has been. Our authors realize that it is better to deal with what is there than to raise speculations about why something else is not there. But it is clear that the question haunts their minds. And we know so little about cultural history that we not only cannot answer such a question, but we do not even know whether or not it is a real question. The notion, doubtless of romantic origin, that "genius" is a certain quantum that an individual is born with, as he might be born with red hair, is still around, but mainly as a folktale motif in fiction, like the story of Finch in the Jalna books. "Genius" is as much, and as essentially, a matter of social context as it is of individual character. We do not know

what the social conditions are that produce great literature, or even whether there is any causal relation at all. If there is, there is no reason to suppose that they are good conditions, or conditions that we should try to reproduce. The notion that the literature one admires must have been nourished by something admirable in the social environment is persistent, but has never been justified by evidence. One can still find books on Shakespeare that profess to make his achievement more plausible by talking about a "background" of social euphoria produced by the defeat of the Armada, the discovery of America a century before, and the conviction that Queen Elizabeth was a wonderful woman. There is a general sense of filler about such speculations, and when similar arguments are given in a negative form to explain the absence of a Shakespeare in Canada they are no more convincing. Puritan inhibitions, pioneer life, "an age too late, cold climate, or years" — these may be important as factors or conditions of Canadian culture, helping us to characterize its qualities. To suggest that any of them is a negative cause of its merit is to say much more than anyone knows.

One theme which runs all through this book is the obvious and unquenchable desire of the Canadian cultural public to identify itself through its literature. Canada is not a bad environment for the author, as far as recognition goes: in fact the recognition may even hamper his development by making him prematurely self-conscious. Scholarships, prizes, university posts await the dedicated writer: there are so many medals offered for literary achievement that a modern Canadian Dryden might well be moved to write a satire on medals, except that if he did he would promptly be awarded the medal for satire and humour. Publishers take an active responsibility for native literature, even poetry; a fair proportion of the books bought by Canadian readers are by Canadian writers; the CBC and other media help to employ some writers and publicize others. The efforts made at intervals to boost or hard-sell Canadian literature, by asserting that it is much better than it actually is, may look silly enough in retrospect, but they were also, in part, efforts to create a cultural community, and the

aim deserves more sympathy than the means. Canada has two languages and two literatures, and every statement made in a book like this about "Canadian literature" employs the figure of speech known as synecdoche, putting a part for the whole. Every such statement implies a parallel or contrasting statement about French-Canadian literature. The advantages of having a national culture based on two languages are in some respects very great, but of course they are for the most part potential. The difficulties, if more superficial, are also more actual and more obvious.

Canada began as an obstacle, blocking the way to the treasures of the East, to be explored only in the hope of finding a passage through it. English Canada continued to be that long after what is now the United States had become a defined part of the Western world. One reason for this is obvious from the map. American culture was, down to about 1900, mainly a culture of the Atlantic seaboard, with a western frontier that moved irregularly but steadily back until it reached the other coast. The Revolution did not essentially change the cultural unity of the English-speaking community of the North Atlantic that had London and Edinburgh on one side of it and Boston and Philadelphia on the other. But Canada has, for all practical purposes, no Atlantic seaboard. The traveller from Europe edges into it like a tiny Jonah entering an inconceivably large whale, slipping past the Straits of Belle Isle into the Gulf of St. Lawrence, where five Canadian provinces surround him, for the most part invisible. Then he goes up the St. Lawrence and the inhabited country comes into view, mainly a French-speaking country, with its own cultural traditions. To enter the United States is a matter of crossing an ocean; to enter Canada is a matter of being silently swallowed by an alien continent.

It is an unforgettable and intimidating experience to enter Canada in this way. But the experience initiates one into that gigantic east-to-west thrust which historians regard as the axis of Canadian development, the "Laurentian" movement that makes the growth of Canada geographically credible. This drive to the west has attracted to itself nearly everything that is

heroic and romantic in the Canadian tradition. The original impetus begins in Europe, for English Canada in the British Isles, hence though adventurous it is also a conservative force, and naturally tends to preserve its colonial link with its starting-point. Once the Canadian has settled down in the country, however, he then becomes aware of the longitudinal dimension, the southward pull toward the richer and more glamorous American cities, some of which, such as Boston for the Maritimes and Minneapolis for the eastern prairies, are almost Canadian capitals. This is the axis of another kind of Canadian mentality, more critical and analytic, more inclined to see Canada as an unnatural and politically quixotic aggregate of disparate northern extensions of American culture — "seven fishing-rods tied together by the ends," as Goldwin Smith put it.

The simultaneous influence of two larger nations speaking the same language has been practically beneficial to English Canada, but theoretically confusing. It is often suggested that Canada's identity is to be found in some *via media*, or *via mediocris*, between the other two. This has the disadvantage that the British and American cultures have to be defined as extremes. Haliburton seems to have believed that the ideal for Nova Scotia would be a combination of American energy and British social structure, but such a chimera, or synthetic monster, is hard to achieve in practice. It is simpler merely to notice the alternating current in the Canadian mind, as reflected in its writing, between two moods, one romantic, traditional and idealistic, the other shrewd, observant and humorous. Canada in its attitude to Britain tends to be more royalist than the Queen, in the sense that it is more attracted to it as a symbol of tradition than as a fellow-nation. The Canadian attitude to the United States is typically that of a smaller country to a much bigger neighbour, sharing in its material civilization but anxious to keep clear of the huge mass movements that drive a great imperial power. The United States, being founded on a revolution and a written constitution, has introduced a deductive or *a priori* pattern into its cultural life that tends to define an American way of life

and mark it off from anti-American heresies. Canada, having a seat on the sidelines of the American Revolution, adheres more to the inductive and the expedient. The Canadian genius for compromise is reflected in the existence of Canada itself.

The most obvious tension in the Canadian literary situation is in the use of language. Here, first of all, a traditional standard English collides with the need for a North American vocabulary and phrasing. As long as the North American speaker feels that he belongs in a minority, the European speech will impose a standard of correctness. This is to a considerable extent still true of French in Canada, with its campaigns against "joual" and the like. But as Americans began to outnumber the British, Canada tended in practice to fall in with the American developments, though a good deal of Canadian theory is still Anglophile. A much more complicated cultural tension arises from the impact of the sophisticated on the primitive, and vice versa. The most dramatic example, and one I have given elsewhere, is that of Duncan Campbell Scott, working in the Department of Indian Affairs in Ottawa. He writes of a starving squaw baiting a fish-hook with her own flesh, and he writes of the music of Debussy and the poetry of Henry Vaughan. In English literature we have to go back to Anglo-Saxon times to encounter so incongruous a collision of cultures.

Cultural history, we said, has its own rhythms. It is possible that one of these rhythms is very like an organic rhythm: that there must be a period, of a certain magnitude, as Aristotle would say, in which a social imagination can take root and establish a tradition. American literature had this period, in the north-eastern part of the country, between the Revolution and the Civil War. Canada has never had it. English Canada was first a part of the wilderness, then a part of North America and the British Empire, then a part of the world. But it has gone through these revolutions too quickly for a tradition of writing to be founded on any one of them. Canadian writers are, even now, still trying to assimilate a Canadian environment at a time when new techniques of communication, many of which, like television, constitute a verbal market, are annihilating the boundaries of that environment. This foreshortening

of Canadian history, if it really does have any relevance to Canadian culture, would account for many features of it: its fixation on its own past, its penchant for old-fashioned literary techniques, its preoccupation with the theme of strangled articulateness. It seems to me that Canadian sensibility has been profoundly disturbed, not so much by our famous problem of identity, important as that is, as by a series of paradoxes in what confronts that identity. It is less perplexed by the question "Who am I?" than by some such riddle as "Where is here?"

We are obviously not to read the mystique of Canadianism back into the pre-Confederation period. Haliburton, for instance, was a Nova Scotian, a Bluenose: the word "Canadian" to him would have summoned up the figure of someone who spoke mainly French and whose enthusiasm for Haliburton's own political ideals would have been extremely tepid. The mystique of Canadianism was specifically the cultural accompaniment of Confederation and the imperialistic mood that followed it. But it came so suddenly after the pioneer period that it was still full of wilderness. To feel "Canadian" was to feel part of a no-man's-land with huge rivers, lakes, and islands that very few Canadians had ever seen. "From sea to sea, and from the river unto the ends of the earth" — if Canada is not an island, the phrasing is still in the etymological sense isolating. One wonders if any other national consciousness has had so large an amount of the unknown, the unrealized, the humanly undigested, so built into it. Rupert Brooke speaks of the "unseizable virginity" of the Canadian landscape. What is important here, for our purposes, is the position of the frontier in the Canadian imagination. In the United States one could choose to move out to the frontier or to retreat from it back to the seaboard. The tensions built up by such migrations have fascinated many American novelists and historians. In the Canadas, even in the Maritimes, the frontier was all around one, a part and a condition of one's whole imaginative being. The frontier was primarily what separated the Canadian, physically or mentally, from Great Britain, from the United States, and even more important, from other

Canadian communities. Such a frontier was the immediate datum of his imagination, the thing that had to be dealt with first.

After the Northwest passage failed to materialize, Canada became a colony in the mercantilist sense, treated by others less like a society than as a place to look for things. French, English, Americans plunged into it to carry off its supplies of furs, minerals, and pulpwood, aware only of their immediate objectives. From time to time recruiting officers searched the farms and villages to carry young men off to death in a European dynastic quarrel. Travellers visit Canada much as they would visit a zoo: even when their eyes momentarily focus on the natives they are still thinking primarily of how their own sensibility is going to react to what it sees. A feature of Canadian life that has been noted by writers from Susanna Moodie onward is the paradox of vast empty spaces and lack of privacy, with no defences against the prying or avaricious eye. The resentment expressed against this in Canada seems to have taken political rather than literary forms: this may be partly because Canadians have learned from their imaginative experience to look at each other in much the same way: "as objects, even as obstacles," as one writer says.

It is not much wonder if Canada developed with the bewilderment of a neglected child, preoccupied with trying to define its own identity, alternately bumptious and diffident about its own achievements. Adolescent dreams of glory haunt the Canadian consciousness (and unconsciousness), some naive and some sophisticated. In the naive area are the predictions that the twentieth century belongs to Canada, that our cities will become much bigger than they ought to be, or like Edmonton and Vancouver, "gateways" to somewhere else, reconstructed Northwest passages. The more sophisticated usually take the form of a Messianic complex about Canadian culture, for Canadian culture, no less than Alberta, has always been "next year country." The myth of the hero brought up in the forest retreat, awaiting the moment when his giant strength will be fully grown and he can emerge into the world, informs a good deal of Canadian criticism down to our own time.

Certain features of life in a new country that are bound to handicap its writers are obvious enough. In drama, which depends on a theatre and consequently on a highly organized urban life, the foreshortening of historical development has been particularly cruel, as drama was strangled by the movie just as it was getting started as a popular medium. Other literary genres have similar difficulties. Culture is born in leisure and an awareness of standards, and pioneer conditions tend to make energetic and uncritical work an end in itself, to preach a gospel of social unconsciousness, which lingers long after the pioneer conditions have disappeared. The impressive achievements of such a society are likely to be technological. It is in the inarticulate part of communication, railways and bridges and canals and highways, that Canada, one of whose symbols is the taciturn beaver, has shown its real strength. Again, Canadian culture, and literature in particular, has felt the force of what may be called Emerson's law. Emerson remarks in his journals that in a provincial society it is extremely easy to reach the highest level of cultivation, extremely difficult to take one step beyond that. In surveying Canadian poetry and fiction, we feel constantly that all the energy has been absorbed in meeting a standard, a self-defeating enterprise because real standards can only be established, not met. Such writing is academic in the pejorative sense of that term, an imitation of a prescribed model, second-rate in conception, not merely in execution. It is natural that academic writing of this kind should develop where literature is a social prestige symbol. However, it is not the handicaps of Canadian writers but the distinctive features that appear in spite of them which are our main concern at present.

II

The sense of probing into the distance, of fixing the eyes on the skyline, is something that Canadian sensibility has inherited from the *voyageurs*. It comes into Canadian painting a good deal, in Thomson whose focus is so often farthest back in the picture, where a river or a gorge in the hills twists elusively out

of sight, in Emily Carr whose vision is always, in the title of a compatriot's book of poems, "deeper into the forest." Even in the Maritimes, where the feeling of linear distance is less urgent, Roberts contemplates the Tantramar marshes in the same way, the refrain of "miles and miles" having clearly some incantatory power for him. It would be interesting to know how many Canadian novels associate nobility of character with a faraway look, or base their perorations on a long-range perspective. This might be only a cliché, except that it is often found in sharply observed and distinctively written books. Here, as a random example, is the last sentence of W. O. Mitchell's *Who Has Seen the Wind*: "The wind turns in silent frenzy upon itself, whirling into a smoking funnel, breathing up top soil and tumbleweed skeletons to carry them on its spinning way over the prairie, out and out to the far line of the sky."

A vast country sparsely inhabited naturally depends on its modes of transportation, whether canoe, railway, or the driving and riding "circuits" of the judge, the Methodist preacher, or the Yankee peddler. The feeling of nomadic movement over great distances persists even into the age of the aeroplane, in a country where writers can hardly meet one another without a social organization that provides travel grants. Pratt's poetry is full of his fascination with means of communication, not simply the physical means of great ships and locomotives, though he is one of the best of all poets on such subjects, but with communication as message, with radar and asdic and wireless signals, and, in his war poems, with the power of rhetoric over fighting men. What is perhaps the most comprehensive structure of ideas yet made by a Canadian thinker, the structure embodied in Innis's *Bias of Communication*, is concerned with the same theme, and a disciple of Innis, Marshall McLuhan, continues to emphasize the unity of communication, as a complex containing both verbal and non-verbal factors, and warns us against making unreal divisions within it. Perhaps it is not too fanciful to see this need for continuity in the Canadian attitude to time as well as space, in its preoccupation with its own history, its

relentless cultural stock-takings and self-inventories. The Burke sense of society as a continuum — consistent with the pragmatic and conservative outlook of Canadians — is strong and begins early. As I write, the centennial of Confederation in 1967 looms up before the country with the moral urgency of a Day of Atonement: I use a Jewish metaphor because there is something Hebraic about the Canadian tendency to read its conquest of a promised land, its Maccabean victories of 1812, its struggle for the central fortress on the hill at Quebec, as oracles of a future. It is doubtless only an accident that the theme of one of the most passionate and intense of all Canadian novels, A. M. Klein's *The Second Scroll*, is Zionism.

Civilization in Canada, as elsewhere, has advanced geometrically across the country, throwing down the long parallel lines of the railways, dividing up the farm lands into chessboards of square-mile sections and concession-line roads. There is little adaptation to nature: in both architecture and arrangement, Canadian cities and villages express rather an arrogant abstraction, the conquest of nature by an intelligence that does not love it. The word conquest suggests something military, as it should — one thinks of General Braddock, preferring to have his army annihilated rather than fight the natural man on his own asymmetrical ground. There are some features of this generally North American phenomenon that have a particular emphasis in Canada. It has often been remarked that Canadian expansion westward had a tight grip of authority over it that American expansion, with its outlaws and sheriffs and vigilantes and the like, did not have in the same measure. America moved from the back country to the wild west; Canada moved from a New France held down by British military occupation to a northwest patrolled by mounted police. Canada has not had, strictly speaking, an Indian war: there has been much less of the "another redskin bit the dust" feeling in our historical imagination, and only Riel remains to haunt the later period of it, though he is a formidable figure enough, rather like what a combination of John Brown and Vanzetti would be in the American conscience. Otherwise, the conquest, for the last two centuries,

has been mainly of the unconscious forces of nature, person-
ified by the dragon of the Lake Superior rocks in Pratt's
Towards the Last Spike:

> On the North Shore a reptile lay asleep —
> A hybrid that the myths might have conceived,
> But not delivered.

Yet the conquest of nature has its own perils for the imagi-
nation, in a country where the winters are so cold and where
conditions of life have so often been bleak and comfortless,
where even the mosquitoes have been described as "memen-
toes of the fall." I have long been impressed in Canadian poetry
by a tone of deep terror in regard to nature, a theme to which
we shall return. It is not a terror of the dangers or discom-
forts or even the mysteries of nature, but a terror of the soul
at something that these things manifest. The human mind
has nothing but human and moral values to cling to if it is to
preserve its integrity or even its sanity, yet the vast uncon-
sciousness of nature in front of it seems an unanswerable
denial of those values. A sharp-witted Methodist circuit rider
speaks of the "shutting out of the whole moral creation" in the
loneliness of the forests.

If we put together a few of these impressions, we may get
some approach to characterizing the way in which the
Canadian imagination has developed in its literature. Small
and isolated communities surrounded with a physical or
psychological "frontier," separated from one another and from
their American and British cultural sources: communities that
provide all that their members have in the way of distinctively
human values, and that are compelled to feel a great respect
for the law and order that holds them together, yet confronted
with a huge, unthinking, menacing, and formidable physical
setting — such communities are bound to develop what we
may provisionally call a garrison mentality. In the earliest maps
of the country the only inhabited centres are forts, and that
remains true of the cultural maps for a much later time.
Frances Brooke, in her eighteenth-century *Emily Montague,*

wrote of what was literally a garrison; novelists of our day studying the impact of Montreal on Westmount write of a psychological one.

A garrison is a closely knit and beleaguered society, and its moral and social values are unquestionable. In a perilous enterprise one does not discuss causes or motives: one is either a fighter or a deserter. Here again we may turn to Pratt, with his infallible instinct for what is central in the Canadian imagination. The societies in Pratt's poems are always tense and tight groups engaged in war, rescue, martyrdom, or crisis, and the moral values expressed are simply those of that group. In such a society the terror is not for the common enemy, even when the enemy is or seems victorious, as in the extermination of the Jesuit missionaries or the crew of Franklin (a great Canadian theme that Pratt pondered but never completed). The real terror comes when the individual feels himself becoming an individual, pulling away from the group, losing the sense of driving power that the group gives him, aware of a conflict within himself far subtler than the struggle of morality against evil. It is much easier to multiply garrisons, and when that happens, something anti-cultural comes into Canadian life, a dominating herd-mind in which nothing original can grow. The intensity of the sectarian divisiveness in Canadian towns, both religious and political, is an example: what such groups represent, of course, vis-à-vis one another, is "two solitudes," the death of communication and dialogue. Separatism, whether English or French, is culturally the most sterile of all creeds. But at present I am concerned rather with a more creative side of the garrison mentality, one that has had positive effects on our intellectual life.

Earlier Canadian writers were certain of their moral values: right was white, wrong black, and nothing else counted or even existed. Such certainty invariably produces a sub-literary rhetoric. Or, as Yeats would say, we make rhetoric out of quarrels with one another, poetry out of the quarrel with ourselves. To use words, for any other purpose than straight description or command, is a form of play, a manifestation of *homo ludens*. But there are two forms of play, the contest and the

construct. The editorial writer attacking the Family Compact, the preacher demolishing imaginary atheists with the argument of design, are using words aggressively, in theses that imply antitheses. Ideas are weapons; one seeks the verbal *coup de grâce*, the irrefutable refutation. Such a use of words is congenial enough to the earlier Canadian community: all the evidence, including the evidence of this book, points to a highly articulate and argumentative society in nineteenth-century Canada. We notice that scholarship in Canada has so often been written with more conviction and authority, and has attracted wider recognition, than the literature itself. There are historical reasons for this, apart from the fact, which will become clearer as we go on, that scholarly writing is more easily attached to its central tradition.

Leacock has a story which I often turn to because the particular aspect of Canadian culture it reflects has never been more accurately caught. He tells us of the rivalry in an Ontario town between two preachers, one Anglican and the other Presbyterian. The latter taught ethics in the local college on weekdays — without salary — and preached on Sundays. He gave his students, says Leacock, three parts Hegel and two parts St. Paul, and on Sunday he reversed the dose and gave his parishioners three parts St. Paul and two parts Hegel. Religion has been a major — perhaps the major — cultural force in Canada, at least down to the last generation or two. The churches not only influenced the cultural climate but took an active part in the production of poetry and fiction, as the popularity of Ralph Connor reminds us. But the effective religious factors in Canada were doctrinal and evangelical, those that stressed the arguments of religion at the expense of its imagery.

Such a reliance on the arguing intellect was encouraged by the philosophers, who in the nineteenth century were invariably idealists with a strong religious bias. One writer quotes the Canadian philosopher George as saying that civilization consists "in the conscience and intellect" of a cultivated people, and Watson as asserting that "we are capable of knowing Reality as it actually is. . . . Reality when so known is

absolutely rational." An even higher point may have been reached by that triumphant nineteenth-century theologian whose book I have not read but whose title I greatly admire: *The Riddle of the Universe Solved*. Naturally sophisticated intelligence of this kind was the normal means of contact with literature. We are told that James Cappon judged poetry according to whether it had a "rationalized concept" or not — this would have been a very common critical assumption. Sara Jeannette Duncan shows us a clergyman borrowing a copy of Browning's *Sordello*, no easy reading, and returning it with original suggestions for interpretation. Such an interest in ideas is not merely culti-vated but exuberant.

But using language as one would use an axe, formulating arguments with sharp cutting edges that will help to clarify one's view of the landscape, remains a rhetorical and not a poetic achievement. To quote Yeats again, one can refute Hegel (perhaps even St. Paul) but not the "Song of Sixpence." To create a disinterested structure of words, in poetry or in fiction, is a very different achievement, and it is clear that an intelligent and able rhetorician finds it particularly hard to understand how different it is. A rhetorician practising poetry is apt to express himself in spectral arguments, generalizations that escape the feeling of possible refutation only by being vast enough to contain it, or vaporous enough to elude it. The mystique of Canadianism was accompanied by an intellectual tendency of this kind. World-views that avoided dialectic, of a theosophical or transcendentalist cast, became popular among the Canadian poets of that time, Roberts and Carman particularly, and later among painters, as the reminiscences of the Group of Seven make clear. Bucke's *Cosmic Consciousness*, though not mentioned by any of our authors so far as I remember, is an influential Canadian book in this area. When minor rhetorically-minded poets sought what Samuel Johnson calls, though in a very different context, the "grandeur of generality," the result is what has been well described as "jejune chatter about infinity."

The literature of protest illustrates another rhetorical tradition. In the nineteenth century the common assumption

that nature had revealed the truth of progress, and that it was the duty of reason to accommodate that truth to mankind, could be either a conservative or a radical view. But in either case it was a revolutionary doctrine, introducing the conception of change as the key to the social process. In the proletarian social Darwinists, who represented a fusion of secularism, science and social discontent, there was a strong tendency to regard literature as a product and a symbol of a ruling-class mentality, with, as we have tried to indicate, some justification. Hence radicals tended either to hope that "the literature of the future will be the powerful ally of Democracy and Labour Reform," or to assume that serious thought and action would bypass the creative writer entirely, building a scientific socialism and leaving him to his Utopian dreams.

The radicalism of the period up to the Russian Revolution was, from a later point of view, largely undifferentiated. A labour magazine could regard Ignatius Donnelly, with his anti-Semitic and other crank views, as an advanced thinker equally with William Morris and Edward Bellamy. Similarly, even today, in Western Canadian elections, a protest vote may go Social Credit or NDP without much regard to the difference in political philosophy between these parties. The depression introduced a dialectic into Canadian social thought which profoundly affected its literature. In one writer's striking phrase, "the Depression was like an intense magnetic field that deflected the courses of all the poets who went through it." In this period there were, of course, the inevitable Marxist manifestos, assuring the writer that only social significance, as understood by Marxism, would bring vitality to his work. The *New Frontier*, a far-left journal of that period, shows an uneasy sense on the part of its contributors that this literary elixir of youth might have to be mixed with various other potions, not all favourable to the creative process: attending endless meetings, organizing, agitating, marching, demonstrating, or joining the Spanish Loyalists. It is easy for the critic to point out the fallacy of judging the merit of literature by its subject-matter, but these arguments over the role of "propaganda" were genuine and serious

moral conflicts. Besides helping to shape the argument of such novels as Grove's *The Master of the Mill* and Callaghan's *They Shall Inherit the Earth*, they raised the fundamental issue of the role of the creative mind in society, and by doing so helped to give a maturity and depth to Canadian writing which is a permanent part of its heritage.

It is not surprising, given this background, that the belief in the inspiration of literature by social significance continued to be an active force long after it had ceased to be attached to any specifically Marxist or other political programmes. It is still strong in the *Preview* group in the forties, and in their immediate successors, though the best of them have developed in different directions. The theme of social realism is at its most attractive, and least theoretical, in the poetry of Raymond Souster. The existentialist movement, with its emphasis on the self-determination of social attitudes, seems to have had very little direct influence in Canada: the absence of the existential in Pratt suggests that this lack of influence may be significant.

During the last decade or so a kind of social Freudianism has been taking shape, mainly in the United States, as a democratic counterpart of Marxism. Here society is seen as controlled by certain anxieties, real or imaginary, which are designed to repress or sublimate human impulses toward a greater freedom. These impulses include the creative and the sexual, which are closely linked. The enemy of the poet is not the capitalist but the "square," or representative of repressive morality. The advantage of this attitude is that it preserves the position of rebellion against society for the poet, without imposing on him any specific social obligations. This movement has had a rather limited development in Canada, somewhat surprisingly considering how easy a target the square is in Canada: it has influenced Layton and many younger Montreal poets, but has not affected fiction to any great degree, though there may be something of it in Richler. It ignores the old political alignments: the Communists are usually regarded as Puritanic and repressive equally with the bourgeoisie, and a recent poem of Layton's contrasts the social

hypocrisy in Canada with contemporary Spain. Thus it represents to some extent a return to the undifferentiated radicalism of a century before, though no longer in a political context.

As the centre of Canadian life moves from the fortress to the metropolis, the garrison mentality changes correspondingly. It begins as an expression of the moral values generally accepted in the group as a whole, and then, as society gets more complicated and more in control of its environment, it becomes more of a revolutionary garrison within a metropolitan society. But though it changes from a defence of to an attack on what society accepts as conventional standards, the literature it produces, at every stage, tends to be rhetorical, an illustration or allegory of certain social attitudes. These attitudes help to unify the mind of the writer by externalizing his enemy, the enemy being the anti-creative elements in life as he sees life. To approach these elements in a less rhetorical way would introduce the theme of self-conflict, a more perilous but ultimately more rewarding theme. The conflict involved is between the poetic impulse to construct and the rhetorical impulse to assert, and the victory of the former is the sign of the maturing of the writer.

III

There is of course nothing in all this that differentiates Canadian from other related cultural developments. The nineteenth-century Canadian reliance on the conceptual was not different in kind from that of the Victorian readers described by Douglas Bush, who thought they were reading poetry when they were really only looking for Great Thoughts. But if the tendency was not different in kind, it was more intense in degree. Here we need another seminal fact, one that we have stumbled over already: the fact that the Canadian literary mind, beginning as it did so late in the cultural history of the West, was established on a basis, not of myth, but of history. The conceptual emphasis in Canadian culture we have been speaking of is a consequence, and an essential part, of this historical bias.

Canada, of course, or the place where Canada is, can supply distinctive settings and props to a writer who is looking for local colour. Tourist-writing has its own importance (*e.g., Maria Chapdelaine*), as has the use of Canadian history for purposes of romance, of which more later. But it would be an obvious fallacy to claim that the setting provided anything more than novelty. When Canadian writers are urged to use distinctively Canadian themes, the fallacy is less obvious, but still there. The forms of literature are autonomous: they exist within literature itself, and cannot be derived from any experience outside literature. What the Canadian writer finds in his experience and environment may be new, but it will be new only as content: the form of his expression of it can take shape only from what he has read, not from what he has experienced. The great technical experiments of Joyce and Proust in fiction, of Eliot and Hopkins in poetry, have resulted partly from profound literary scholarship, from seeing the formal possibilities inherent in the literature they have studied. A writer who is or who feels removed from his literary tradition tends rather to take over forms already in existence. We notice how often critics of Canadian fiction have occasion to remark that a novel contains a good deal of sincere feeling and accurate observation, but that it is spoiled by an unconvincing plot, usually one too violent or dependent on coincidence for such material. What has happened is that the author felt he could make a novel out of his knowledge and observation, but had no story in particular to tell. His material did not come to him in the form of a story, but as a consolidated chunk of experience, reflection, and sensibility. He had to invent a plot to put this material in causal shape (for writing, as Kafka says, is an art of causality), to pour the new wine of content into the old bottles of form. Even Grove works in this way, though Grove, by sheer dogged persistence, does get his action powerfully if ponderously moving.

Literature is conscious mythology: as society develops, its mythical stories become structural principles of storytelling, its mythical concepts, sun-gods and the like, become habits of metaphorical thought. In a fully mature literary tradition the

writer enters into a structure of traditional stories and images. He often has the feeling, and says so, that he is not actively shaping his material at all, but is rather a place where a verbal structure is taking its own shape. If a novelist, he starts with a story-telling impetus; if a poet, with a metaphor-crystallizing impetus. Down to the beginning of the twentieth century at least, the Canadian who wanted to write started with a feeling of detachment from his literary tradition, which existed for him mainly in his school books. He had probably, as said above, been educated in a way that heavily stressed the conceptual and argumentative use of language. We have been shown how the Indians began with a mythology which included all the main elements of our own. It was, of course, impossible for Canadians to establish any real continuity with it: Indians, like the rest of the country, were seen as nineteenth-century literary conventions. Certain elements in Canadian culture, too, such as the Protestant revolutionary view of history, may have minimized the importance of the oral tradition in ballad and folk song, which seems to have survived best in Catholic communities. In Canada the mythical was simply the "prehistoric" (this word, we are told, is a Canadian coinage), and the writer had to attach himself to his literary tradition deliberately and voluntarily. And though this may be no longer true or necessary, attitudes surviving from an earlier period of isolation still have their influence.

The separation of subject and object is the primary fact of consciousness, for anyone so situated and so educated. Writing for him does not start with a rhythmical movement, or an impetus caught from or encouraged by a group of contemporaries: it starts with reportage, a single mind reacting to what is set over against it. Such a writer does not naturally think metaphorically but descriptively; it seems obvious to him that writing is a form of self-expression dependent on the gathering of a certain amount of experience, granted some inborn sensitivity toward that experience. We note how many Canadian novelists have written only one novel, or only one good novel, how many Canadian poets have written only one good book of poems, generally their first. Even the dream

of "the great Canadian novel," the feeling that somebody some day will write a Canadian fictional classic, assumes that whoever does it will do it only once. This is a characteristic of writers dominated by the conception of writing up experiences or observations: nobody has enough experience to keep on writing about it, unless his writing is an incidental commentary on a non-literary career.

The Canadian writers who have overcome these difficulties and have found their way back to the real headwaters of inspiration are heroic explorers. There are a good many of them, and enough of them to say that the Canadian imagination has passed the stage of exploration and has embarked on that of settlement. But it is of course full of the failures as well as the successes of exploration, imaginative voyages to Golconda that froze in the ice, and we can learn something from them too. Why do Canadians write so many historical romances, of what has been called the rut and thrust variety? One can understand it in the earlier period: the tendency to melodrama in romance makes it part of a central convention of that time. But romances are still going strong in the twentieth century and if anything even stronger in our own day. They get a little sexier and more violent as they go on, but the formula remains much the same: so much love-making, so much "research" about antiquities and costume copied off filing cards, more love-making, more filing cards. There is clearly a steady market for this, but the number of writers engaged in it suggests other answers. There is also a related fact, the unusually large number of Canadian popular best-selling fiction-writers, from Agnes Fleming through Gilbert Parker to Mazo de la Roche.

In nineteenth-century Canadian literature not all the fiction is romance, but nearly all of it is formula-writing. In the books of this type that I have read I remember much honest and competent work. Some of them did a good deal to form my own infantile imagination, and I could well have fared worse. What there is not, of course, is a recreated view of life, or anything to detach the mind from its customary attitudes. In the early twentieth century we begin to notice a more

consistent distinction between the romancer, who stays with established values and usually chooses a subject remote in time from himself, and the realist, who deals with contemporary life, and therefore — it appears to be a therefore — is more serious in intention, more concerned to unsettle a stock response. One tendency culminates in Mazo de la Roche, the other in Morley Callaghan, both professional writers and born story-tellers, though of very different kinds. By our own time the two tendencies have more widely diverged. One is mainly romance dealing with Canada's past, the other is contemporary realism dealing with what is common to Canada and the rest of the world, like antique and modern furniture stores. One can see something similar in the poetry, a contrast between a romantic tradition closely associated with patriotic and idealistic themes, and a more intellectualized one with a more cosmopolitan bias. This contrast is prominently featured in the first edition of A.J.M. Smith's anthology, *The Book of Canadian Poetry* (1943).

This contrast of the romantic and the realistic, the latter having a moral dignity that the former lacks, reflects the social and conceptual approach to literature already mentioned. Here we are looking at the same question from a different point of view. Literature, we said, is conscious mythology: it creates an autonomous world that gives us an imaginative perspective on the actual one. But there is another kind of mythology, one produced by society itself, the object of which is to persuade us to accept existing social values. "Popular" literature, the kind that is read for relaxation and the quieting of the mind, expresses this social mythology. We all feel a general difference between serious and soothing literature, though I know of no critical rule for distinguishing them, nor is there likely to be one. The same work may belong to both mythologies at once, and in fact the separation between them is largely a perspective of our own revolutionary age.

In many popular novels, especially in the nineteenth century, we feel how strong the desire is on the part of the author to work out his situation within a framework of established social values. In the success-story formula frequent in such

fiction the success is usually emotional, *i.e.*, the individual fulfils himself within his community. There is nothing hypocritical or cynical about this: the author usually believes very deeply in his values. Moral earnestness and the posing of serious problems are by no means excluded from popular literature, any more than serious literature is excused from the necessity of being entertaining. The difference is in the position of the reader's mind at the end, in whether he is being encouraged to remain within his habitual social responses or whether he is being prodded into making the steep and lonely climb into the imaginative world. This distinction in itself is familiar enough, and all I am suggesting here is that what I have called the garrison mentality is highly favourable to the growth of popular literature in this sense. The role of romance and melodrama in consolidating a social mythology is also not hard to see. In romance the characters tend to be psychological projections, heroes, heroines, villains, father-figures, comic-relief caricatures. The popular romance operates on Freudian principles, releasing sexual and power fantasies without disturbing the anxieties of the superego. The language of melodrama, at once violent and morally conventional, is the appropriate language for this. A subliminal sense of the erotic release in romance may have inspired some of the distrust of novels in nineteenth-century pietistic homes. But even those who preferred stories of real life did not want "realism": that, we learn, was denounced on all sides during the nineteenth century as nasty, prurient, morbid, and foreign. The garrison mentality is that of its officers: it can tolerate only the conservative idealism of its ruling class, which for Canada means the moral and propertied middle class.

The total effect of Canadian popular fiction, whatever incidental merits in it there may be, is that of a murmuring and echoing literary collective unconscious, the rippling of a watery Narcissus world reflecting the imaginative patterns above it. Robertson Davies' *Tempest Tost* is a sardonic study of the triumph of a social mythology over the imaginative one symbolized by Shakespeare's play. Maturity and individualization, in such a body of writing, are almost the same process.

Occasionally a writer is individualized by accident. Thus Susanna Moodie in the Peterborough bush, surrounded by a half-comic, half-sinister rabble that she thinks of indifferently as Yankee, Irish, native, republican, and lower class, is a British army of occupation in herself, a one-woman garrison. We often find too, as in Leacock, a spirit of criticism, even of satire, that is the complementary half of a strong attachment to the mores that provoke the satire. That is, a good deal of what goes on in Mariposa may look ridiculous, but the norms or standards against which it looks ridiculous are provided by Mariposa itself. In Sara Jeannette Duncan there is something else again, as she watches the garrison parade to church in a small Ontario town: "The repressed magnetic excitement in gatherings of familiar faces, fellow-beings bound by the same convention to the same kind of behaviour, is precious in communities where the human interest is still thin and sparse." Here is a voice of genuine detachment, sympathetic but not defensive either of the group or of herself, concerned primarily to understand and to make the reader see. The social group is becoming external to the writer, but not in a way that isolates her from it.

This razor's edge of detachment is naturally rare in Canadian writing, even in this author, but as the twentieth century advances and Canadian society takes a firmer grip of its environment, it becomes easier to assume the role of an individual separated in standards and attitudes from the community. When this happens, an ironic or realistic literature becomes fully possible. This new kind of detachment of course often means only that the split between subject and object has become identified with a split between the individual and society. This is particularly likely to happen when the separated individual's point of view is also that of the author, as in the stories of misunderstood genius with which many minor authors are fascinated. This convention was frequent in the plays of the twenties, and even more so in the fiction. But some of the most powerful of Canadian novels have been those in which this conflict has been portrayed objectively. Buckler's *The Mountain and the Valley* is a Maritime example, and Sinclair

Ross's *As for Me and My House* one from the prairies.

The essayist B. K. Sandwell remarks: "I follow it [society] at a respectful distance . . . far enough away to make it clear that I do not belong to it." It is clear that this is not necessarily any advance on the expression of conventional social values in popular romance. The feeling of detachment from society means only that society has become more complex, and inner tensions have developed in it. We have traced this process already. The question that arises is: once society, along with physical nature, becomes external to the writer, what does he then feel a part of? For rhetorical or assertive writers it is generally a smaller society, the group that agrees with them. But the imaginative writer, though he often begins as a member of a school or group, normally pulls away from it as he develops.

If our general line of thought is sound, the imaginative writer is finding his identity within the world of literature itself. He is withdrawing from what Douglas LePan calls a country without a mythology into the country of mythology, ending where the Indians began. The dramatist John Coulter says of his play, or libretto, *Deirdre of the Sorrows*: "The art of a Canadian remains . . . the art of the country of his forebears and the old world heritage of myth and legend remains his heritage . . . though the desk on which he writes be Canadian." But the progress may not be a simple matter of forsaking the Canadian for the international, the province for the capital. It may be that when the Canadian writer attaches himself to the world of literature, he discovers, or rediscovers, by doing so, something in his Canadian environment which is more vital and articulate than a desk.

IV

At the heart of all social mythology lies what may be called, because it usually is called, a pastoral myth, the vision of a social ideal. The pastoral myth in its most common form is associated with childhood, or with some earlier social condition — pioneer life, the small town, the *habitant* rooted to his

land — that can be identified with childhood. The nostalgia for a world of peace and protection, with a spontaneous response to the nature around it, with a leisure and composure not to be found today, is particularly strong in Canada. It is overpowering in our popular literature, from *Anne of Green Gables* to Leacock's Mariposa, and from *Maria Chapdelaine* to *Jake and the Kid.* It is present in all the fiction that deals with small towns as collections of characters in search of an author. Its influence is strong in the most serious writers: one thinks of Gabrielle Roy, following her *Bonheur d'occasion* with *La poule d'eau.* It is the theme of all the essayists who write of fishing and other forms of the simpler life, especially as lived in the past. We may quote MacMechan: "golden days in memory for the enrichment of less happier times to come." It even comes into our official documents — the Massey Report begins, almost as a matter of course, with an idyllic picture of the Canada of fifty years ago, as a point of departure for its investigations. One writer speaks of the eighteenth-century Loyalists as looking "to a past that had never existed for comfort and illumination," which suggests that the pastoral myth has been around for some time.

The Indians have not figured so largely in the myth as one might expect, though in some early fiction and drama the noble savage takes the role, as he does to some extent even in the Gothic hero Wacousta. The popularity of Pauline Johnson and Grey Owl, however, shows that the kind of rapport with nature which the Indian symbolizes is central to it. Another form of pastoral myth is the evocation of an earlier period of history which is made romantic by having a more uninhibited expression of passion or virtue or courage attached to it. This of course links the pastoral myth with the vision of vanished grandeur that comes into the novels about the *ancien régime.* In *The Golden Dog* and *The Seats of the Mighty* the forlorn little fortress of seventeenth-century Quebec, sitting in the middle of what Madame de Pompadour called "a few arpents of snow," acquires a theatrical glamour that would do credit to Renaissance Florence. The two forms of the myth collide on the Plains of Abraham, on the one side a marquis, on the

other a Hanoverian commoner tearing himself reluctantly from the pages of Gray's *Elegy*.

Close to the centre of the pastoral myth is the sense of kinship with the animal and vegetable world, which is so prominent a part of the Canadian frontier. I think of an image in Mazo de la Roche's *Delight*. Delight Mainprize — I leave it to the connoisseurs of ambiguity to explore the overtones of that name — is said by her creator to be "not much more developed intellectually than the soft-eyed Jersey in the byre." It must be very rarely that a novelist — a wideawake and astute novelist — can call her heroine a cow with such affection, even admiration. But it is consistent with her belief in the superiority of the primitive and the instinctive over the civilized and conventional. The prevalence in Canada of animal stories, in which animals are closely assimilated to human behaviour and emotions, illustrates the same point. Conversely, the killing of an animal, as a tragic or ironic symbol, has a peculiar resonance in Canadian poetry, from the moose in Lampman's Long Sault poem to the Christmas slaughter of geese which is the informing theme of James Reaney's *A Suit of Nettles*. More complicated pastoral motifs are conspicuous in Morley Callaghan, who turns continually to the theme of betrayed or victorious innocence — the former in *The Loved and the Lost*, the latter in *Such Is My Beloved*. The Peggy of *The Loved and the Lost*, whose spontaneous affection for Negroes is inspired by a childhood experience and symbolized by a child's toy, is particularly close to our theme.

The theme of Grove's *A Search for America* is the narrator's search for a North American pastoral myth in its genuinely imaginative form, as distinct from its sentimental or socially stereotyped form. The narrator, adrift in the New World without means of support, has a few grotesque collisions with the hustling mercantilism of American life — selling encyclopaedias and the like — and gets badly bruised in spirit. He becomes convinced that this America is a false social development which has grown over and concealed the real American social ideal, and tries to grasp the form of this buried society. In our terms, he is trying to grasp something of the myth of

America, the essential imaginative idea it embodies. He meets, but irritably brushes away, the tawdry and sentimentalized versions of this myth — the cottage away from it all, happy days on the farm, the great open spaces of the west. He goes straight to the really powerful and effective versions: Thoreau's *Walden*, the personality of Lincoln, Huckleberry Finn drifting down the great river. The America that he searches for, he feels, has something to do with these things, though it is not defined much more closely than this.

Grove drops a hint in a footnote near the end that what his narrator is looking for has been abandoned in the United States but perhaps not yet in Canada. This is not our present moral: pastoral myths, even in their genuine forms, do not exist as places. They exist rather in such things as the loving delicacy of perception in Grove's own *Over Prairie Trails* and *The Turn of the Year*. Still, the remark has some importance because it indicates that the conception "Canada" can also become a pastoral myth in certain circumstances. One writer, speaking of the nineteenth-century mystique of Canadianism, says: "A world is created, its centre in the Canadian home, its middle distance the loved landscape of Canada, its protecting wall the circle of British institutions . . . a world as centripetal as that of Sherlock Holmes and as little liable to be shaken by irruptions of evil." The myth suggested here is somewhat Virgilian in shape, pastoral serenity serving as a prologue to the swelling act of the imperial theme. Nobody who saw it in that way was a Virgil, however, and it has been of minor literary significance.

We have said that literature creates a detached and autonomous mythology, and that society itself produces a corresponding mythology, to which a good deal of literature belongs. We have found the pastoral myth, in its popular and sentimental social form, to be an idealization of memory, especially childhood memory. But we have also suggested that the same myth exists in a genuinely imaginative form, and have found its influence in some of the best Canadian writers. Our present problem is to see if we can take a step beyond Grove and attempt some characterization of the myth he was

looking for, a myth which would naturally have an American context but a particular reference to Canada. The sentimental or nostalgic pastoral myth increases the feeling of separation between subject and object by withdrawing the subject into a fantasy world. The genuine myth, then, would result from reversing this process. Myth starts with the identifying of subject and object, the primary imaginative act of literary creation. It is therefore the most explicitly mythopoeic aspect of Canadian literature that we have to turn to, and we shall find this centred in the poetry rather than the fiction. There are many reasons for this: one is that in poetry there is no mass market to encourage the writer to seek refuge in conventional social formulas.

A striking fact about Canadian poetry is the number of poets who have turned to narrative forms (including closet drama) rather than lyrical ones. The anthologist who confines himself wholly to the lyric will give the impression that Canadian poetry really began with Roberts's "Orion" in 1880. Actually there was a tradition of narrative poetry well established before that (Sangster, Heavysege, Howe, and several others), which continues into the post-Confederation period (Mair, Isabella Crawford, Duvar, besides important narrative works by Lampman and D. C. Scott). It is clear that Pratt's devotion to the narrative represents a deep affinity with the Canadian tradition, although so far as I know (and I think I do know) the affinity was entirely unconscious on his part. I have written about the importance of narrative poetry in Canada elsewhere, and have little new to add here. It has two characteristics that account for its being especially important in Canadian literature. In the first place, it is impersonal. The bald and dry statement is the most effective medium for its treatment of action, and the author, as in the folk song and ballad, is able to keep out of sight or speak as one of a group. In the second place, the natural affinities of poetic narrative are with tragic and ironic themes, not with the more manipulated comic and romantic formulas of prose fiction. Consistently with its impersonal form, tragedy and irony are expressed in the action of the poem rather than in its moods

or in the poet's own comment.

We hardly expect the earlier narratives to be successful all through, but if we read them with sympathy and historical imagination, we can see how the Canadian environment has exerted its influence on the poet. The environment, in nineteenth-century Canada, is terrifyingly cold, empty and vast, where the obvious and immediate sense of nature is the late Romantic one, increasingly affected by Darwinism, of nature red in tooth and claw. We notice the recurrence of such episodes as shipwreck, Indian massacres, human sacrifices, lumbermen mangled in log-jams, mountain climbers crippled on glaciers, animals screaming in traps, the agonies of starvation and solitude — in short, the "shutting out of the whole moral creation." Human suffering, in such an environment, is a by-product of a massive indifference which, whatever else it may be, is not morally explicable. What confronts the poet is a moral silence deeper than any physical silence, though the latter frequently symbolizes the former, as in the poem of Pratt that is explicitly called "Silences."

The nineteenth-century Canadian poet can hardly help being preoccupied with physical nature; the nature confronting him presents him with the riddle of unconsciousness, and the riddle of unconsciousness in nature is the riddle of death in man. Hence his central emotional reaction is bound to be elegiac and sombre, full of loneliness and fear, or at least wistful and nostalgic, hugging, like Roberts, a "darling illusion." In Carman, Roberts, and D. C. Scott there is a rhetorical strain that speaks in a confident, radio-announcer's voice about the destiny of Canada, the call of the open road, or the onward and upward march of progress. As none of their memorable poetry was written in this voice, we may suspect that they turned to it partly for reassurance. The riddle of unconsciousness in nature is one that no moralizing or intellectualizing can answer. More important, it is one that irony cannot answer:

> The gray shape with the paleolithic face
> Was still the master of the longitudes.

The conclusion of Pratt's *Titanic* is almost documentary: it is as stripped of irony as it is of moralizing. The elimination of irony from the poet's view of nature makes that view pastoral — a cold pastoral, but still a pastoral. We have only physical nature and a rudimentary human society, not strong enough yet to impose the human forms of tragedy and irony on experience.

The same elegiac and lonely tone continues to haunt the later poetry. Those who in the twenties showed the influence of the death-and-resurrection myth of Eliot, notably Leo Kennedy and A. J. M. Smith, were also keeping to the centre of a native tradition. The use of the Eliot myth was sometimes regarded as a discovery of myth, but of course the earlier poets had not only used the same myth, but were equally aware of its origins in Classical poetry, as Carman's *Sappho* indicates. The riddle of the unconscious may be expressed by a symbol such as the agonies of a dying animal, or it may be treated simply as an irreducible fact of existence. But it meets us everywhere: I pick up Margaret Avison and there it is, in a poem called "Identity":

> But on this sheet of beryl, this high sea,
> Scalded by the white unremembering glaze,
> No wisps disperse. This is the icy pole.
> The presence here is single, worse than soul,
> Pried loose forever out of nights and days
> And birth and death
> And all the covering wings.

In such an environment, we may well wonder how the sentimental pastoral myth ever developed at all. But of course there are the summer months, and a growing settlement of the country that eventually began to absorb at least eastern Canada into the north temperate zone. Pratt's Newfoundland background helped to keep his centre of gravity in the elegiac, but when he began to write the feeling of the mindless hostility of nature had largely retreated to the prairies, where a fictional realism developed, closely related to this feeling in

mood and imagery. The Wordsworthian sense of nature as a teacher is apparent as early as Mrs. Traill, in whom we note a somewhat selective approach to the subject reminiscent of Miss Muffet. As the sentimental pastoral myth takes shape, its imaginative counterpart takes shape too, the other, gentler, more idyllic half of the myth that has made the pastoral itself a central literary convention. In this version nature, though still full of awfulness and mystery, is the visible representative of an order that man has violated, a spiritual unity that the intellect murders to dissect. This form of the myth is more characteristic of the second phase of Canadian social development, when the conflict of man and nature is expanding into a triangular conflict of nature, society, and individual. Here the individual tends to ally himself with nature against society. A very direct and haunting statement of this attitude occurs in John Robins's *Incomplete Anglers*: "I can approach a solitary tree with pleasure, a cluster of trees with joy, and a forest with rapture; I must approach a solitary man with caution, a group of men with trepidation, and a nation of men with terror." The same theme also forms part of the final cadences of Hugh MacLennan's *The Watch That Ends the Night*: "In the early October of that year, in the cathedral hush of a Quebec Indian summer with the lake drawing into its mirror the fire of the maples, it came to me that to be able to love the mystery surrounding us is the final and only sanction of human existence."

It is the appearance of this theme in D. C. Scott which makes him one of the ancestral voices of the Canadian imagination. It is much stronger and more continuous in Lampman, who talks less than his contemporaries and strives harder for the uniting of subject and object in the imaginative experience. This union takes place in the contact of individual poet and a landscape uninhabited except for Wordsworth's "huge and mighty forms" that are manifested by the union:

> Nay more, I think some blessèd power
> Hath brought me wandering idly here.

Again as in Wordsworth, this uniting of individual mind and nature is an experience from which human society, as such, is excluded. Thus when the poet finds a "blessèd power" in nature it is the society he leaves behind that tends to become the God-forsaken wilderness. Usually this society is merely trivial or boring; once, in the unforgettable "City of the End of Things," it becomes demonic.

The two aspects of the pastoral tradition we have been tracing are not inconsistent with each other; they are rather complementary. At one pole of experience there is a fusion of human life and the life in nature; at the opposite pole is the identity of the sinister and terrible elements in nature with the death-wish in man. In Pratt's "The Truant" the "genus *homo*" confronts the "great Panjandrum" of nature who is also his own death-wish: the great Panjandrum is the destructive force in the Nazis and in the Indians who martyred Brébeuf, the capacity in man that enables him to be deliberately cruel. Irving Layton shows us not only the cruelty but the vulgarity of the death-wish consciousness; as it has no innocence, it cannot suffer with dignity, as animals can; it loses its own imaginary soul by despising the body:

> Listen: for all his careful fuss,
> Will this cold one ever deceive us?
> Self-hating, he rivets a glittering wall;
> Impairs it by a single pebble
> And loves himself for that concession.

We spoke earlier of a civilization conquering the landscape and imposing an alien and abstract pattern on it. As this process goes on, the writers, the poets especially, tend increasingly to see much of this process as something that is human but still dehumanized, leaving man's real humanity a part of the nature that he continually violates but is still inviolate.

Reading through any good collection of modern Canadian poems or stories, we find every variety of tone, mood, attitude, technique, and setting. But there is a certain unity of impression one gets from it, an impression of gentleness and

reasonableness, seldom difficult or greatly daring in its imaginative flights, the passion, whether of love or anger, held in check by something meditative. It is not easy to put the feeling in words, but if we turn to the issue of the *Tamarack Review* that was devoted to West Indian literature, or to the Hungarian poems translated by Canadians in the collection *The Plough and the Pen*, we can see by contrast something of both the strength and the limitations of the Canadian writers. They too have lived, if not in Arcadia, at any rate in a land where empty space and the pervasiveness of physical nature have impressed a pastoral quality on their minds. From the deer and fish in Isabella Crawford's "The Canoe" to the frogs and toads in Layton, from the white narcissus of Knister to the night-blooming cereus of Reaney, everything that is central in Canadian writing seems to be marked by the imminence of the natural world. The sense of this imminence organizes the mythology of Jay Macpherson; it is the sign in which Canadian soldiers conquer Italy in Douglas LePan's *The Net and the Sword*; it may be in the foreground, as in Alden Nowlan, or in the background, as in Birney; but it is always there.

To go on with this absorbing subject would take us into another book: *A Literary Criticism of Canada*, let us say. Here we can only sum up the present argument emblematically, with two famous primitive American paintings. One is "Historical Monument of the American Republic," by Erastus Salisbury Field. Painted in 1876 for the centennial of the Revolution, it is an encyclopaedic portrayal of events in American history, against a background of soaring towers, with clouds around their spires, and connected by railway bridges. It is a prophetic vision of the skyscraper cities of the future, of the tremendous technological will to power of our time and the civilization it has built, a civilization now gradually imposing a uniformity of culture and habits of life all over the globe. Because the United States is the most powerful centre of this civilization, we often say, when referring to its uniformity, that the world is becoming Americanized. But of course America itself is being Americanized in this sense, and the uniformity imposed on New Delhi and Singapore, or on Toronto and Vancouver,

is no greater than that imposed on New Orleans or Baltimore. A nation so huge and so productive, however, is deeply committed to this growing technological uniformity, even though many tendencies may pull in other directions. Canada has participated to the full in the wars, economic expansions, technological achievements, and internal stresses of the modern world. Canadians seem well adjusted to the new world of technology and very efficient at handling it. Yet in the Canadian imagination there are deep reservations to this world as an end of life in itself, and the political separation of Canada has helped to emphasize these reservations in its literature.

English Canada began with the influx of defeated Tories after the American Revolution, and so, in its literature, with a strong anti-revolutionary bias. The Canadian radicalism that developed in opposition to Loyalism was not a revival of the American revolutionary spirit, but a quite different movement, which had something in common with the Toryism it opposed: one thinks of the Tory and radical elements in the social vision of William Cobbett, who also finds a place in the Canadian record. A revolutionary tradition is liable to two defects: to an undervaluing of history and an impatience with law, and we have seen how unusually strong the Canadian attachment to law and history has been. The attitude to things American represented by Haliburton is not, on the whole, hostile: it would be better described as noncommittal, as when Sam Slick speaks of a Fourth of July as "a splendid spectacle; fifteen millions of freemen and three millions of slaves a-celebratin' the birthday of liberty." The strong romantic tradition in Canadian literature has much to do with its original conservatism. When more radical expressions begin to creep into Canadian writing, as in the poetry of Alexander McLachlan, there is still much less of the assumption that freedom and national independence are the same thing, or that the mercantilist Whiggery which won the American Revolution is necessarily the only emancipating force in the world. In some Canadian writers of our own time — I think particularly of Earle Birney's *Trial of a City* and the poetry of

F. R. Scott — there is an opposition, not to the democratic but to the oligarchic tendencies in North American civilization, not to liberal but to laissez-faire political doctrine. Perhaps it is a little easier to see these distinctions from the vantage-point of a smaller country, even one which has, in its material culture, made the "American way of life" its own.

The other painting is the much earlier "The Peaceable Kingdom," by Edward Hicks, painted around 1830. Here, in the background, is a treaty between the Indians and the Quaker settlers under Penn. In the foreground is a group of animals, lions, tigers, bears, oxen, illustrating the prophecy of Isaiah about the recovery of innocence in nature. Like the animals of the Douanier Rousseau, they stare past us with a serenity that transcends consciousness. It is a pictorial emblem of what Grove's narrator was trying to find under the surface of America: the reconciliation of man with man and of man with nature: the mood of Thoreau's Walden retreat, of Emily Dickinson's garden, of Huckleberry Finn's raft, of the elegies of Whitman. This mood is closer to the haunting vision of a serenity that is both human and natural which we have been struggling to identify in the Canadian tradition. If we had to characterize a distinctive emphasis in that tradition, we might call it a quest for the peaceable kingdom.

The writers of the last decade, at least, have begun to write in a world which is post-Canadian, as it is post-American, post-British, and post everything except the world itself. There are no provinces in the empire of aeroplane and television, and no physical separation from the centres of culture, such as they are. Sensibility is no longer dependent on a specific environment or even on sense experience itself. A remark of one critic about Robert Finch illustrates a tendency which is affecting literature as well as painting: "the interplay of sense impressions is so complicated, and so exhilarating, that the reader receives no sense impression at all." Marshall McLuhan speaks of the world as reduced to a single gigantic primitive village, where everything has the same kind of immediacy. He speaks of the fears that so many intellectuals have of such a world, and remarks amiably: "Terror is the normal state of any

oral society, for in it everything affects everything all the time."
The Canadian spirit, to personify it as a single being dwelling
in the country from the early voyages to the present, might
well, reading this sentence, feel that this was where he came in.
In other words, new conditions give the old ones a new impor-
tance, as what vanishes in one form reappears in another. The
moment that the peaceable kingdom has been completely
obliterated by its rival is the moment when it comes into the
foreground again, as the eternal frontier, the first thing that
the writer's imagination must deal with. Pratt's "The Truant,"
already referred to, foreshadows the poetry of the future,
when physical nature has retreated to outer space and only
individual and society are left as effective factors in the imagi-
nation. But the central conflict, and the moods in which it is
fought out, are still unchanged.

One gets very tired, in old-fashioned biographies, of the
dubious embryology that examines a poet's ancestry and
wonders if a tendency to fantasy in him could be the result of
an Irish great-grandmother. A reader may feel the same
unreality in efforts to attach Canadian writers to a tradition
made up of earlier writers whom they may not have read or
greatly admired. I have felt this myself whenever I have writ-
ten about Canadian literature. Yet I keep coming back to the
feeling that there does seem to be such a thing as an imagi-
native continuum, and that writers are conditioned in their
attitudes by their predecessors, or by the cultural climate of
their predecessors, whether there is conscious influence or
not. Again, nothing can give a writer's experience and sensi-
tivity any form except the study of literature itself. In this
study the great classics, "monuments of its own magnifi-
cence," and the best contemporaries have an obvious priority.
The more such monuments or such contemporaries there are
in a writer's particular cultural traditions, the more fortunate
he is; but he needs those traditions in any case. He needs
them most of all when what faces him seems so new as to
threaten his identity. For present and future writers in Canada
and their readers, what is important in Canadian literature,
beyond the merits of the individual works in it, is the inheri-

tance of the entire enterprise. The writers of Canada have identified the habits and attitudes of the country, as Fraser and Mackenzie have identified its rivers. They have also left an imaginative legacy of dignity and of high courage.

(1965)

Selected Index